Founder/Editor-in-Chief: Kate E. Hinshaw
Contributing Editor and Writer: B. Sonenreich
Cover Design: Hogan Seidel
Analog Cookbook Logo: Sarah Lawrence's Design Emporium
Questions: hello@analogcookbook.com
Published by Analog Cookbook © 2021

LETTER FROM THE EDITOR

The image on the right is a self-portrait. If you've met me in person, then it should come as no surprise that this self-portrait is a 35mm still that has been soaked in washing soda and boiling water in order to obscure my face all together. It's from an unfinished film--one that will likely never be finished along with a 16mm film of a friend twirling in roller skates and a few aimless animation attempts.

When I tell people I work with celluloid, I'm often asked, "can't you get the same effect with digital? Can't you just add grain and a filter? Can't you just use AfterEffects?" To which I say, sure! Of course you can. Hell, you could probably even fool me into thinking your DaVinci Resolve project was celluloid if you tried hard enough.

But then again, that's not the point.

Working with celluloid is about process--a space to think through touching. Each frame I scratch, bleach, or boil brings up ideas, thoughts, memories. It's a space where I feel entirely myself. Where I don't feel pressure to perform, pressure to be productive, a space where I don't feel the need to put anyone's needs above my own.

In this particular time, digital media feels antithetical to that. Digital is a means of staying productive through Zoom calls, a way to "pivot" (a word I've come to hate), and a disembodied way of existing.

This past year, I've learned to accept my unfinished celluloid films as part of a process of re-entering my analog body, and a way to find time and space for myself. In a year where there is all this pressure on artists to be productive, to reflect in deep prose on the pandemic, I feel fine opting out.

This issue is full of essays, articles, interviews and recipes that grapple with the analog body, what it means to make work amidst sickness, collective grief, and paradigm shifts. In reading it, I hope you walk away feeling inspired to make work from the heart, and feel ok about those tasks, projects, and ideas left unfinished.

-Kate

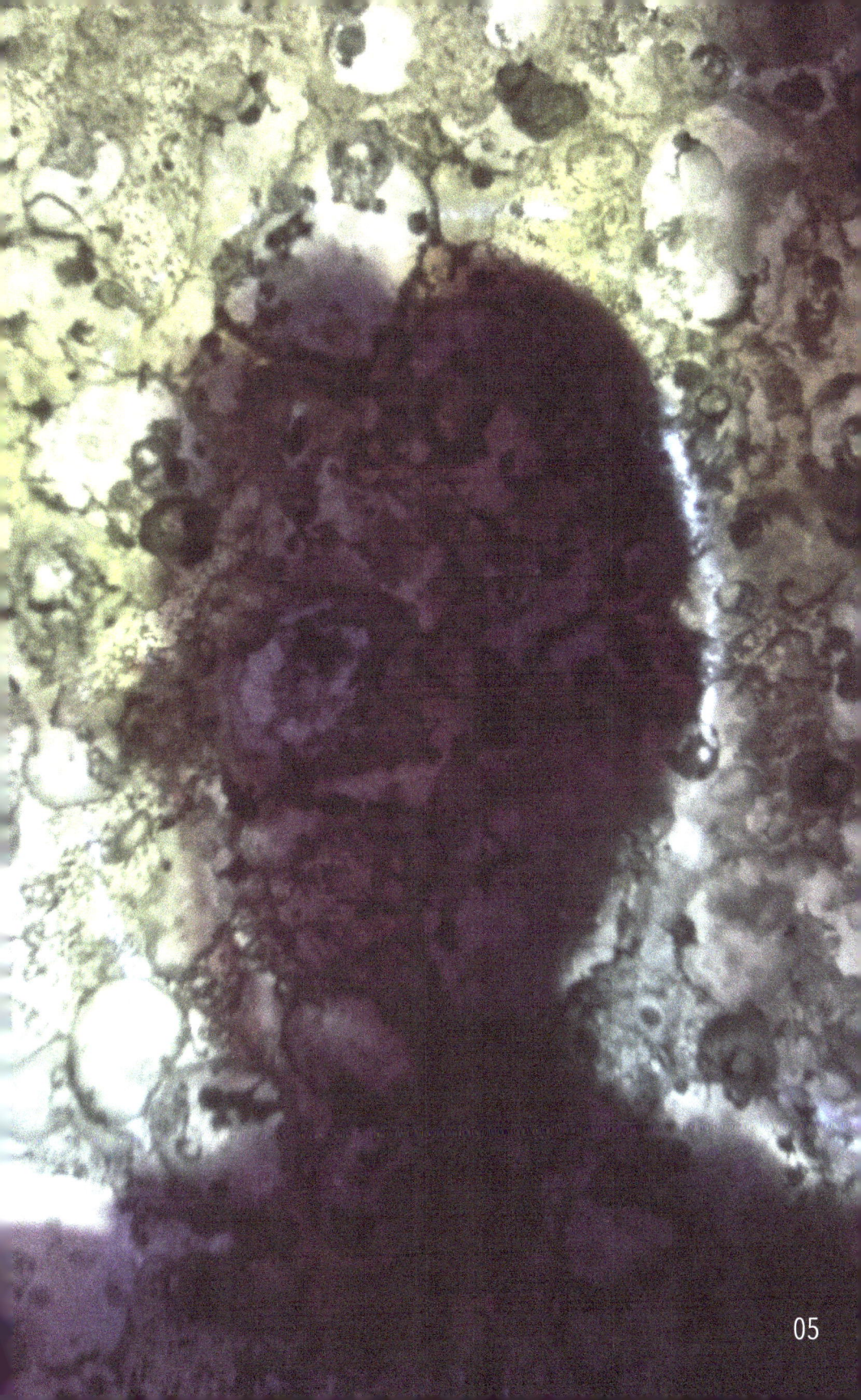

ARTISTS FEATURED

Where Uncertainty Meets Imagination Essay and photos by John Fitzgerald **16**

Fitzgerald is a visual artist and educator based in Louisville, KY. His work interrogates assumptions about blackness, masculinity, performance and representation. He is also a world renowned mind traveler and ten-time unanimous Father of Year recipient. He makes art to prove existence.

Day off Vibes Melina Kiyomi Coumas **24**

Melina Coumas is an experimental filmmaker and photographer from the island of O'ahu. With a BA in Film Studies from Portland State University, she shoots moving and still images primarily on celluloid film formats exploring themes surrounding memory, identity, and perception. Her work has screened at the Portland International Film Festival, NW Film Forum's Local Sightings Film Festival, Engauge Experimental Film Festival, and numerous other festivals around the world. She is currently based in Portland, Oregon where she drinks tea all day while working on personal projects in her free time.

Retrato de Análogo // Portrait of Analog Jean-Jacques Martinod **27**

Jean-Jacques Martinod is a filmmaker, transmedia artist and educator. His works oscillate among modalities of hybrid cinemas using methodologies that experiment with archival materials, celluloid film, analog tape, digital media, synesthetic operations, personal mythologies and travelogues. His work has been exhibited at the Museo do MAM Rio de Janeiro, the Cinemateca Nacional del Ecuador, the Los Angeles Center for Digital Arts, the Museum of the Moving Image in New York, and festivals that include FIDMarseille, International Film Festival Rotterdam, Sheffield Doc/Fest, Mar del Plata, Images Festival, European Media Arts Festival, among many others, as well as galleries, artist-led spaces, and clandestine DIY screenings.

Landscapes Zoe Chronis 28

Zoe Chronis is an artist whose work includes video, film, drawing, performance and printed matter. She holds a BA in Anthropology and Film from Vassar College and a MFA in Fine Arts from the University of Pennsylvania. In 2012 she received a fellowship at The American Academy in Rome and in 2019, attended a residency for text-based art in Hämeenkyrö, Finland. She currently works for public access television in Brooklyn, NY.

Postcards for John Cody Edison & Christine Wood 32

Cody Edison is an artist based on the Chumash, Kizh and Tongva ancestral homelands also known as Los Angeles, California. He works with film, video and photography to explore the possibilities of authorship, collaboration and text in documentary practices. Edison's work investigates issues of farming, rural culture, racial & gender equality, historical amnesia and climate crisis.

Film As a Language for Loss Essay and stills by Ellery Bryan 38

Ellery Bryan is a nonbinary visual artist working primarily with loss, ritual and temporality. Their artwork is interdisciplinary and manifests as tactile objects, written and verbal text, sound, performance, film, and video. They use their studio practice to explore embodiment and disembodiment, tangibility and the transcendental, by experimenting with the formal physicality of film and its transfer into ephemeral media. They live and work on unceded Piscataway land currently called Baltimore, Maryland.

All Dust is Skin Meesh Kislyakov 42

Meesh Kislyakov is a sometimes-person and sometimes-artist living in Brooklyn, NY. She is interested in the color red, found footage, and starting new, hopefully-fruitful hobbies. Throughout her work, she explores misplaced and/or misaligned objects and memories. In her spare time she looks for street treasures from her 5th floor window using her grandma's USSR opera binoculars, uses a lot of garlic in her cooking, and recently has gotten some very dry hands from throwing clay on wheels. More than anything, she seeks and finds inspiration from watching and listening.

Disappearing silence
Sarah Seené

Sarah Seené is a photographer and filmmaker who works with analog media (35mm, 120mm, Polaroid, Super8). Bringing together mainly portraits, her images focus on faces, bodies and the human being. The photographic material offered by the film has allowed her to develop a singular poetry, a dream that animates each of her series. Her work is inspired by the concept of resilience and the capacity to be reborn from ashes.

Her photographs have been exhibited internationaly in solo and group shows. Her short films have been screened at various festivals in Europe and North America. She creates music videos and analog portraits of musicians in France and Quebec.

The Bearers of Memories
Miglė Križinauskaitė-Bernotienė

Miglė Križinauskaitė-Bernotienė (b. 1987) is an audio-visual artist, photographer and a creator of experimental documentary films, who is currently based in Utena (Lithuania). In 2020, she graduated from the Lithuanian Academy of Music and Theatre with an MA in Film Directing. She is also founder of the cinema TAURAPILIS – a space for showing and producing films, for cinema activities, and education programmes of the cinema industry. Filmmaker's work usually spans multiple disciplines including experimental and documentary moving image works in both: film and video. She chooses present abstract ideas through a subjective, personal, and sensitive way of storytelling. Her newest experimental documentary film is called "The Bearers of Memories", the theme of which is the erosion of memory and time. The film intertwines the reality around us with the forms of experimental cinema.

River Ghosts
Jonathan Onsuwan Johnson

Jonathan Johnson is a photographer and filmmaker whose work explores ideas about place, identity and nature. Autobiography plays a role in Johnson's work as he often references his mixed-race background, travel and backcountry exploration. He has received awards and grants from Duke University, The Society for Photographic Education, CINECAFEST, The National Endowment for the Humanities and The Ann Arbor Film Festival. His work has been shown at film festivals and galleries in over 30 countries including: Museo Nacional Centro de Arte Reina Sofia, Madrid; Modern Art Museum, Sao Paulo, Brazil; Wexner Center for the Arts, Columbus, Ohio; Galleria Sment, Braga, Portugal; Africa Centre, Cape Town, South Africa; Sofia Arsenal Museum of Contemporary Art, Sofia, Bulgaria; Center for Contemporary Culture Barcelona ; Benaki Museum, Athens, Greece; Union Docs, Brooklyn; Winnipeg Underground Film Festival and the EXiS Film Festival, Seoul, South Korea.

Film Enviornments

Taiga Leena Lehti **58**

Leena Lehti (1979) is a filmmaker who works in Tampere, Finland. She has graduated as a Bachelor of Media and Master of Arts. Her favourite themes are winter, proceeding, and the merging of the inner and outer worlds. Lehti is interested in enviromental politics and encounters in everyday life. She often shoots her experimental videos on Super 8mm film for its special visuality and materiality. She loves the tactile feeling of film and the flow of making hand-made effects. Lehti´s films are shown in several screenings, art exhibitions and film festivals in Europe.

 Anthology for Fruits and Vegetables Dawn George **62**

Dawn George likes to muck about in the yard and make films, videos, and installations with the plants, insects, and molds she finds around the garden. Her DIY approach to filmmaking reflects her appreciation and respect for movement, nature, science, and sound. Through her practice, she seeks a deeper understanding of life through nature. Dawn is a graduate of Ryerson's Radio and Television Arts Program and received her film and media arts training from the Atlantic Filmmakers Cooperative and the Centre for Art Tapes, she continues to be a strong advocate for artists, artist run centres, and cooperatives. Dawn has participated in residencies at the Independent Imaging Retreat (Film Farm), Handmade Film Institute, and the Ayatana Artists Research Program. She is one of the founding members of the Handmade Film Collective located in K'jiputuk, Mi'kma'ki (Halifax, Nova Scotia) and teaches workshops on film eco-processing.

He Needs Dark to See Abigail He **70**

Abigail He is a Brooklyn based filmmaker and video artist. Her recent work explores the alternative relationships between image and sound through integrating film with conceptual art and deconstructing pre-recorded visual, audio materials, and found footage in digital and analog formats.

✺ = recipe

Bloom Ashley Manigo 74

Ashley Manigo is a visual artist, filmmaker, and poet born in Würzburg, Germany and raised in Fayetteville, North Carolina where she developed a fascination with drawing and painting. While an undergraduate at Duke University, Manigo began experimenting with celluloid and video storytelling. Her experimental film "Bloom", which Manigo describes as "a kaleidoscope of color and foliage captured through chemical experimentations", premiered in the Interference Fest: Women Making Noise 2020. Manigo has been awarded the Benenson Award in the Arts for an upcoming visual arts project titled "Taste of the Land", that uses experimental filmmaking techniques to investigate her evolving and complicated relationship towards food cultures.

Babes in the Woods Leanna Kaiser 78

Leanna Kaiser is an experimental filmmaker and musician originally from St. Louis, MO and currently residing in Los Angeles, CA. She has an MFA in Film and Video from CalArts. Her work in both film and music address emotional states, seasonal changes, improvisation, and the tactile quality of both these mediums.

�֎ Handmade / Homemade Michael Lyons 84

Michael Lyons (Canada, Scotland) is a researcher and artist based in Kyoto, Japan. His experimental short films and videos have screened in festivals and exhibitions around the world. He currently works as a professor of image arts and sciences at Ritsumeikan University.

Zine within a Zine

�֎ Home Office Cinema Karissa Hahn 88

Karissa Hahn is a visual artist based in Los Angeles. Her work articulates the nature of contemporary image reproduction and dissemination through the use of analog and digital technologies. Whether creating performative films to highlight the hidden intensities of the everyday or blurring digital ephemera into physical reality through

inkjet printing, she conjures up a storm of 'spectra ephemera.' Hahn has shown around the planet Earth in various cinemas, galleries, and institutions such as the New York Film Festival Projections, TIFF Wavelengths, MoMA Eyeslicer Series, CROSSROADS, International Film Festival Rotterdam, Ann Arbor Film Festival, and the Anthology Film Archives, among others.

Reticulation as a tool for queering the body: compulsory heterosexuality **124**

Essay and images by emily van loan

Emily Van Loan is an experimental filmmaker and artist. They create diaristic, autobiographical works with the intention of fostering connections between audience and maker or perhaps within an audience.

Folly Shane Dedman **126**

Shane Dedman (they | he) is a trans-masculine non-binary video-based artist, educator, (former) sex worker, and writer. Their interdisciplinary practice is concerned with new media, divergent selfdom, accessible archiving, and the translation of trauma into material. In addition to art-making, he has worked as an arts educator in juvenile detention centers in Georgia, and as an art handler across the South East. Dedman received their BFA in Photography from Georgia State University. His most recent work, PHYSICAL BODY OF WORK; a love letter to an evolving self, is a trilogy of short films that is currently on view at the 2021 Atlanta Biennial at Atlanta Contemporary.

Side Effects May Include Claire Donohue **136**

Claire Donohue is a Northern California based filmmaker with an interest in analog practices. During her undergraduate film studies at UC Santa Cruz she worked closely with the Center for Digital Arts and New Media on campus and was awarded the Porter Fellowship for Film and Digital Media (2019). She currently works as a video editor in Santa Cruz, CA.

✳ = recipe

Kinky Paradise — Claudia Rojas — 140

Claudia Rojas is a Colombian photographer who is fascinated and only works with analog cameras (35mm) and Collage. She begins her photographic work after some workshops in Buenos Aires, where she lived for a few years. After college, she works as a costume designer and art director for advertising, always close to photographers. At this time a feeling for photographic creation it's stronger, she is interested and works with experimental photography, filmsoup, double exposures, different development times and temperatures, etc.

Conversations

The Matters of Black Skin: A Comprehensive Conversation with Frederick Taylor — Interview by B. Sonenreich — 145

B. Sonenreich is the Editor-in-Chief of Oz Magazine, the Atlanta-based film and television publication. Originally from Miami, Sonenreich relocated to Atlanta to receive her Master-s degree in film and television studies at Georgia State University, where she was also an instructor of undergraduate courses like motion picture history and film aesthetics. Prior to receiving her graduate degree, Sonenreich studied screenwriting and playwriting in London and worked on multiple sets in New York City. She served as juror on Film Impact Georgia's Spring 2021 cycle, and curates film screenings throughout Atlanta.

Hai! Oui! A Dance Between Countries: French and Japanese piano compositions — Christine A. Banna — 158

Christine A. Banna is an internationally showing, multidisciplinary visual artist and educator. She works in both modern and traditional methods with a focus on experimental animation and projection design. Her animations and projections have been shown at the CICA Museum in South Korea and in film festivals in San Fransisco and Boston. Some of her former credits and clients for projection design include the National Young Arts Foundation, Greater Boston Stage Company, MassOpera, Lowell Chamber Orchestra, and Keene State College. Born in Providence, RI, Banna grew up with a deep love of ancient history and science which has been a driving force for her since she was a young girl. This dichotomy between ancient and modern is reflected in both Banna's subject matter and medium choices in her work. Christine A. Banna received her MFA from the School of the Museum of Fine Arts, Boston. She received her BFA in Painting with a minor in Art History from Boston University's College of Fine Art. She is currently a faculty member of the School of Film & Animation at Rochester Institute of Technology.

Sainte-Croix — Alix Galdin — 162

Alix Galdin is a French artist living in Montreal. Self-taught, she became interested in 35mm photography and darkroom at a very young age thanks to her family. In 2016 she joined the 3ème Œil, a photo club located in Montreal and equipped with a large darkroom. She joined the board members in 2017, and has been giving courses in photo development and workshops on the polaroid emulsion transfer technique. Since 2017 she has participated in several group exhibitions in Quebec and France. Her work has been presented at the artist center La Cenne (Montreal), at the Gesù for Maison Photo Montréal and at the Capsule Galerie (Rennes), as well as at the cultural bar VV Tavernä (Montreal) for a solo exhibition in 2020. That same year, she made her first short documentary in Super 8 film, Sainte-Croix, which depicts the world of Quebec musician Pierre Potvin. She is currently working on a documentary short film project with glass-blowing artist Annie Cantin.

Bad Dream — Camilo Diaz — 166

Camilo Diaz is a Colombian writer-director based in Atlanta, Georgia. His award winning work has gone through the national and international film festival circuit and became a Sundance Film Institute Alumnus when his script was selected for the 2018 Sundance Screenwriter's Intensive held in Macon, Georgia.

Glory Box — Leanora Olmi — 170

Leanora is a community artist working with archives and photochemical film. Her work explores visual documents in rural areas of Australia and the histories that they embody. She talks to people about the smaller stories that are sometimes lost in the grand narrative of Australia. These stories are hidden on mantelpieces and in stories around the kitchen table. She works only in rural areas, believing that a collaborative, honorable and experimental approach to creating dialogues and artworks is beneficial and rewarding to both artist and communities. Leanora is excited by archives: they are fertile collections, not dead or decaying, but vital with latent stories waiting to be reimagined and brought into the present. She works with analog photographic equipment, preferring to work with film: the materiality of the medium is itself a retainer of memory. Film can present so many unknowns, as can her 60 year-old camera.

Jeux de lumière // Light Plays — Anne-Marie Bouchard — 174

Anne-Marie Bouchard lives and works in Québec City. She directed several experimental videos and installations. Her work is about exploring the mysteries and wonders of the world and questioning the way we perceive and analyze it. To sense, to feel, to be immersed, and to question: her cinema is poetry.

Double X — Kioto Aoki — 180

Kioto Aoki is a visual artist and educator using analog image and image-making process to explore modes of perception as a politics of vision. She is interested in philosophical and process-based inquiries grounded in the integrity of the analog image as an artistic process to support a material-specific and site-responsive practice. Forming a rhetoric of nuanced quietude, her practice tangibly engages these elements of time, space, form, light and movement through nuances of the mundane, using the idiosyncrasies of conceptual photography and experimental cinema. She currently resides in Chicago and has exhibited both nationally and internationally. Her work is held in the Joan Flasch Artists' Book Collection and the Museum of Contemporary Art Chicago Library. Curatorial projects include the ongoing Chicago Obihiro Exchange Project and 思考回路 •Shikoukairo: Patterns of Thought which reframes the conversation around Asian & Asian-American cultural diegesis in the arts.

Instant Vinegar Syndrome Dye Job — Christine Lucy Latimer — 186

Christine Lucy Latimer is an interdisciplinary lens-based and time-based media maker. Her work has been featured across 5 continents in over 300 film festivals and gallery exhibitions. She currently lives and works in Toronto, Canada.

Scope *Olly Knights* **192**

Out and Out films are London based couple Rachel and Olly Knights, working on 16mm, Super 8 and digital formats. Rachel is a freelance filmmaker and editor, specialising in qualitative and observational research filmmaking. She began her career shooting wedding films and was the first UK female to offer Super 8 weddings. Olly is a professional musician whose heart has always been that of a filmmaker. Graduating from Central St Martins College of Art where he specialised in experimental film and video. Rachel and Olly make and collate films that span many genres such as documentary, experimental and narrative. Always playing with ambiguity and stripping the traditional film language, encouraging the viewer to embrace slow cinema and experience meaning in-between meaning. Influenced by filmmakers such as John Smith and Jon Jost where films own absurdities and accidental narratives are allowed to develop fully.

Zen and the Art of Film Projection Markus Maicher **196**

Markus Maicher, 1984, is an experimental filmmaker, projectionist at the Austrian Filmmuseum and part of the artist-run film lab filmkoop wien. In his PhD thesis at the University of Applied Arts Vienna he focuses on experimental analog film practices in relation to the digital. His film works engage with the structure and poetry of analog film material itself, they have been shown at festivals such as Diagonale, Vienna Shorts Film Festival, International Short Film Festival Oberhausen, Experiments in Cinema, Analogica, Alchemy Film and Moving Image Festival, Fracto, RPM Festival and at the Austrian Filmmuseum, Stadtkino and Metro Kinokulturhaus.

Where Uncertainty Meets Imagination

Essay and photos by John Fitzgerald

Uncertainty has a way of shifting the body, depending on your relationship to it. For some, it came as a response to COVID becoming part of their daily lives; the not being able to move freely or visit loved ones, to losing them, and then losing themselves trying to find new ways to grieve. Before last spring if you lived in relative privilege, I imagine that when life halted, you felt as if the rug swept from under your feet. What should have been an immediate collision with a cold floor, has instead been a year-long free fall. Imagine falling and expecting to hit a bottom and discovering it isn't where you left it. Or waking up in a body that feels heavier than you remember, and then someone telling you which ways you could or couldn't move it. You probably realized quickly just how many things you took for granted because you simply could.

For George Floyd and Breonna Taylor, for me, for my friend who lost both of his brothers during the pandemic, and for my other Black and queer and trans siblings, uncertainly didn't creep in. It moved through our community as it always has: through systems that disenfranchise, imprison, and discard Black folk. It polices us. Last year, it simply doubled back, headlights on and sirens blaring. It exacerbates the strain on bodies that have been, and for some time now, overextended. For those of us growing up poor or living where there are no grocery stores, where low economic outcomes beget violence, where exposure to healthy choices and second chances are limited, the body has a way of building a sort of callus against uncertainty. The protection it offers is mostly a fallacy, but is certainly better than being completely naked and exposed.

Whichever body you inhabit, there is a unique impact on the artistic body. The

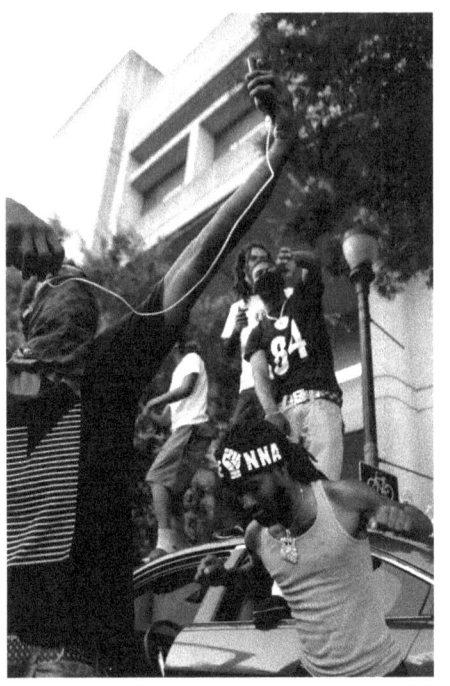

collateral damage to artists and makers wading uncertainty is that we begin to hesitate to capture, create and contextualize the same world that depends on our disposability to make sense of itself. The movie theaters closed. Film festivals paused indefinitely. Exhibits and residencies retracted offers. The artist visits and talks that allowed us to critique and question and deconstruct ideas and feelings became water drops on scorched earth. We went from communing to isolating, unsure of what was supposed to be next. And while all the major News networks exploited our fear through infection rates that didn't make sense and our inability to buy toilet paper, something interesting happened.

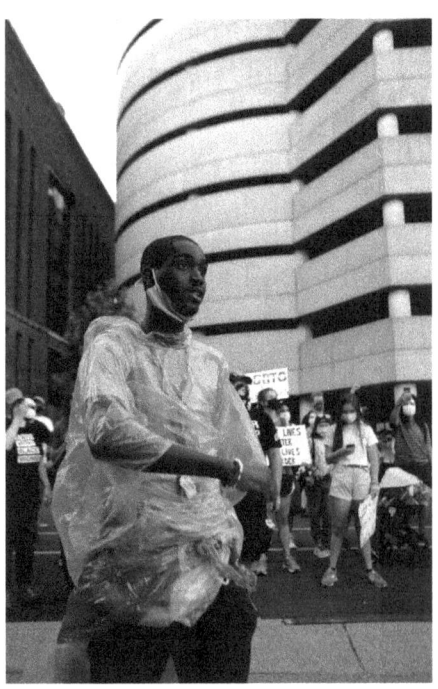

We were all given something that for many of us had up until now been a rare luxury: an abundance of time. Time to think and rethink. Time to evaluate and reevaluate. Time to be critical and gentle and doubtful and afraid and daring and hopeful. Time for wounds to be opened and closed; time to mourn; time to grieve. Time to love; fight; heal, and most importantly time to rest. Having been forced to move to a new city amid the pandemic, and in an apartment with little to no furniture–a computer desk, book shelf, record player and a few cameras–I made the choice to take advantage of our collective uncertainty. I chose that with how much ever time I had left, however the pandemic would play out, however my Black body would be engaged while out documenting the Breonna Taylor protests in Louisville, I would explore the sanctity of time.

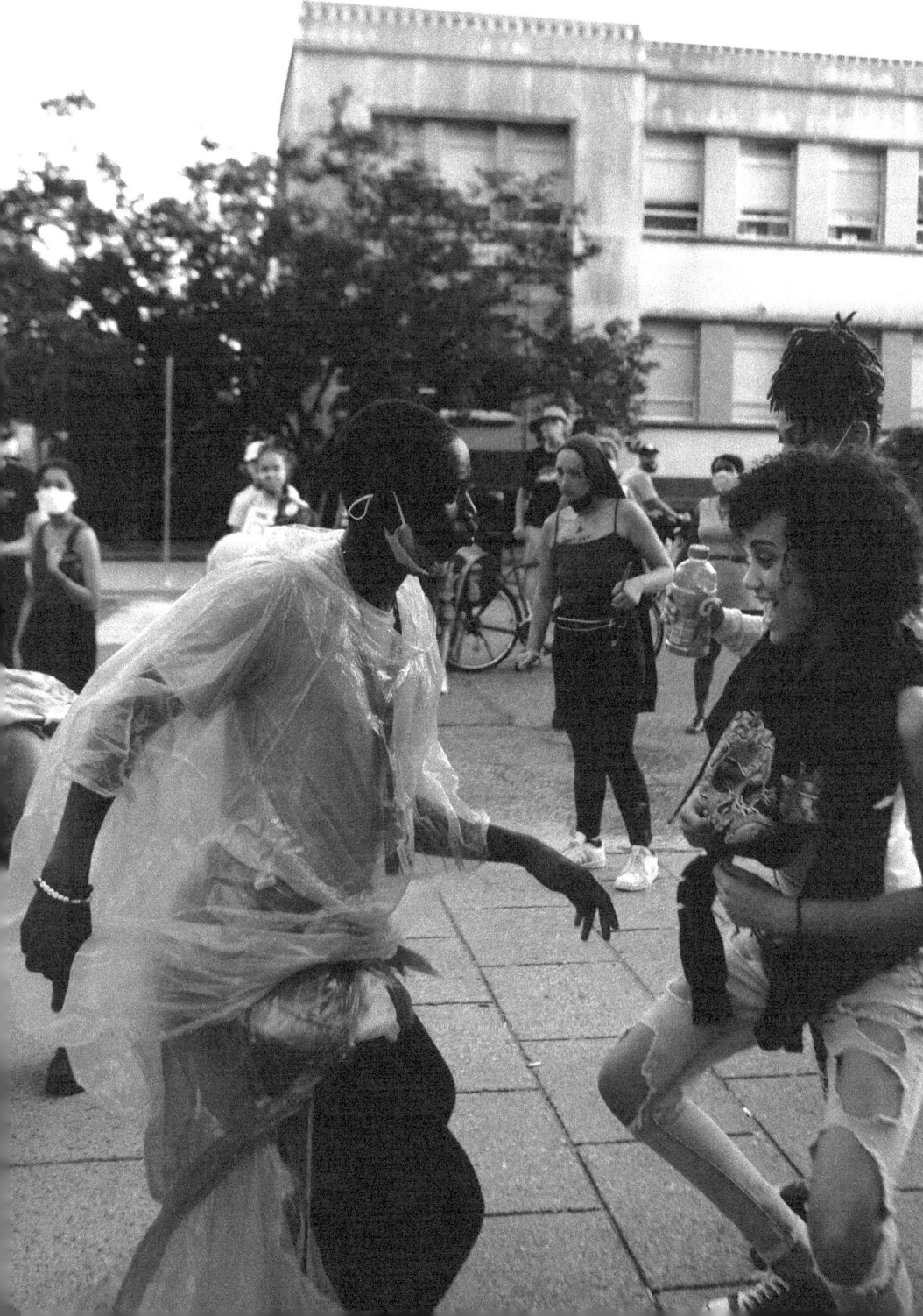

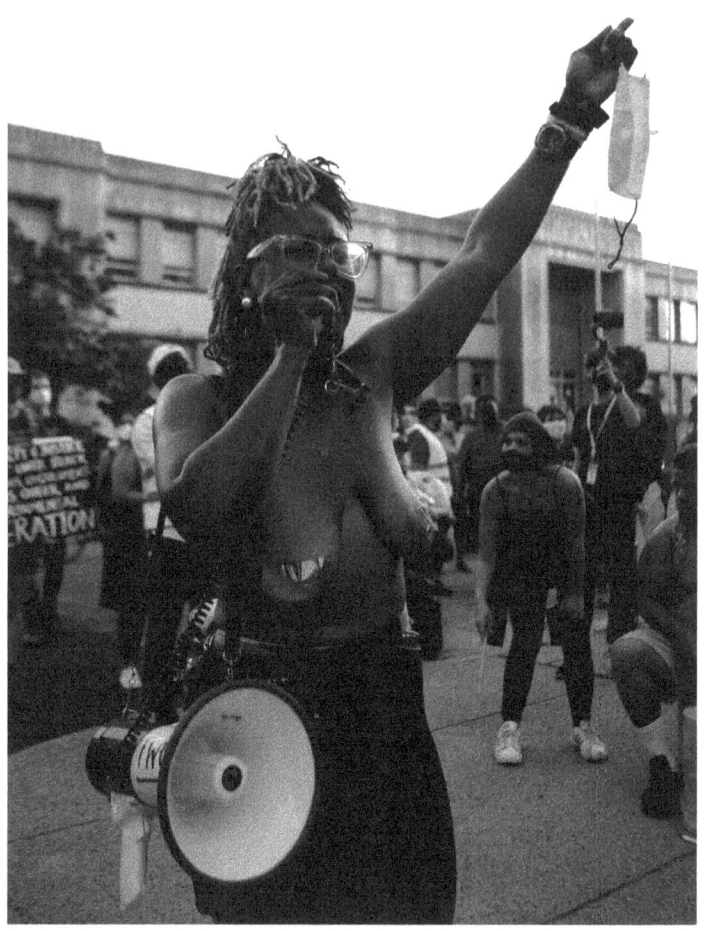

And what we become now, as the world works itself back into its norms, is entirely dependent upon what we believe deserves our time. The thing that deserved my time most was rest. Quality and intentional rest. To reduce rest to more hours of sleep would be an oversimplification, though sleep was certainly a part of it. I began to dream vividly again. I felt fresh more than fatigue. But during my waking hours, I also felt my art open up in ways that were closed by always feeling I was making work for the next audience to consume–that generally felt centered on my trauma. It felt similar to people I knew who spent their entire life caring for sick people never really getting to be sick. And I felt my work get postured in this way, too. The unspoken pressure to keep creating work that explains and reexplains trauma, but never being allowed to heal from it. Pressure to make Black stories and Black dreams and Black bodies matter when they aren't told in the wake of those very things being stolen. Pressure to prove we deserve the benefit of humanity. Pressure to validate having a police officer

point a gun in my face when I was eleven by juxtaposing Tamir Rice.

What gets lost there is the individuality of experience. What should be a space that demands reciprocity, where viewers deposit something of themselves for the artist (for me) to take away, is reduced to content that is as quickly discarded by audiences as quickly as it is consumed by them. Rarely do we get the privilege of long and thoughtful consideration to the process of erecting story or carving out characters that are breathing, living beings. We might get to observe, but rarely do we get to truly feel them. To be touched by their plight. To feel their pains and celebrate their triumph. The irony in all of this is that most of us chose artistic expression to communicate the gravity of these exact things. I turn to art—painting and music and filmmaking—to escape an upbringing that was overwhelmingly traumatic, and devoid of healthy love and second chances. The most liberating thing that came out of the last year—while I confronted the reality that the pandemic didn't make police kinder to Black people, that we certainly weren't all in this together—was giving myself permission to make time to rediscover creating work from a healthier space. I asked myself a simple set of questions:

What if I center my hopes and dreams instead of my anxieties and fears? What if I create story from a place of abundance instead of lack? What would the body of that work look like?

For people who have created an identity from their trauma, the potential answers to questions like these might be a bit

terrifying. But I contend, on the other side of whatever terrifies us is something magical and meaningful. Something nurturing and needed. I will go further and say to those who have the gift to tell stories, across whichever medium or practice we choose, therein lies a responsibility to offer these ideas to those who depend on us to make sense of the world we live in. To craft and create new work from places of abundance, ripe with hope and curiosity. Whether we will recognize this moment as "post-pandemic" or a chapter in the longer history of fighting for basic human rights, we all have a space to occupy that is completely ours, that no one else can, in a room where those present will only listen to our words and thoughts and ideas. It is a space where people will open themselves to the possibility of experiencing something wholly different. And it is there, where our paintings, images, films, and voices will transform others. The only thing standing in between what's inside of us, transforming what is inside of them, is the intention of our time.

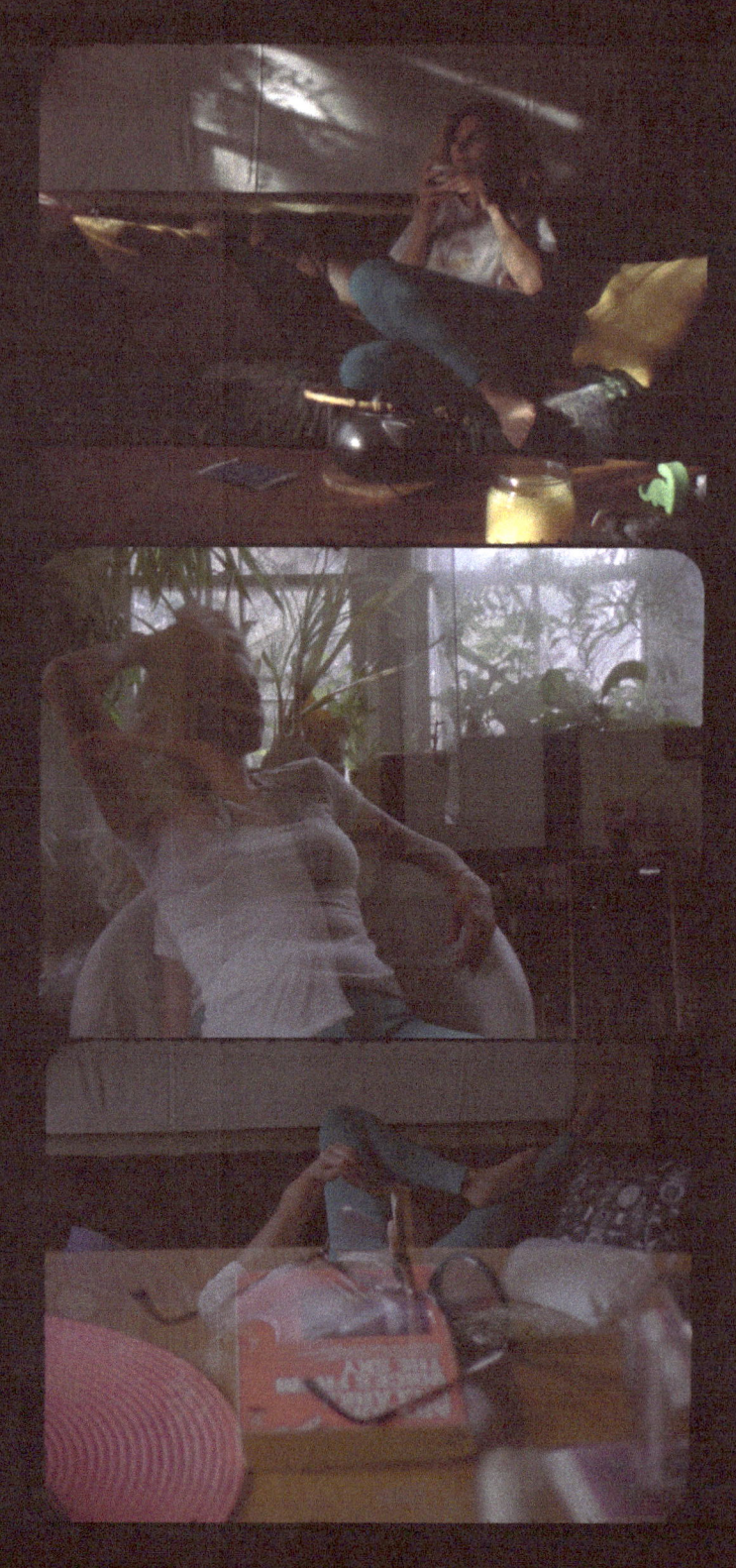

DAY OFF VIBES IS AN EXPERIMENTAL 16MM SHORT FILM ABOUT THE PRESSURES OF BEING PRODUCTIVE AND WHAT HAPPENS WHEN YOU HAVE A MULTITUDE OF INTERESTS TO PURSUE, NOW GIVEN NEW MEANING UNDER QUARANTINE MEASURES. ALL MULTIPLE EXPOSURES DONE IN-CAMERA.

What is the reasoning behind the moments of super imposition?

I set out to make a film about the pressures of being productive, and having too many varying interests to pursue at once. I wanted to capture that feeling of starting work on one project, then remembering another and another, and progressively getting more and more scatterbrained bouncing around between them, that you never actually get anything done in the end. To convey this chaotic type of frustration, I knew that I wanted to shoot in-camera multiple exposures. Some of the double exposures were rather literal, showing the subject doing one thing and gazing at another project of interest, while other overlays were intended to convey the dreary existence of focusing your entire day around levels of productivity. I also just wanted a dreamy, hazy afternoon look.

How did you decide on your music selection for this piece?

I wanted something that would make you feel a bit loopy, like you just woke up from an uncomfortable nap in the hot sun. I like how the track at first seems bright and dewy, and as it goes on becomes rather monotonous and grating. I initially planned on recording some audio using sounds of everyday household items, but I came across a song from one of my partner's bands that seemed to do the trick.

How do you set out to successfully capture the spirit of the mundane?

As an only child and homebody, I'm very familiar with not knowing what to do with myself. Also as someone in their late twenties living in a capitalist society, I've always been made to feel guilty for not being "productive" in my free time. I wanted to capture this particular anxiety while trying to recreate one of the many aimless days off I've experienced in my life. Also all the props and objects you see in the film are just items I had lying around my apartment (including my pup)! In these ways, I think I was able to give the piece a sort of realistic mundanity.

What film stock did you use for this film?

I used two 100ft rolls of Kodak 250D 16mm film and shot it with an Arriflex 16 s/b (one of my favorites). I planned out the shots that I wanted to overlap, and noted on which side of the frame the actions would take place to prevent the final image from becoming too convoluted. I kept a note pad nearby to jot down footage counter numbers for reference on the second pass through. Naturally with film, some shots just didn't work out while others

unintentionally created happy accidents that I decided to keep in. The magic of film!

Who are some filmmakers who inspired this work?

For this project, I was mainly inspired by the look of 35mm multiple exposures that I've been playing around with for years in my still photography. This was actually my first experience shooting multiple exposures on motion picture film. In general though, seeing films by Maya Deren, Chantal Akerman, Agnès Varda, and Gunvor Nelson really set me on an experimental filmmaking trajectory. A short by Chantal Akerman in particular called *La Chambre* (1972) which is essentially a moving still life, made me realize I can just shoot a film in my own living space - no travel or setup needed! I'm also very inspired by Apichatpong Weerasethakul, Sergei Parajanov, and Béla Tarr/Ágnes Hranitsky.

Anything else to add?

Looking back on this project through the lens of the past year, I can't help but also read the film as "Quarantine Vibes" which I think also works. Hope folks are doing okay out there!

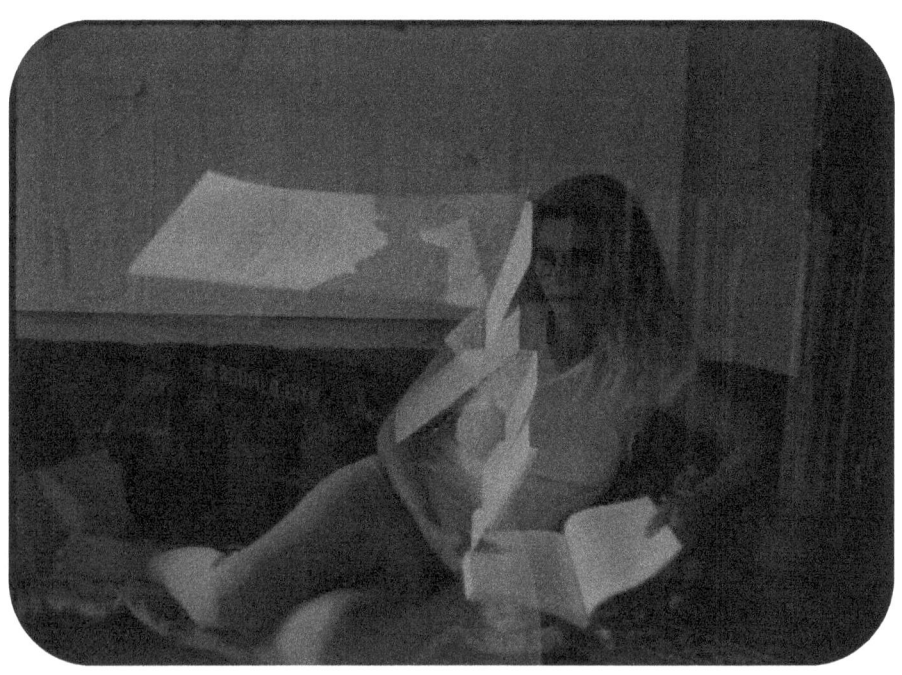

RETRATO DE ANÁLOGO // PORTRAIT OF ANALOG

HA HA HA HA HA HA HA HA HA HA HA

JEAN-JACQUES MARTINOD

In 2020 I created about 200 digital collages by re-assembling personal 35mm film photos (shot in my everyday life, 1993-2006) within Instagram's layout features on my phone. I built a library of severed images that could be infinitely re-arranged through a combination of intention and chance. Social media apps have made structuralist experimentation commonplace—the kinds practiced in analog by Michael Snow or Susan Weil.

What part does symbolism play in your photography?

I assume that symbolic associations worked their way into my shooting process unconsciously, since these photos were taken casually in my everyday life without much thought. Certain images reoccur, like water, stone, and cars. Repetition can turn objects into symbols.

Can you tell more about why you chose to collage these photographs?

In my current practice I shoot 16mm film and digital photos, but had never revisited what I was doing when I started shooting photos for the first time. In 2020 I began digitally collaging my early 35mm photos to consider them more closely. I was looking at work by Susan Weil, who rearranges her own segmented drawings and paintings, and Florence Henri, who used mirrors to create collages "in-camera."

How did you decide on a color palette for this collection?

I took a digital image of each 35mm photo in front of a larger 35mm photo as background; an Ohio River landscape my mother shot around 1985 had faded into purple, so that defines the color palette. In the first series of these collages I used a neon green background to tie them together. I wanted to find out what would happen if the unifying ground was another photo, and that landscape was the largest 35mm print I had.

What film stock did you use?

I took most of the photos in the 1990s from ages 9-15 using mainly Kodak Gold Color 400 film. My first camera was probably something like a Canon Sure Shot, and then later a Canon EOS A2, and various disposable cameras.

What experience do you have developing your film?

I've only recently started learning how to develop film at Gowanus Darkroom in Brooklyn, NY.

How much is trial and error a part of your artistic process?

I used a grid app on my phone to arrange the photos in a hundred different ways. Sometimes the best way to bring about a new state of being is to suspend intentionality. I thought I knew what I had shot and that these past experiences were set in stone, but my understanding of them was altered, along with my understanding of photography.

POSTCARDS FOR JOHN

On July 26, 2020, the late John Lewis crossed the Edmund Pettus Bridge in Selma, Alabama. In 1965 trails of blood covered the bridge from the bodies of peaceful protestors beaten by white Alabama state troopers, but on this day a path of rose petals welcomed the passage of the flag-draped casket of Representative John Lewis. Upon a horse-drawn carriage, with the Lewis family walking in tow, John traversed the infamous civil rights site one last time. As I watched the celebration of his life from my home TV, commentators announced that we were 100 days away from the election. In honor of John's life, I decided to start this on-going project of printing archival silver gelatin postcard prints to generate money for non-profits, COVID-19 relief, legal defense funds and to support the USPS. The printed mailed object represents solidarity, community and connection in a time of solitude, illness and continued reckonings.

Arundhati Roy wrote in early April of 2020 that, "Historically, pandemics have forced humans to break with the past and imagine their world anew. This one is no different. It is a portal, a gateway between one world and the next. We can choose to walk through it, dragging the carcasses of our prejudice and hatred, our avarice, our data banks and dead ideas, our dead rivers and smoky skies behind us. Or we can walk through lightly, with little luggage, ready to imagine another world. And ready to fight for it." Her words, and the life work of John Lewis, inspired the action of producing postcards from this portal of 2020 to demand, and to call forth that "fuller, fairer, better America," if it exists.

Series collaborators include Christine Wood, Eve-Lauryn LaFountain, and OPIA (Heather O'Brien & Jonathan Takahashi). This project is designed, printed and produced in collaboration with Christine Wood.

CODY EDISON & CHRISTINE WOOD

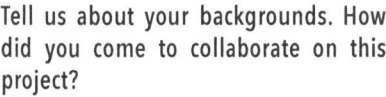

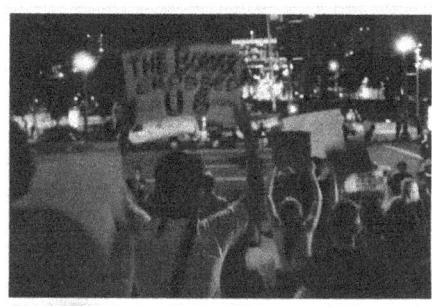

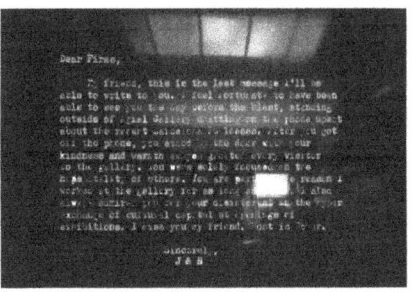

Tell us about your backgrounds. How did you come to collaborate on this project?

Cody: We met at CalArts when we were both undergraduates. I studied in the photography and media program and Christine studied acting. Years after graduating we ran into each other at my favorite venue to hear music in Los Angeles (1642) and we started dating. Fast forward 5 years and a pandemic later and we finally started collaborating with one another.

Christine: We have always wanted to collaborate. We help each other on our individual artistic endeavors, particularly our film work, and value the others' insight and contribution. On July 26, 2020 we were watching the solemn funeral procession of the late Congressman John Lewis when Cody had the idea for the project. In honor of the life and legacy of John Lewis, we would begin an on-going artist project to generate money for legal defense funds, non-profits, and COVID-19 relief. All of the postcards were printed in the central coast of California on Rumsen and Ohlone lands.

Cody: Postcards for John combines many of my interests in working with photography and text to address ideas of authorship and employing intersectional politics/solidarity through collaborations. It is also a devotional artist project to analog, and it nurtured connections with artists we love during the continued reckonings the pandemic has laid bare before us all.

What kind of hesitations did you have for

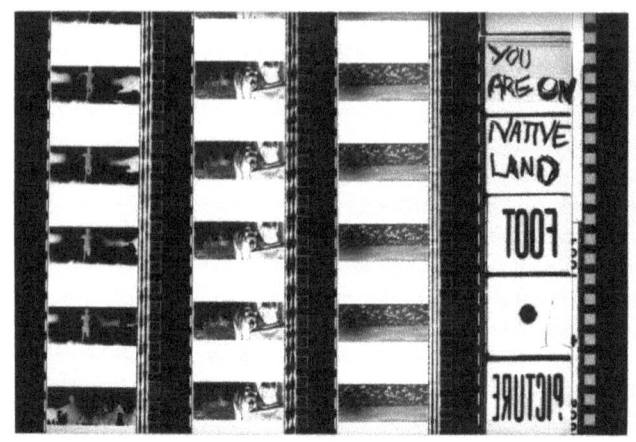

the postcards that capture real activists at protests?

Cody: The hesitations are on-going...

Christine: We had a long discussion about this. We did spend an entire day looking through news coverage and social media to reach out to the people in the photographs but were unsuccessful finding them.

Cody: Ultimately it made sense in a project that's name is an homage to the lifework of John Lewis to incorporate images of protest and resistance. These photographs were made in Los Angeles the evenings that followed Trump's electoral college victory over Clinton. We discussed how that was the first presidential election to take place since the Shelby County vs. Holder ruling (2013), which removed pivotal protections from the Voting Rights Act of 1965. Basically the ruling opened the floodgates for discriminatory voting laws and restrictions that impact the ability of BIPOC communities to vote. It was a big blow to the heart of the Voting Rights Act. We felt the images were powerful in this context and belonged in the unfolding arc of this project.

Deciding to use this imagery to support Fair Fight Action (led by Stacey Abrams) felt right despite our hesitations. I wouldn't be comfortable selling these images without supporting an organization like hers or progressive pro-voting rights leaders.

What was the reasoning behind choosing

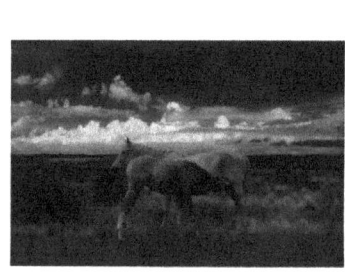
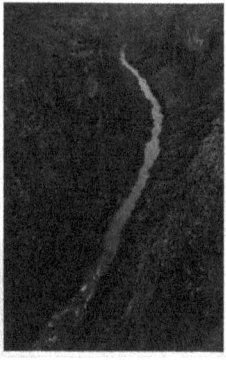
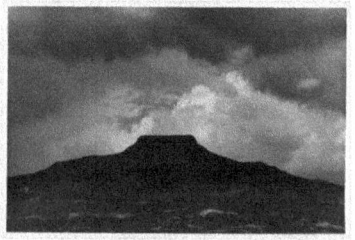

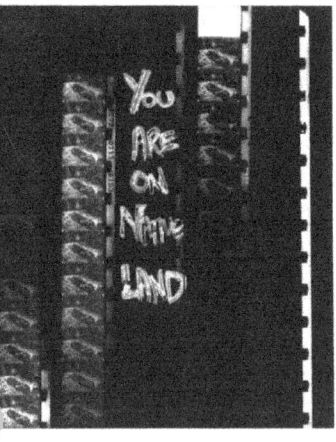
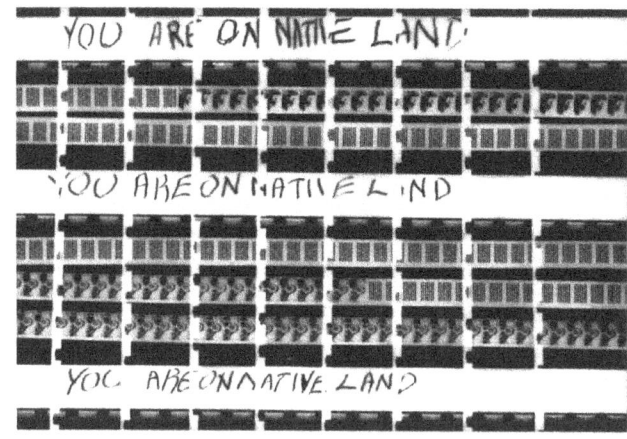

to print these photographs on postcards?

Cody: I held on to a box of the Ilford postcard paper for years and actually regretted buying it. Making postcards wasn't something I was interested in other than maybe one day as an invite to a screening or exhibition. That all changed with the pandemic especially during the summer of 2020. For so long I admired the work of ASCO (especially the "No Movies" project) and Danny Lyon's work as the staff photographer for SNCC. In August, I remember seeing Indya Moore share on their Instagram different ways to support trans-woman of color. We decided we could start the inaugural series by raising funds for the burgeoning House of Resilience in San Diego, California.

Christine: At that time there was major controversy surrounding Trump-appointed Postmaster General DeJoy for undermining the USPS with sweeping cutbacks. Postcards as well as purchasing stamps in large rolls were our ways of supporting the USPS in anticipation of the upcoming election. For the first few series, we even typed the number of days counting down to the election on the back of the card at the end of our messages.

Why did you choose black and white film?

Cody: I love shooting color and black and white film. With that said, the perception altering emotion and poetry of black and white photography is what first engaged me with the medium.

Christine: For this project specifically, you can only print black and white on this postcard paper in a darkroom. A few weeks ago we finished printing the entire project. If you count the extra artist proofs we've printed about 600 prints within the year.

Cody: I've done a lot of printing in the darkroom since undergrad, but I couldn't have done this without Christine. We developed an efficient system sharing the work on the enlarger with exposures and running the prints through the chemicals. She's now a wiz in the darkroom. It's impressive!

How did the postcard medium assist you in spreading your art geographically?

Christine: So far the work has travelled all throughout the United States and abroad to Europe, Canada, and Lebanon. The next series will be released in India by our friends Gavati Wad and Nehal Vyas.

What part does symbolism play in this collection?

Christine: It's subjective and fluid. Each card will have its own life and meaning wherever it arrives. These are not prints in a gallery, or that exist exclusively on social media or on our websites. I like the intimacy in mail art and how, like a time capsule, it anchors you to a specific moment. In the case of say 10 years from now, hopefully it's a way to remember this period and measure how far we have come.

Cody: Every card is stamped with an upside down American flag to represent distress and disgust towards the American project's oppressive and genocidal foundation. The nationalistic fantasy for justice, equality and opportunity for all has failed so far. It was designed to benefit folx like us and until it radically changes the stamp is staying put just like that!

Christine: It'll be nice to see what Gavati and Nehal do to explore similar concepts during the compounding crisis in India. Their series is in support of the Indian Farmers' Protest and COVID-19 relief. They've worked with symbolism in a unique way. One of their postcards features a childlike drawing of the ideal Indian farm with the slogan, "Jai Jawan, Jai Kisaan." This phrase is taught to children in school and translates to "Hail the Soldier, Hail the Farmer." Gavati says "During the Farmers' Protest we saw the two against each other. The slogan was raised again… to question where the Hail the Farmer part was lost."

What camera or cameras did you use to put this collection together?

Cody: I have a 35mm chrome Leica M. Besides that, Eve-Lauryn LaFountain mailed us woven film artworks (8mm, 16mm and 35mm) with the words, "You Are on Native Land" scratched into the emulsion. The titles for each image in that series are in Ojibwe, her tribal language, which she learns word by word through her art practice. Christine and I made photograms for our collaborations which are camera-less images that symbolize the natural world and a site specificity of our quarantine location.

Christine: I had recently gotten my hands on a Hermes 3000 typewriter (manufactured by Paillard-Bolex in Switzerland) in near pristine condition. Connecting with the world at large became solely a digital experience in 2020. Cody and I already embrace analog in our lives, so we felt all the more compelled to commit to using analog practices for Postcards for John. Everything being made by hand gave the work a personal touch. Hopefully those who purchase a card feel the care we put into each and every one.

What film stock did you use?

Cody: I photograph with Ilford black and white films: hp5+, and delta 400 + 3200.

Christine: For almost all the collaborations, Eve's series aside, we made digital negatives of the images sent to us via email. We then contact-printed them in the darkroom. This digital hack, if you will, enabled us to work with people all over the world and maintain the analog spirit of the project.

How does the photographic medium lend itself better to your message than moving image would?

Cody: In participating in this project you have a unique editioned physical object that contributes funds to important causes. I'm a sentimental person. All the mail ever sent to me is all archived in a special box. Some of my most cherished items are pulled from it like a postcard from Nepal at the peak Annapurna base camp sent to me by a childhood friend in 2014. The stamp is amazing. The imagery is absurd and shows a bunch of guys riding elephants playing soccer… this object is worthless to everyone but me and I know I'll keep it the rest of my life. All of that is to say the moving image experience is more ephemeral than what we are doing with this artist project.

What's next for each of you?

Christine: We released the Postcards for John project in August of 2020 and we intend to release our final series in August of 2021. We have some exciting collaborations coming out soon. You can learn more about the project at codyedisonmedia.com or follow us @postcardsforjohn. Our collaborators in chronological order are:

Eve-Lauryn LaFountain
Opia (Heather M. O"Brien & Jonathan Takahashi)
Luis Gutiérrez Arias & Zaina Bseiso
Nehal Vyas & Gavati Wad (forthcoming)
Harmony Holiday (forthcoming)
Johanna Breiding & Sho Halajian (forthcoming)

Cody: Thanks to all them for working with us. I can't imagine this project existing and growing as it has without them.

For us personally, we're heading out to New Mexico this summer to get married. While we're there, we also plan to collaborate on a documentary short with an artist named Doug Coffin in Abiquiu.

Christine: Thank you for including our project in Analog Cookbook!

Film As a Language for Loss

Essay and stills by Ellery Bryan

I started working on film again specifically to talk about death. It had been several years since I first used 16mm in undergrad - I had stopped doing it because of loss of access to equipment and funds, which the graduate program I now attend has, although the chair of my department (a video department) tried to talk me out of it. I had spent the year prior to beginning my work on film again writing, following a massive loss on top of many other losses. Grief funneled into a personal repeat-vernacular of symbolic text-images pulled from dreams, prayers, presence. I wanted to work on film because of its substance and, conversely, capacity for erasure, which seemed appropriately abrupt to reflect my relationship with a rift.

The process of shooting on film mirrored the process of mediation in an uncanny sense. It's an unavoidable call and response, even when I process what I shoot on the same day. There's a delay after shooting where I have no idea what I actually got or what it looks like, especially when I am performing myself and cannot hold my own camera. So the results come back to me sort of removed from the moment of making and they bounce off of each other in this constantly accumulating collection of images - things become pairs in conversation with one another, or iterations on the same symbol or movement, or they need something in between to connect the dots - so I go shoot again.

Language is essentially a consistent series of symbols and signals assigned meaning and relationships to one another. We make these languages

between ourselves and all sources from which we derive meaning. What is significant to me is not necessarily what signals significance to you, although there are cultural archetypes for these things that often involve light and water. The vocabulary for connection that I have with a person who is still living, where the textual exchange manifests in spoken words, typed messages, shared pictures and traded looks, is going to be very different from my experience of needing to build a novel method of consistently relating to a person I cannot see or touch. Everything might be something significant. There are no concretes or constants, only hopeful correlations.

Filmmaking is a perfectly fitted medium for thinking about loss, as it happens in a sort of channeling. Ghosts may be, arguably, traces of something former, composed of light or shadow. They reside in an impenetrable world of no substance, suspended behind a threshold that cannot be crossed using the body. When I put myself in a film, I am a thing that used to be, which no longer has a body. I am made of light, and I never grow any older. I am contained behind the barrier, re-animating. I interact with other things that are made of light and which used to be. This is a project about meeting halfway. I experiment at how I might most effectively re-purpose everything I have known about relationships (embodied, sensory, physical) with a very real and patient collaborator who no longer has a body of their own. This project is about getting to know each other.

Film's capacity for dispossession is a specific and powerful tool for actual mediation. I can enter the un-enterable place and ask for the others to join me there. I can open an actual frame for them to fill up and make myself a visible presence inviting them to arrive. And then, on the negative, I can intervene to fulfill the symbolic representation - I can create a profound portrait of absence and show you how I dance with it. I can create a figure made of nothing but light that light-me gazes at and responds in their own conversation. Film is an alternate and alter-able reality by which visions become material and pliable things that intersect the embodied, inhabitable world with transcendent phenomena. The compositions that occupy the frames make up the stained glass windows to the temple of my own devotion.

I call out with my belief - I ask to be given a discernible vision. I receive the vision post-processing - then I respond. Filmmaking has revolutionized my relationship with losing and with believing by presenting consistent wonders that escape all control. It opens up a window for the transcendent to intervene in the everyday. It transfers the spaces I inhabit into a magic mirror - everything becomes a significant artifact. I have held this technology of meaning-making close to me throughout quarantine, and many new and accumulating losses. Film has this fantastic effect of making everything in its precious record into something of profound importance for holding onto. It becomes a method of rendering what is sacred and holding it dear.

ALL DUST

My grandmother, Eva, was a very special and dear person to me. She didn't speak much English and I didn't speak much Russian, but something we'd always do together was look through her photo albums for hours. If she could remember, she would tell me who was in each photo.

A little over 1 year ago, my grandma was moved to a nursing home because of her worsening dementia and lost her Brooklyn apartment that she'd had since moving to the US in the early 90s. There were so many things to pack up, and my mom flew from Virginia to help. She could only fit so much in her suitcase, so I told her I'd ship all of my grandma's photo albums to her. The box containing the only remaining photos of my mom's side of the family were lost in the mail, and no where to be found no matter how many times I returned to the post office. In April 2020, her New York nursing home was infected with Covid-19 and she passed away 5 days after contracting the virus.

In 2018, I briefly worked at a media conversion shop, where people would bring in old home movies and have them converted into digital files. This super 8mm film stuck out to me more than any others I'd seen. The camera-work is so exploratory and intentional. In this film, broken up into three parts, I superimpose the memories of others to hold space for my own.

-MEESH KISLYAKOV

IS SKIN

How does poetry play a part in your film?

While making this film, I was taking an open-genre writing class. We started studying Zuihitsu, a Japanese literature genre that consists of stream-of-conscious, loosely-connected personal essays. A lot of times these pieces of writing fit together like a puzzle if many pieces were missing: fragmented but seemingly connecting to a whole. I was really inspired by this style of writing and felt it was the most fitting way to express the way I was feeling. I used skin as the "connective tissue" to gather my thoughts.

What was the process in choosing the landscapes you decided to capture?

These rolls of home footage were all over the place, but probably some of the most beautiful and spontaneous footage I had converted in my time working in an archival shop. There's one person behind the camera, and their eye wanders, mostly focusing on their family, but capturing these moments that feel significant. They're at a distance from everyone, always following behind. I wanted to focus on the landscapes from this footage that felt like the interstitial moments in an otherwise standard home film.

There's a lot of non diegetic sound; what was your process in gathering this audio?

Freesound.org is one of my favorite places on the internet. It's a huge resource of millions of field recordings from people around the world. I love using non diegetic sound in my films that give movement to a piece without being too literal. In the first section of this film, I talk about layers of paint and I wanted a sound to match the thought of digging and pulling these

layers away. The second scene shows water, and I used a dripping faucet; it's a sound that nags and won't go away, much like the moment I'm writing about. In the third scene, I use field recordings of someone walking through a city with the sounds of cars passing by. I wanted the sound of moving forward, leaving somewhere. Finally, I wove in pieces of a recording I made of an artist that had a residency in a chateau that I happened to be wwoofing in one summer. There were so many layers of sound going on and I wanted to keep layering and layering on as he talks about illusions, surfaces, and feelings. It all felt like my secret language and I pieced these sounds together.

What film stock did you use for this film?

This is an 8mm color home film from the 1960s.

What would you say are the overarching themes in this piece?

I use the theme of skin to talk about the passage of time, the retrieval of memory, and renewal. With the loss of all of my grandmother's photos, I'm taking over the memories of someone else. I'm superimposing into the memories of someone else, making myself comfortable, but moving on when the skin begins to shed.

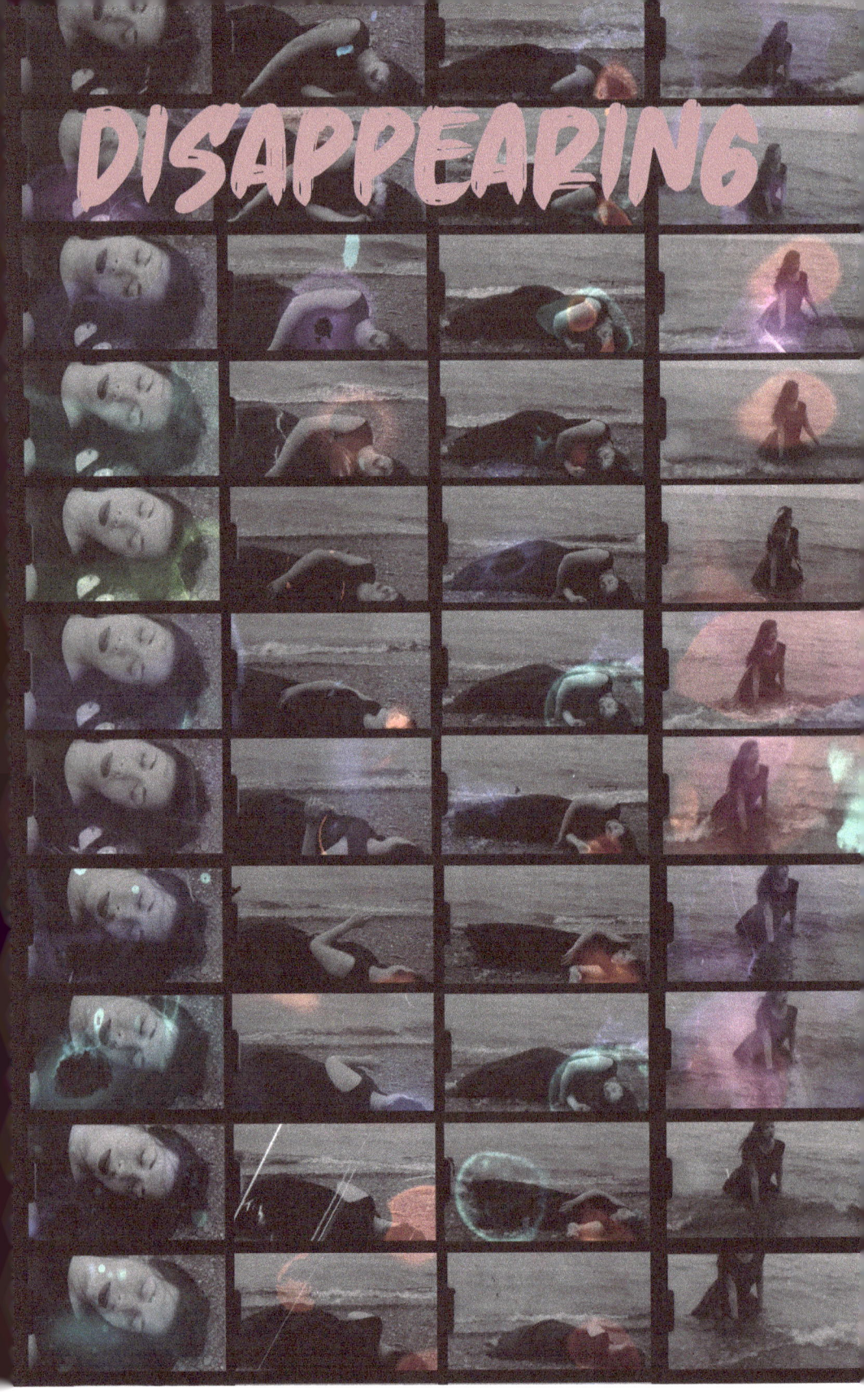

SILENCE

The silence subtly disappeared sometimes in mid-January 2019, following a traumatic event that occurred one year before. Since then, white noise, scintillating sounds, and other dysfunctional frequencies have been with me every moment of every day, like impalpable symbols of trauma, superimposed.

This self-portrait, shot in Super 8 film, illustrates the sensory chaos provoked by permanent tinnitus. I have had to tame this "phantom pain," like perpetually surging sound waves, to define a new state of silence.

What part does symbolism play in your film?

Water is a very important symbol in my personal and artistic life. Water is a constant in my dreams and nightmares since I was a child. I very often dream that I lose affected objects I hold because a gust of wind suddenly makes them fall into a river or the sea and I see them sink, without being able to recover them because I risk of sinking myself. In 2005, I was introduced to my first reading of the book *Water and Dreams: An Essay on the Imagination of Matter* by Gaston Bachelard, which analyzes in a remarkable way the different symbolisms of water. He distinguished, among others, calm waters, violent waters, maternal waters. This book has shown me how much it resonate with the different ways in which I can perceive water. For me, water has something fascinating, bewitching and frightening all at the same time. And then, the novel *The Waves* by Virginia Woolf has inspired me for years when it comes to the flow of consciousness. In my film, Disappearing silence, the element of water came to me as a way to symbolize the dread generated by tinnitus in which it's easy to drown. They can make us sink if we get caught up in them.

Can you tell us a little bit about the choices you made for the sound of this film?

It was obvious to me that I was going to create the sound of the film by myself, since the idea is to translate what I hear into sound. The "ghost sounds" I hear aren't as loud in real life but they can sound so if I "listen" to them too much. It's like what you hear when you leave a concert but all the time. In my case, there are several "thumping" and high-pitched

SARAH SEENÉ

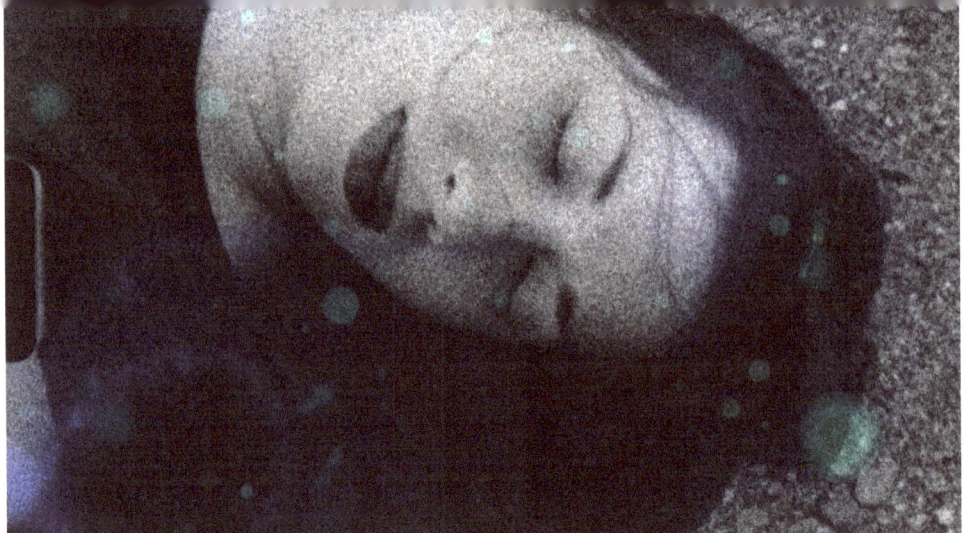

sounds that keep getting tuned and out of tune with crackles and bubbles. I wanted to share them with the audience hearing them. So I used a broken '80s baby monitor and I've experimented with it to create little feedback similar to what I hear. The sound is therefore deliberately singular, sometimes unpleasant. It contrasts with the black and white images, painted with colors. It's like in real life: there is a contrast between what people see of me and what I hear inside my head: sounds that other people don't hear. It was this inner sound madness that I wanted to represent.

What character role does the ocean play in your piece?

This film is a self-portrait. The person we see on screen is myself. And the other character is indeed the ocean which has a very important role. The film was shot with the help of my companion, filmmaker Guillaume Vallée, in a deserted square on the Atlantic Ocean in New Brunswick (Canada). The waves physically represent the different waves that overlap, mix, argue, somewhere between the brain and the auditory system. At the same time, with their dizzying appearance, they paradoxically evoke a state of peace. People with tinnitus are often advised to "mask" the tinnitus noises by listening to recordings of looping wave sounds in order to forget the ghost sounds that obsess them, especially to fall asleep. It's all about focus. This is all the interpretive space that I leave to the viewer: that of imagining that these waves carry me away, if I fight with them or if I embrace them. Personally, I see it as brighter than dark, just like the way I experience tinnitus in my everyday life. At first it was extremely difficult to mourn the silence (hence the title of the film) but now I have made them my own, I have tamed them and they define my new silence which is unique.

This is such a vulnerable piece. You're starring in it, and the film is about the after effects of a traumatic experience. How did it feel to tell this story on film?

I strongly believe in the power of expression. I am a person who expresses myself a lot through words (I studied literature) but the images are very complementary to my way of expressing myself. I also believe in the immense potential of art to transfigure ordeals, to sublimate them and to give them meaning. The tinnitus I have are physical sequelae that are still present following a serious assault I suffered several years ago.

Beyond the psychological consequences, I had several physical ones that disappeared. But the tinnitus is still there, maybe to remind me of something that was not heard. I've been doing a great job in psychotherapy for years on this and other events in my personal life. For me, this film is related to this work on myself. It's a process. I also believe that it can affect people who can identify with it, especially if they have tinnitus themselves or have been through trauma. After sharing pictures from my film and writing words about it, an overwhelming number of people have written to me telling me that they have also been living with tinnitus for years and feel misunderstood because it's a very particular invisible and intangible "pain." The experiences of one can repair others and generate relationships, empathy and well-being.

What film stock did you shoot on?

The film was shot with Kodak TriX Black and White film.

Why did you make the choice to shoot this on film as opposed to digital?

For all my projects, I only work in analog, never in digital. I need the physical, vivid aspect of film. I need to find it in my hands, to touch it. And then, in the case of Disappearing silence, I hand worked on the film, painting it painstakingly to represent the sound waves in my brain. The small touches, the drops of color have a great importance in their almost electric symbolism on the black and white.

As we get closer to the water in this film, sounds become more repetitive. Is there a story behind this?

Indeed! As this short film is a micro audiovisual experience, the idea is that the closer the viewer gets to the water, the further I get away from him, and the more the sound becomes haunting, as if he himself was doing the tinnitus experience. It is as if he were plunging into the waves, attracted by a siren song that was strangely captivating and dizzying at the same time.

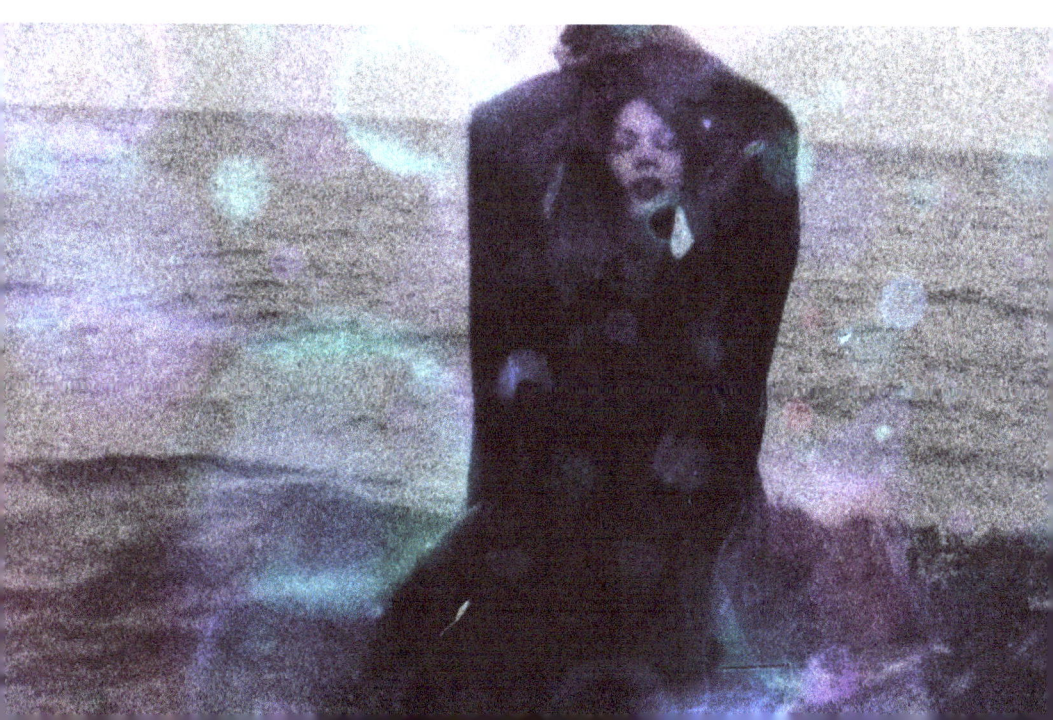

THE BEARERS OF MEMORIES

Miglė Križinauskaitė-Bernotienė

WITH EVERY MOMENT – ONE MORE MEMORY. BUT MEMORY SOMETIMES GOES BLIND AND WHAT IS LEFT BECOMES HAZY.

Tell us about your background. When was the first time you shot film?

I'm an audio-visual artist, photographer and a creator of experimental documentary films from Lithuania. In 2020, I graduated from the Lithuanian Academy of Music and Theatre with an MA in Film Directing. In fact, I came into the world of cinema from analog photography just a few years ago. At some point, I felt that still images were not enough for me to tell the stories I want. And because of my interest in analog photography, I always had a desire to make moving images on celluloid. *The Bearers of Memories* was my first movie made on 16mm film.

Can you tell us about the inspiration for this piece?

My work usually spans multiple disciplines including experimental and documentary moving image works. I usually choose to present abstract ideas through a subjective, personal, and sensitive way of storytelling. *The Bearers of Memories,* the theme of which is the erosion of memory and time, intertwines the reality around us with the forms of experimental cinema. The film illustrates that destructive reality and imitates fading memory, as well as personal reflections that are not related to reality--contradictory, manipulative and irrational, sometimes even just a fantasy.

Reality disappears before us every moment - only those memories who are able to survive, remain and find a place in our memory, to tell the truth, which is not eternal and unchanging. Man constantly tries to fight it, tries to save images and visuals by capturing them.

While I was searching for artifacts that would help to understand the connection between memory and time, the idea was born to "talk" about my grandmother's photography, which later became the axis of the film. In that way, the film became very autobiographical.

Why was it important to create a film about memory on celluloid?

The Bearers of Memories is more of an emotional film. In the film, the facts are modified to correspond more to the truth than to reality. From these problems of

representation of truth and reality in documentaries, just arises the desire to use the tools of meta-cinema language, to reflect the film medium itself. So, creating a film about memory on celluloid seems to be right.

The chosen form of filming (flashes of light, twitching, very short or long shots) also plays a very important role in the film, that replicates a human imperfect memory. A fragmentary, sometimes jerky image stored in our heads. The film is basically about capturing the moment, about the fight with time which is erasing our memories, and about that desire to transfer moments, feelings and faces on the material object. Therefore, I believe, the celluloid is a great expression of that, as a choice to portray the act of photography itself.

How did you create the sound for this piece?

Sound is a very important element to me in my work. In the film, traditional documentary shots intertwine with shots of experimental cinema. I wanted the sound of the film to match the visual of the film. Because of that, the film is rich in atmospheric sounds, asynchronous sounds typical for experimental documentaries, and music, both traditional and experimental. I worked on this project with a promising young Composer Agnė Matulevičiūtė and great Sound Designer Rūta Girnytė.

The soundtrack of the film often features a jerky, ever-ridiculous sound that mimics an imperfect, fragmented human memory. The film also includes the throat singing of the Tuvan tribe, which becomes a reference to the Siberian tribe's different understanding of time and performs a slightly earthlier function--creating a mood of mystery, oblivion. I hope the music heard in the

film envelops the images in a nostalgic mood, encouraging the audiences to immerse themselves in their memories, childhood, and melancholy.

What film stock did you shoot on?

We shoot on Kodak Vision 3 7207 and Kodak Double X 7222. We used Arriflex sr3 HR (super 16) camera for shooting. Also, I believe this is the place to mention incredible young artist Nojus Drąsutis, who was the Cinematographer of the film.

What do you hope audiences walk away feeling after seeing this piece?

Although the film talks about memory and time, past and future, it seems to me that at the same time it invites the audiences to be fully present in time. Also, while making the film, it was very important to keep in mind how personal things at the same time need to be turned into something universal so that the viewer can identify, empathize. So, I hope I achieved it.

What's next for you?

I usually make deeply personal artwork. Basically, all my films draw inspiration from my own introspection. I'm constantly looking for ways to create something that would be not only expressive in its form but also meaningful. Meaningful to me and to the audience. After graduating with a master's degree in film directing, I continued my artistic research and artistic practices in the "field" of experimental documentary, especially in personal cinema. So now I'm shooting some personal footage with my super 8mm camera, doing some research in a few different themes and working on making some audiovisual collages.

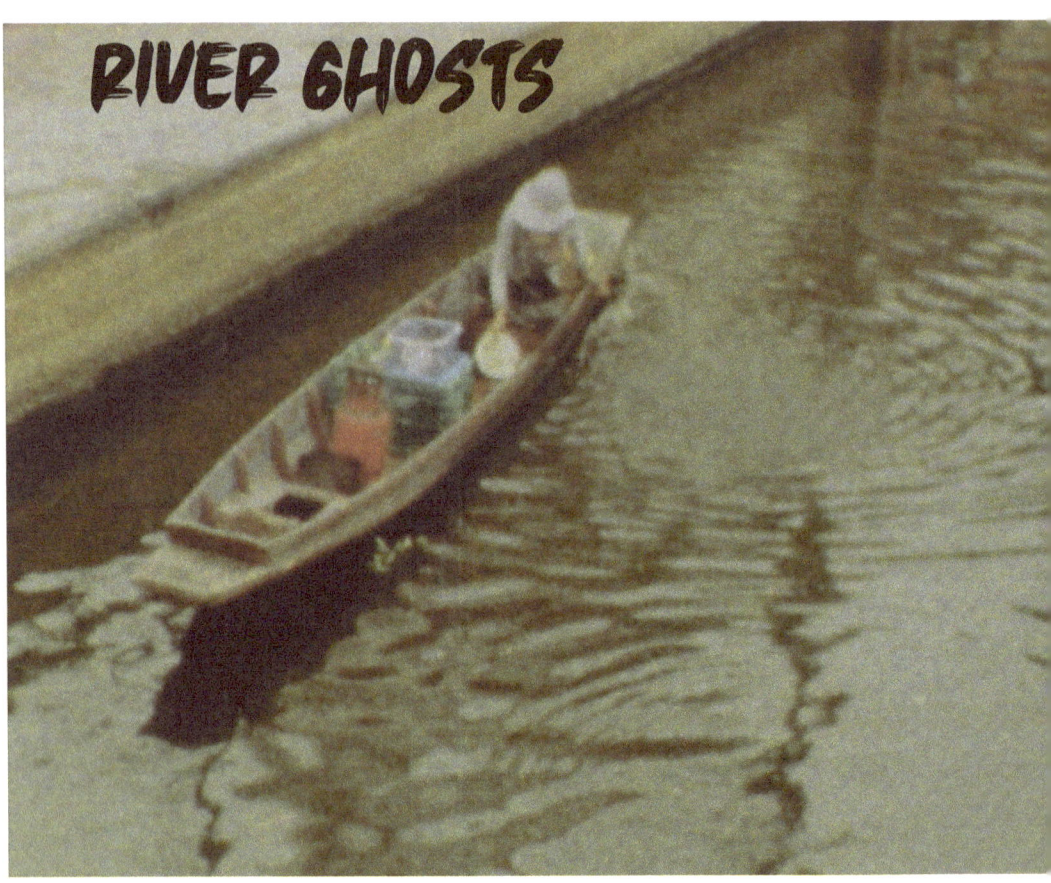

RIVER GHOSTS

In this experimental documentary, an unseen filmmaker uses unseen memories to follow traces of his deceased grandparents throughout urban and rural Thailand. Loosely following a travelogue- essay format, the search for identity is intertwined with the old and new history of rural and urban Thailand.

Tell us about your background. When did you first start shooting on film?

I have a photojournalism and radio background–fine art photography and filmmaking came to me later, so I have analog experience across different mediums and audiences. I was also a DJ, using vinyl records to create unique, themed music sets. The physicality and being able to directly manipulate sound and image is something that feels natural to me. I've been shooting film since high school since there was a darkroom photography class, and then in college I took a 16mm film course. All of the indie filmmakers were shooting on 16mm, so that really drew me in.

Tell us about the process of searching for ghosts on film.

A friend of mine once remarked that just because you can't see something doesn't mean it's not there. I've only seen my Thai grandparents a few times in my entire life, so much of my relation to them was through stories, photographs and memories that functioned like brief sound and moving image clips in my mind. I inventoried certain places that came up over the years in conversations between my parents and me–a certain canal in Bangkok where my grandparents met and the town where my father lived in Thailand, for instance. I met up with my filmmaker friend Uruphong Raksasad in Thailand and we went on a road trip looking for traces of presence in landscapes around Bangkok and in a province just north.

This was shot on Super 8mm. Why was it important to shoot on film?

I don't like sitting in front of a computer to make art. Shopping, work, research, email–it all happens on the computer, and then at the end of the day you're supposed to go back to the same screen and get creative. It's a challenge. I prefer the old school method where you're present with the world and your art materials–thinking about frames, time, moments and slowing down. Then you process the film, and your results are there in front of you. Sure, you have to edit, do sound and output the work; but so much of the magic has been accomplished by that

JONATHAN ONSUWAN JOHNSON

point. And, not surprisingly, I love the aesthetic. The warmth, grain and color reproduction are so tactile and creates that archival effect or that feeling of direct contact with the light and shapes that were recorded on film. Finally, I wanted to parallel the Super 8mm era of personal and family travel films; because, ultimately, that's what River Ghosts is.

What film stocks did you use?

I usually use Kodak Ektachrome. At this point, it seems like every day that film is being manufactured is a gift!

You mentioned this film is a Travelogue. Why did you choose to tell this story in this genre?

I love road films and the concept of the photo and film travelogue. It's a great framework for imagination, discovery and surreal encounters. When it comes to the travelogue, there's a lot of negative baggage–colonialism, boorish tourism, and navel gazing. But with any genre, you've got to use that history as fuel to reinvent the category. Thailand is a big tourist destination with a lot of mystique and stereotypes surrounding it; creating this film from the perspective of an Asian American perspective embraces the allure of the everyday as a novel with a thread of autobiography.

What do you hope audiences walk away feeling after watching your film?

I hope audiences have an experience that is multi-sensory (and not purely visual) that's tied to a particular geography, whether internal or within the various landscapes presented in the film.

What's next for you?

This summer I'll take my film gear to the Wayne National Forest in Southeastern Ohio– it's a little-known gem that needs its natural beauty recorded on film!

Anything else to add?

Just appreciation for everyone using and promoting analog media. It's not a fad or nostalgia, it's simply another way of making art.

Film Environments

TAIGA
LEENA LEHTI

An elegy to boreal forest, this tactile film is made totally without camera. It combines hand scratched animation with real tiny plants and moss collected in subarctic region in Finland. In south Finland the Taiga is already starting to change to temperate forest.

When did you first cut your teeth on scratching film?

I made a little experimental film called *Gimme winter and You Can Keep the Rest* in 2014. I had a dark and underexposed cross country skiing scene that I started to scratch with a knife. I was fascinated by how magical the light shining through the film was when I was projecting it with my super 8mm projector. I think I scratched, projected, and watched that same scene again and again about 100 times until I was happy with it.

What does the film medium lend to you that digital could never compete with?

The most important thing in the film medium is the tactility and handcrafting process. I'm also very interested in film's own aesthetic--grain, softness, dirt, dust. Editing in the old way with a splicer and tape is literally like holding time in your hands.

How does sound play a significant part in this piece?

For me, the focus is on the image. In *Taiga*, sound is made with a reed organ to create the atmosphere. Spoken words are names of the plants that grow in the Taiga area. I chose Finnish words that sound like gibberish on purpose, and because of this there is no need to make subtitles. In Taiga I think subtitles would ruin the film experience.

What film stock did you use for this film?

I used black and clear 16mm film. Taiga is a cameraless film. It's made with real plants and moss taped on film. Scratching is made frame by frame with metal needles and colored with pencils.

What's the significance behind using more natural materials, e.g. flowers and plants?

I played with the idea of a herbarium. We know that we are losing biodiversity all the time. But I really hope that the wood sorrels I filmed are not disappearing and I have made some kind of historical herbarium I can show my children instead of real plants growing in the real forest.

What part does symbolism play in your film?

I think I make little fairy tales and I don't like to explain them too much. I don't use traditional narrative, but I try to create strong and symbolic images instead. I often have several different storylines in my head for the same film and I believe that the viewer has her own story.

For example, there are two symbolic human-like characters, one for the winter darkness and another for summer light. Or am I the only one who sees them?

There's a playful quality to this piece; how does play work its way into your process?

I love to test new materials and techniques. When I start a new project it's very much searching and trying to reach a certain visuality. I can proudly say that I'm playing with film. I don't use a traditional script, I start with a feeling and image. I try not to think too much about a target or purpose in the beginning of the process. But just like in children playing, the theme of the play can be deep and serious.

How do Environmental concerns play a factor?

Taiga is an elegy to boreal forest. In southern Finland taiga has already started to change to temperate forest. In +3C climate change scenario Finland will lose almost all coniferous trees that are now the most common forest type.

Whose work are you most inspired by?

I get my inspiration mostly from poetry, literature and music. But I have to mention Finnish video artist Salla Tykkä. And Jan Švankmajer. And Emir Kusturica. And many more.

ANTHOLOGY FOR FRUITS AND VEGETABLES

The secret language of 26 fruits and vegetables are revealed through eco-developing and eco-reversal, hand-processing techniques. Each plant in the film was hand developed in its own "essence" or "tea," made by boiling down the fruit or vegetable and straining the solids from the liquid. The liquid was then mixed with vitamin C and washing soda and used as a developer for a specific duration and a specific temperature. The film then underwent an eco-reversal process; that uses a combination hydrogen peroxide (H2O2), vinegar and water. The film is then exposed to bright light and is followed by a second eco-developer, fixed, and hung to dry. The results not only reveal the characteristic of each plant but also the filmic qualities that each plant texturally imparts on the film stock. With digital colors inspired by botanical tints and a deliciously, playful sound design, this film is a refreshing way to get your recommended dose of 26 fruits and vegetables without all the harsh chemicals.

DAWN GEORGE

Tell us about your background. When did you first start working with film?

In 2008, I had just moved to K'jipuktuk, Mi'kma'ki (Halifax, Nova Scotia). I was walking around the city and saw a big red poster on a telephone pole for the Atlantic Filmmakers Cooperative's (AFCOOP) One Minute Film Program. The program provided people with little, or no filmmaking experience the opportunity to create their first one-minute, black and white, non-synced sound, 16mm film. I applied with the idea to make a film about what is like to be inside the body a costumed character. The jury liked my application, and I was selected to be of the fifteen people in program.

We received free workshops that included writing, camera, lighting, editing, and sound design. We also had access to the co-op's equipment and all the supplies necessary to make our films including two roles of Tri-X, a Bolex (or Scoopic), lights, sound gear, and editing time on the Steenbeck. In addition to this, each of us was paired with a member of the co-op to mentor us. Lastly, we each received a one-year associate membership to the co-op and were welcomed into the awesomely, supportive filmmaking community at AFCOOP! The program culminated in a screening at the local cineplex. The One-Minute Film Program changed my life. It offered a gateway to filmmaking for me.

After that, I took more workshops through AFCOOP and at the Centre for Art Tapes (a fantastic local artist-run media arts center), attended screenings, talked to other filmmakers, learned how to write grants. I started to explore different aspects of filmmaking, getting a sense of the kind of films I wanted to make, and the ways in which I wanted to work with film.

How did you process this film? Have any recipes you can share?

There was a lot of testing involved to figure out the exact amounts as well as the times and temperatures for each developer. Working under safe light (red light) was also helpful because I could eyeball when the film was exposed enough.

After the first developer, the film then underwent an eco-reversal process; that uses a combination hydrogen peroxide ($H2O2$), vinegar and water (this recipe was based on Ricardo Leite's experiments and recipes). The film was then exposed to a bright light (or the sun) and underwent a second eco-developer, I reused the first developer for the second developer. Lastly, the film was traditionally fixed, rinsed, and dried outside on the clothesline.

Every plant was filmed on a white background. I was interested in seeing what the eco-developers would do to the imaqes of the plants but also the flecks, lines, and splotches they created around the image. It was important that this was not marred by scratches so I processed the film using a Lomo tank; the spiral insert keeps the film

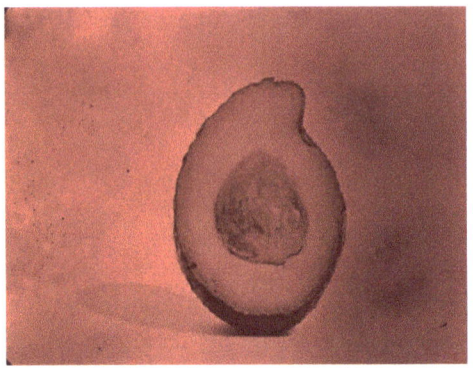

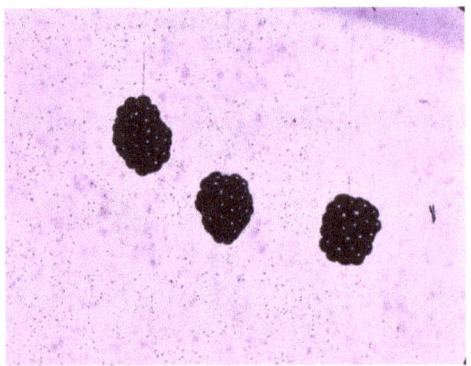

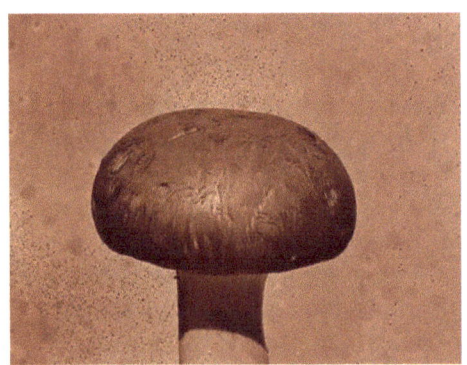

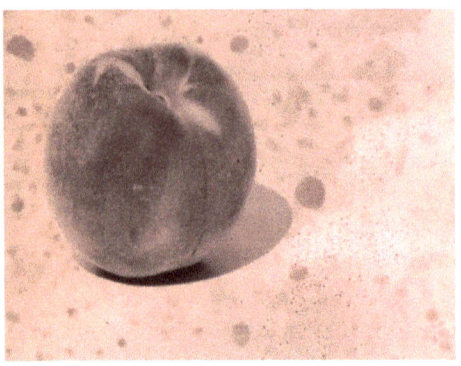

separated and avoids the scratches that I can sometimes get when I bucket process.

The tints in the film are digital tints inspired and derived from dyes I made with the fruits and vegetables. Some of the plant dyes I made worked very well as tints like strawberry and avocado but others either didn't take or the emulsion slid off – which is total bummer after you've spent so much time filming and developing. I don't want to discourage anyone from trying to tint with plant-based dyes (goldenrod is great) but it varies from plant to plant and is dependent on the film stock you use.

I have several recipes posted on my website www.dawngeorge.com. One of the things that I love about the eco-processing community is that people share. There are a lot of variables that go into eco-processing and you can try to control it as best you can, but a lot of the fun is seeing what will happen on that particular day that you develop film. Just like any fruit or vegetable there is a peak time for harvesting; the potency of a developer will fluctuate over the plant's life cycle. If you are not getting the desired results, try experimenting with a stronger tea, hotter tea, or longer developing times, add something, take something away. I have found the more I work with eco-developers I get a sense of what is needed for a developer to work. Caffenol is a great place to start from, it is a tried-and-true recipe. I also recommend weeds in your area, as they are abundant, just remember to leave some for the insects.

What film stock did you use?

3378 and one roll of super 8 black and white Tri-X.

Tell us about the sound choices in this film.

I love making the sound designs for my films, it makes my brain work in a different way! Originally, I was going to record the elements (water, air, earth, fire) interacting with each fruit and vegetable – but after a few tests, everything sounded similar. I wanted the sounds to reflect not only each individual image of the plant but also the unique speckles, flecks, and wavy lines created on the film through the developing process. I began experimenting with different ways to create each of the twenty-six voices, while still having a unifier that would connect them together.

I thought about language and why these combinations of letters were used in naming the plants and how these words resonated and rolled around in the mouth cavity. I ended up using the first letter in each plants English name for its sound. So, the avocado begins with the letter A and has an "awe" sound, dill is a D "duh" sound, eggplant is an E "eah" sound. As I played with these phonetic sounds, they began to embody the essence of each plant.

I used my own voice for the piece; sometimes modulating it with reverb or pitch. For much of the piece the plants are organized by the way the sounds are shaped by the human mouth. The tongue placement of a D and T and N in the mouth are very similar and so the image of the dill-D, leads into the tomatillo-T, leads into nectarine-N. When I ran out of connections, I would use visuals (shapes or movement) to help guide me to the next fruit or vegetable. The film doesn't cover all the 44 sounds found in the English phonetic alphabet just 26, perhaps that is something for another film!

This film takes a comical tone. What lead you to this decision?

All my films have an element of humor to them. I think it is a combination of what I find amusing, but also the humor comes from my interaction with the subject matter. The fruits and vegetables are the actors in this film. They don't talk but they carry their own energy and I certainly have relationship with them. I grew half of the plants in my garden - from seed to film! So those have a special place for me. But even selecting the other fruits and vegetables was an intimate experience, I would go to the market or grocery store looking through the produce section and ask them - sort of jokingly but sort of not, "Would you like to be in a movie?" Also, things like light, wind, and gravity have an influence on plants in different way – sometimes a fruits or vegetables would be wobbly or would roll around. I was also handling the fruit and vegetables a lot, holding them, positioning them, trying not to bruise them. I wanted to capture their spirit in its truest and freshest form! I got close to these fruits and vegetables.

All of this imprints on me and then, when I revisit the footage for editing and sound design, its these aspects or energies and that come through somehow and the personality comes out and sometimes its humorous. It is never my intention to make something funny, it is all approached with sincerity.

I am always delighted when an audience reacts (even if it's walking out of a film) – it means there is a connection going on. Laughing together is a powerful experience, it offers release and just feels good, and I think humor can resonate long after a film is over. I love that people laugh out loud at

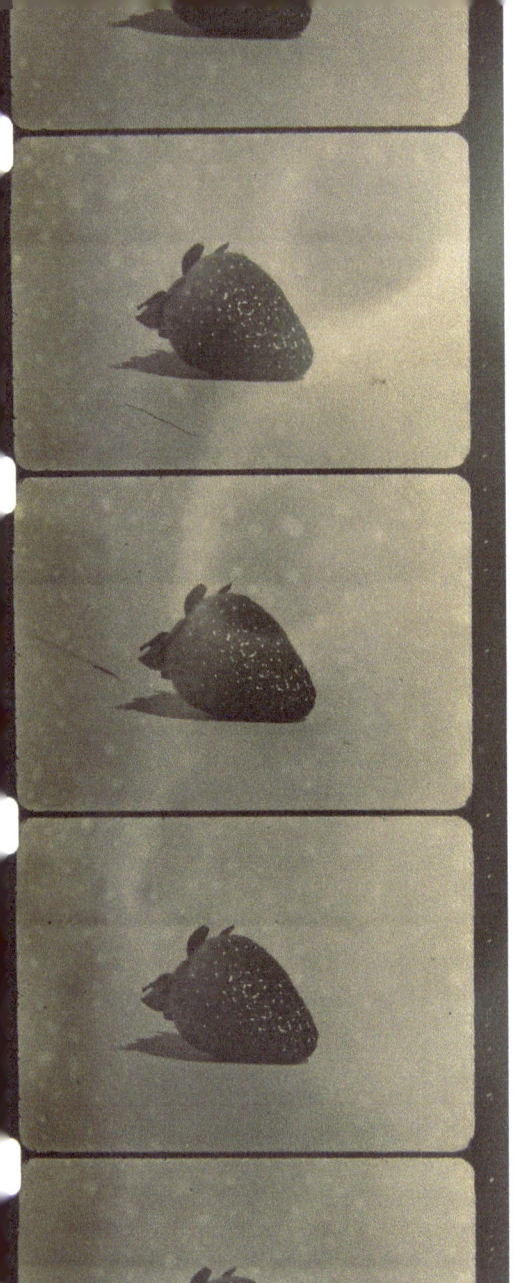

this film of fruits and vegetables!! There are no words, no punch lines, no practical jokes – just plants. People are finding joy in these fruits and veggies without tasting a bite.

How do environmental concerns play a role in your process?

As my practice has evolved, so have the ways in which I work. When I first started making films, I sent my film away (on a plane) to be processed (in chemicals) and then shipped back to me. It was expensive, and had a big environmental footprint, it also didn't feel right for me. I started processing myself which was more sustainable but also a little scary. When learnt about caffenol and then was introduced to the work of Dagie Brundert and her plant-based developers, it was a huge shift for me. I began experimenting with the eco-reversal process and now I am working with salt fixes. Most of my subject matter is based in the natural world, so it makes sense to honor that space and treat it with respect.

What I am doing now, not just in my practice but in life, is making informed choices that will tread lightly on this planet. It starts by evaluating each step in the creation of a film and figuring out what the environmental impacts are going to be and then figuring ways that it can be mitigated.

For this film I was able to grow half of the fruits or vegetables in my garden and then compost the "solids" when I was done brewing the teas for the developer. Some of the fruits and vegetables I could source locally like cranberries and fiddleheads but then there were other plants that travelled thousands of miles to be in the film, I am thinking of the vanilla, avocados, and walnuts. These plants had a bigger environmental impact. This

also led to some serious contemplation on food security, "Should I be using nectarines to develop film, when they could be feeding somebody?" In addition to this, I also used chemical fixer that needed to be disposed of properly. There is lots to consider.

People don't know any of this watching the film except that maybe the film was made using fruits and vegetables. What I hope the film offers is the opportunity for contemplation, conversation, and change. Even if you get a hankering salad afterwards, it has done its job.

There will always be aspects of filmmaking that will impact the environment for example cameras are made from metals, gelatin comes from cows, plastic is used in some film stock – but there are some people experimenting with other materials and methods. We are at intersection with art, science, and technology where there is this opportunity to compliment and influence each other and some cool innovations can occur that can help the people and the planet. There are always choices along the way that we all can do to ease our impact on the environment and if everyone cares enough to do a little bit more than they did before, positive change will happen.

What was your favorite veggie or fruit to film?

Oh, so hard to say! Each one is special memory for me and had its own quirks on shooting day.

The day I filmed the black berries there was a breeze outside, which made the bush dance but also cause a few thorn stabs. Kale is beautiful on film for its textures and shadows. Peaches are so fun to handle because they are fuzzy and they smell so good, that was also the year I had bumper crop peaches. Yam was a surprise developer, I ended up using a juicer to extract the liquid out of the yam, instead of boiling it. When I took the yam film from the developer into the reversal-bleach it had an intense reaction and started bubbling out of the lomo tank! I also liked peeling the layers back on the iceberg lettuce, that turned into the lettuce ballet!

What's next for you?

I am finishing up a film called needles, is part of AFCOOP's Plants on Film program. Myself, along with six other filmmakers (including members of the Handmade Film Collective) have each been commissioned to make a short film that incorporates handmade film techniques along with some aspect of plant material. I suppose it's my Covidian film – it's a reflection on all things needles, my time walking in the bush, sewing masks, and thinking about vaccines. The film was shot on a bolex and hand-processed with spruce, balsam, and pine needles, with the interiors processed in caffenol. I also used light painting in this film, which is a new technique for me. The films will be screened at the Halifax Independent Filmmakers Festival June 24-27, 2021.

Anything to add?

This film was so much fun to make. I wanted to send thanks to Herb and Rena at the Handmade Film Collective, and friends at AFCOOP, as well as Arts Nova Scotia, and the Canada Council for the Arts for the support in the research and creation of this film. I hope it inspires more people to discover the power of plants.

DAWN'S MUSHROOM DEVELOPER

Cremini Developer for 3378 film stock

Cremini Tea
Boil 9 cremini mushrooms in 1.5 liters of water
Let steep
Cool to room temperature
Strain solids from liquids (compost solids)
Save "cremini tea"

Cremini Developer
1 liters of cremini tea
80 grams of washing soda
20 grams of vitamin C power

Combine ingredients in above order stirring gradually until dissolved.
Warm to 22°C

Method:
Can be done in red light with 3378 (total darkness for non-orthochromatic film)

Water rinse film	1 min.
Cremini Developer	3 min.
Water rinse	1 min.
Fix traditional	6 min.
Water rinse	10 min.

-Hang to dry-

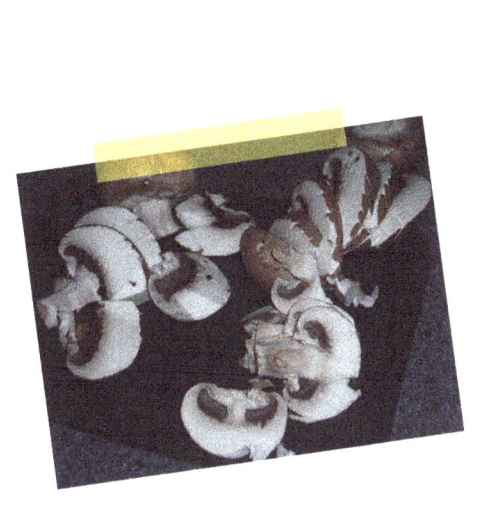
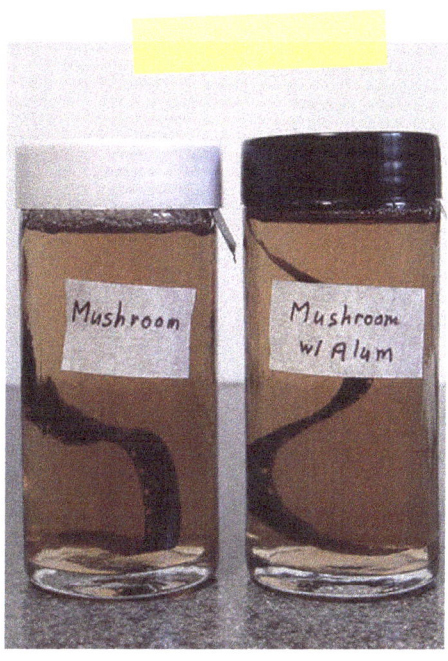
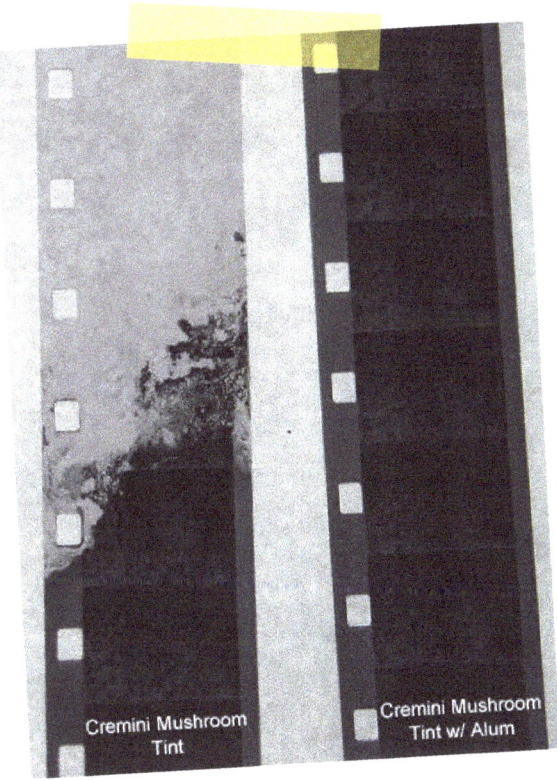

Cremini Mushroom Tint

Cremini Mushroom Tint w/ Alum

HE NEEDS DARK TO SEE

Originally inspired by William Matthews's poem *Eyes*, this film is part of the artist's ongoing series *blackness/void*.

Can you tell me about the creatures we first see in the beginning of your film?

I believe they are caterpillars under the microscope. Because it's a found footage film and the source materials are pieces from different recycled educational films, the original content is a bit unidentifiable. But I think it was this uncertainty that made the material interesting to work with. It has endless possibilities and is open to interpretation, depending on how you redefine and reconstruct it.

When did you first cut your teeth on scratching film?

This film is actually my first attempt at experimenting with scratching and some other direct manipulation techniques on analog film. I've wanted to get hands-on experience in material cinema for quite some time. During the quarantine, I started to produce new work with preexisted or ready-made materials in a very minimalistic style. For this found footage film, I enjoyed the making process a lot. The deconstruction and reconstruction process was physically and psychologically engaging.

What were some of the tactile methods used in this film?

For the opening scene, the text and the eyes animation were scratched with wood carving knives. I didn't have a light box at the time so I ended up putting my phone (with the flashlight on) inside a plastic container and scratching the film on top of the container. It might seem amateur but when you have very limited resources, everything at your disposal can be useful.

As for the upside-down portrait part, I soaked the film in the lemon juice, vinegar, water mixture for a week, and created the emulsion fiber patterns with paper towels afterward.

For the following text collage part, I applied a few drops of black ink on the clear leader and spread it over with a sponge to create the background. The texts were first ripped from the

ABIGAIL HE

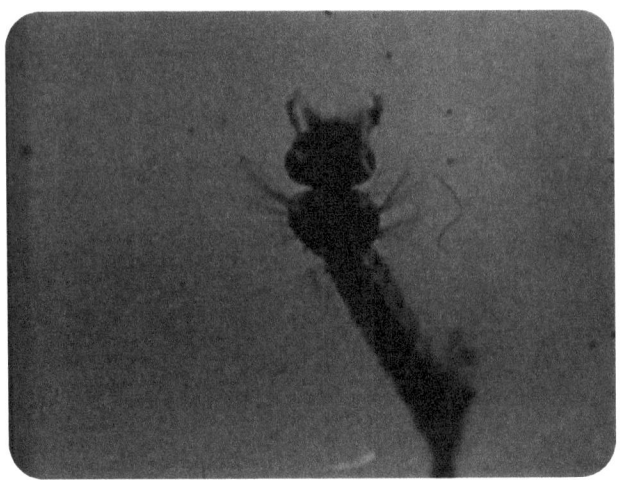

newspapers with scotch tape, then were laid out in different orders and attached to the film with another layer of scotch tape. I was a bit worried it would be too thick for the projector light so I did some testing at home by holding up the film against the light. It turned out as long as you can see light go through the film, it should work fine on the projector as well. The last part of the film was painted with ink. I used up the clear leader for the text collage so I had to bleach some films to get clear film for the painting. Each color has a different thickness of ink and was applied with either cotton balls or paint brushes. For the texture of the ink, I experimented with various approaches to apply the ink on the film to create bobbles, splatters, etc. The filaments and fibers from the brushes and cotton balls also added variety.

How are you inspired by organic materials?

I only experimented with a few common organic materials in this film but definitely will try some other more radical methods and materials in future projects. I think organic materials allow artists to explore the possibility of creating unique work. When you decide to work with organic materials on analog film, you actually allow chances to play a part in the making of the work. So it's to give up some degrees of your creative autonomy in a sense. But there are always surprises involved in the final products because that's the essence of being experimental and boundary pushing, which makes things interesting and exciting.

What was the decision behind not using sound?

I wanted this film to be a pure visual experience. With less than 100ft source materials, I wanted to create something ephemeral yet intense and electrified, like fireworks. Plus, silence carries its own

sound and I believe visual itself can also produce the psychological "sound", so I decided not to add any external sound to the film.

It's also possible that I was unconsciously more drawn to the visual part of this project because of the title. It's actually a line from William Matthew's poem Eyes and I was almost bewitched by it, so it became the title, as well as the "anchor" of the film.

What do you hope audiences walk away feeling after watching this piece?

I hope the viewers can simply enjoy it as a visual experience. The title He Needs Dark to See embodies the beautiful ambivalence of the film. Each of us can decide what to see and how to see. It's best to immerse in the viewing experience and let the piece lead you to wherever that will be.

Anything else to add?

The film is part of my ongoing conceptual series absence/void, which includes film, video, performance, and ready-made sculpture. Influenced by writers and artists such as Samuel Beckett, John Cage, Bruce Nauman, the series is to explore the variation of void and the not-nothingness in art and life.

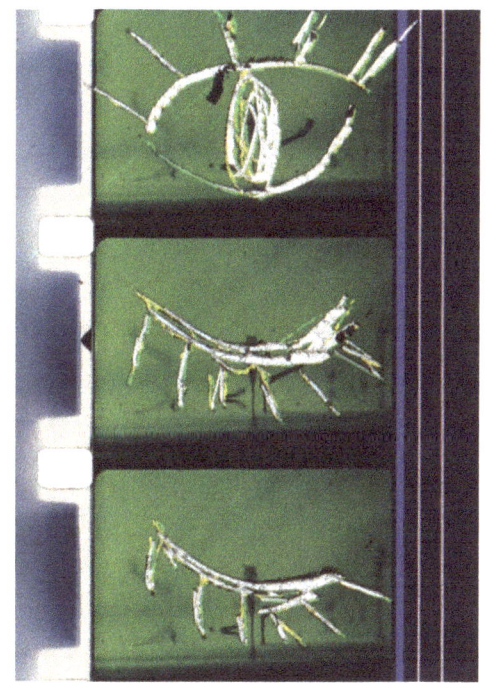

Bloom

Ashley Manigo

A KALEIDOSCOPE OF COLORS AND FOLIAGE CAPTURED THROUGH CHEMICAL EXPERIMENTATIONS ON 16MM. THE IMAGES WERE CREATED BY ADAPTING "FILM SOUPING" RECIPES FROM FILM PHOTOGRAPHERS AND APPLYING THEM TO 16MM FILM AS A PART OF THE DEVELOPING PROCESS.

What part does symbolism play in your film?

In this film, there isn't much symbolism or underlying connections to other aspects, rather I tend to create through a lens of escapism. I like to envision and create fantasy landscapes; worlds that I would like to inhabit and pleasant cinematic experiences for viewers.

Were the firework-like sounds intentionally placed over the Ferris wheel?

It was definitely a happy accident. The firework-like sounds are actually from the optical soundtrack of the film. During the developing process, I noticed there were a lot of textures on the emulsion of the film strip from the corrosion of my pre-development soaking, which led me to wonder how these qualities would sound in the film. I think it complements the visuals fittingly, forming a complete celluloid experience.

What film stock did you use for this film?

I used Kodak 50D 16mm film that I hand-processed as a positive. Before developing I also soaked it in a mixture of water and detergent to get more spontaneity in the colors on the film. I was inspired by researching various "film soups" that film photographers concocted to alter their images and adapting them for 100 feet of 16mm film.

How did you choose a color palette for this piece?

I love the saturation of the Kodak 50D and wanted my subject matter to mirror that. I shot the flashing of the Ferris wheel first, and flowers afterward while walking through the garden of my college campus. I chose foliage that popped out at me and meshed well with the bright colors from the fair.

Can you tell us a bit about your choice to use superimpositions in this piece?

After I filmed the Ferris wheel, I envisioned the pulsating effect with flowers, almost animating a blooming effect, hence the title, and was dying to see the outcome. I also hadn't experimented with double exposure so I decided to give it a shot and see what came out of it.

Can you elaborate on the dichotomy between the natural

(flowers in bloom) and the man-made (a Ferris wheel)?

Perhaps there is less of a dichotomy and more of a union in the feelings associated with the images. Both subjects, the flowers and the Ferris wheel, are typically seen as positive imagery and are associated with joy. Maybe on a subconscious level, I joined the two together in this fashion because of this emotional similarity in addition to creating the visual outcome I desired.

Who are some of your artistic inspirations?

A big artistic inspiration for the creation of this piece was Rose Lowder and her film Bouquets 11-20. This film sparked my interest in capturing nature and foliage on film. Other artists that inspire me include Kristin Reeves, Rouzbeh Rashidi, and Kalpana Subramanian. I love to fall into the ethereal and transformative worlds they create in their films.

Filmed over 4 years, *Babes in the Woods* follows a young woman and her 2 young sons living on a commune in the Ozarks.

Leanna Kaiser

Tell us about your background. When was the first time you shot film?

I'm originally from St. Louis, MO, where I lived most of my life until 6 years ago when I moved to LA to attend CalArts for film and video. In St. Louis, I studied photography and spent most of my time going to shows and playing music while working a random assortment of part-time jobs. I've always been connected to older things: furniture, houses, clothes, objects and specifically cameras and projectors, and would seek these things out at thrift stores and learn about them and their mechanics when I was in high school. The first time I shot on film was at this time, on an old 35mm SLR that belonged to my dad. I loved everything about it; the camera itself, the sound the shutter made, the physicality of winding the film, the negatives and contact sheets and of course the quality of image. I took pictures of everything, and spent a lot of time in the darkroom and eventually took some community college classes in filmmaking which led me to the moving image.

At this time I was using whatever I could get my hands on, mostly Hi-8, VHS and some low quality digital cameras. I chose to go to CalArts because they gave me a great scholarship and had an experimental program that incorporated 16mm film heavily. Once there, I learned how to use a 16mm camera, optical printer, and flatbed, and started processing my own film, and that was that. It's funny because I never considered myself a big movie person, I thought it was too mainstream (before I discovered experimental film existed) and always was way more interested in music, but once I started making my own films and realized I could incorporate music making into them, I just fell in love with the whole process and knew it was the way forward for me.

Who are some of your artistic inspirations?

I would say I'm mostly inspired by my own feelings, surroundings, and people I know personally (Danielle Wakin, Yowshien Kuo, Jack Name, and Joshua Gen Solondz are some of my most artistically inspirational friends, off the top of my head) and try not to think of or look towards other artists when it comes to my own work because it's easy to compare myself and get overwhelmed. I work in a lot of different styles and mediums so I'm kind of all over the place. However, in regards to this film, I would say Les Blank was an inspiration to me, as he worked with a lot of musicians in intimate ways and that's something I do as well, and his style is simultaneously incredibly candid and artistic.

In general, to name a few people, I love David Lynch, Arthur Russell, Sergei Parajanov, Chick Strand, Karen Dalton, Jessica Pratt, Alice Coltrane, Nick Drake, Eve Babitz, Chopin, Kerry James Marshall, anyone who is an outsider doing their own

thing well. Sage was obviously my biggest artistic inspiration for this film, as she is a prolific musician, writer and artist in her own right.

What attracted you to tell a story in the Ozarks?

The first time I went to the Ozarks was when Sage moved to the community featured in the film, East Wind, when she was 18. I went down and stayed there with her for a while, and was enamored from the start. She was living in this totally idyllic one room cabin with no electricity or running water, but with instruments and tapestries everywhere, and it was pretty much my dream life, at that time. I've always had a thing for the 60s and 70s and the commune was founded in 1973, and looked and felt like it was still that year. I took a lot of 35mm photos during that first trip, and found the landscape to be quite beautiful and spooky, and returned every now and then to hang out and soak up the hippie vibes and get away from society, which I really felt I didn't belong in or want to be a part of.

A few years later I began dating someone who worked for a mushroom farm in the Ozarks and started going down to the farm with him, as well, and exploring the region more thoroughly. It's hard for me to explain, but since then I've felt so deeply connected to the region, maybe because it's so complex. It just feels sort of lost in time and its own dimension. It's one of the only regions in the US that has land untouched by humans, ever. But you can also stumble upon abandoned houses from the 1800s in the middle of fields, rare minerals that are only found there, and it just gives me this sense of darkness and beauty and loneliness. Like it just goes on forever and it doesn't matter who has come there or who will. Later in life, I found out some of my family lived there in the 1800s, so maybe that is part of it deep down.

When I first started shooting 16mm film, I knew I wanted to make a film about Sage, because those first photos I took of her at East Wind were so magical to me, and I really yearned to be in the Ozarks because I felt out of place in Los Angeles. It felt like every time I told a classmate I was from Missouri or they asked about my accent, they had this image of it being totally rural and full of uncultured white religious conservative hillbillies, and I wanted to show this other place that exists there, with people from all over the world living and farming and building a society of their own. I felt it was really unique and didn't see a lot of other people making films like that. Sage had just had her first son, Tali, which was obviously a huge milestone in her life, and it started as an elaborate excuse to travel from LA to the commune to meet him because I was too broke to do so on my own. So I thought why not? I'll make a film about her and then I just kept getting grants and traveling down there to film.

What was the most surprising thing you discovered when making this film?

Hmm..that's hard to answer because I filmed it over the span of 4 of some of the most formative and difficult years of my life, so there was a lot I discovered during that time. However, as lame as this answer may be, I would say how expensive shooting and finishing a longer movie on film is, especially when you are using both black and white and color stocks! Before this film I had been doing only hand-processed, very

short films, and it seemed to me it should be cheap since most people didn't really care about 16mm film. How naive! I really had no idea, but I just had to keep going and hope it worked out.

What were some of the challenges you faced telling this story?

There were so many, from figuring out an approachable way to film in this secluded commune where many residents were suspicious of the media and outside world, to raising money to make the film. How to square this film with my previous work, which was more abrasive and surreal with saturated studio lighting and maximalism. Once I started editing on the flatbed, I realized the digital scans I had been referencing did not match up to the workprint, and that was a major nail biter, trying to sync everything up again. The most challenging was probably HOW to tell the story and what story to tell, or if I was telling a story at all. I didn't want to make a straightforward documentary but also didn't want it to be totally abstract. I ended up not planning the content of my shoots, aside from gear lists and what seasons I wanted to shoot, and just shot in the moment what I felt, just me and my Bolex and a Tascam recorder with an onboard mic, and decided to worry about everything else later. There were a lot of facets that interested me; the location, the landscape, the commune element, motherhood, womanhood, the passage of time, generations, Sage's and my long friendship etc, and I had hours of footage. Initially, I wanted to make it a documentary showcasing Sage's music in the context of the folk tradition of the Ozarks, but that didn't pan out, as I was more interested in her life and her family, once I got there. It was so hard to choose a path. I knew I wanted the footage to speak for itself whenever possible and not really let my hand influence the viewer too much on any front, but needed to convey the sense of time and life being lived. How do you show an audience a place and a person who has meant so much to you for so much of your life, in a very small amount of time? I ended up showing the events mostly chronologically and working on a basis of emotions and feelings that I felt while at East Wind, using the seasons as my most major guide, and mainly editing the image to the audio field recordings I took. In a way the film was also about me, which I struggled to become comfortable with for a long time during the making.

How did you meet the subjects of the documentary?

I met Sage in 2003, when I was a senior

in high school and she was a freshman. We went to an all girls Catholic school (very common in St. Louis) and were both outcasts because we were atheists, very into music and looked like depressed little punk kids. She quickly became not only my best friend, but my muse. She was the first person I ever photographed; the camera loves her and she has always had this presence that sparks me, it's sort of innocent and sad and bold at the same time. We both had pretty traumatic childhoods and could relate to each other in that way, as well. St. Louis is a fairly bleak place full of people who had dreams that got away from them, often for financial reasons, and it shows. Sage's mom was a musician and painter in the 70s and 80s in England, and it was fascinating going to their house and seeing all these beautiful paintings everywhere, but she just had this awful normal job she hated as an administrative assistant or something, which I always found to be tragic and strange, as I had never met an adult artist at this point. I met Sage's sons, Taliesin and Elwyn shortly after they were born on the commune, as well as Loch, her partner, who also had lived there for many years. I've never been much of a kid person but as soon as I met Tali I knew he was a special one, we connected instantly and I loved filming him as much as I did his mom. Even at the age of 1, he had a strong interest in the Bolex I used, and was enthralled by the sounds and winding it, and often I would let him shoot when I was there, and it became part of the film. He really wouldn't leave that camera alone and always wanted to play with it, to turn the lenses and look through the viewfinder and hold down the record button, so I just let him do his thing. Every year I came back he gained a better understanding of what I was doing and eventually he learned how to load the camera and record sound on my recorder--at the age of 4! How incredible is that? A four year loading a Bolex! Now he's maybe 7 or so, and he's really into photography and is frighteningly good at it. I like to think maybe I had a part in that.

What film stocks did you shoot on for this film?

I shot it on Kodak negative, I think 50D and Tri-X, but at the time I started, I didn't know or care about film stocks, and also assumed that it would be a much shorter film. I always shot on a Bolex, but the last time I visited, I decided to switch it up and bring an Arri instead, as I wanted some longer static shots, which ended up being a huge mistake. Although I had checked the Arri prior to leaving, something went wrong with the battery connection while I was at the commune and it ate all my film, so I had to shoot on my iPhone, the footage from which I eventually shot off a monitor onto film. I was so disappointed and hated the way it looked. It was actually an omen because the whole last trip was pretty bad, it was dark and raining non-stop and Sage was going through a really rough patch in her life, not getting along with the other members of the community, and ended up deciding to move off the commune at the end of my visit, after being there for over a decade. The community just seemed different and not like how it had to me, before. The magic was fading. My partner was also with me, it was the first time I had let someone else come with me into that world, and he hated it there! So, in a way it was sort of fitting that the dreamy idealism of film stock gave way to the harsh realities of the iPhone and sort of cast a different

light on this place, and showcased the end of an era not just for me and my film, but also for Sage and her family. We have always had a lot of parallels in that way.

What do you hope audiences walk away with after seeing Babes in the Woods?

I think there is a lot in the film for people to relate to, even if on the surface it may seem niche. I want people to have an immersive experience for 34 minutes and get totally lost in that world, and feel some sort of wonder and brightness and calm, which is what I felt during my time at East Wind. And also to realize that there are people out there living totally different lives than what is mainstream, that there are so many ways to live if you don't feel you fit in with society, and to encourage people to look into these ways of life if it appeals to them. I guess mostly I want people to realize that even in these really ugly times there is beauty and it's valid to show it. It's okay to be a parent and celebrate parenthood, even if it's not edgy or cool to a lot of people. I got a lot of criticism for that, mostly from academics, who felt the idea of my film wasn't relevant or provocative enough and dismissed it almost immediately without even watching the whole thing. I feel like there is a big push in art and film for it all to be very political and not emotional in certain ways, which is fine for other people, and I think that political art making is and always has been important, but I don't make those kinds of films and probably never will. I make films to escape from all that. I want to say that hey, you can make a film that is still deep and poignant and meaningful, even if it's not political. There's room for everything.

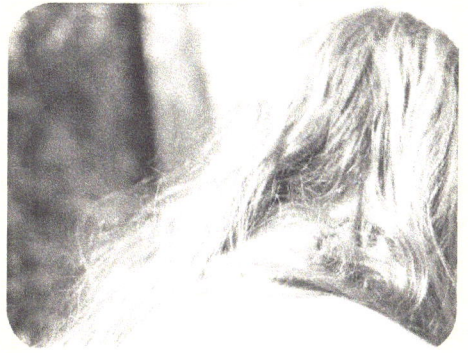

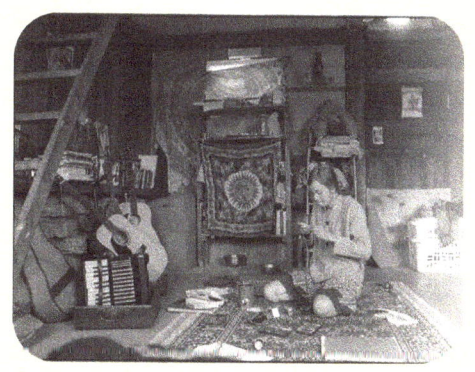

HANDMADE

These series consists of photographs that were shot on expired film and hand developed in home-made developer brewed using matcha powdered green tea from Kyoto, where I am based. The photographs were shot on long expired cine film (16mm and double super 8) using a 35mm SLR camera. This project explores photochemical image making with non-standard processes that are home-made and hand-made. Four of the photographs (sepia colored) were reversal developed using a home made eco bleach made using vinegar and hydrogen peroxide. The fifth photograph was developed as a negative and digitally inverted (hence the black perforation holes), giving a bluish tone. The 16mm photos are segments of film strips that I also used to make film loops.

MICHAEL LYONS

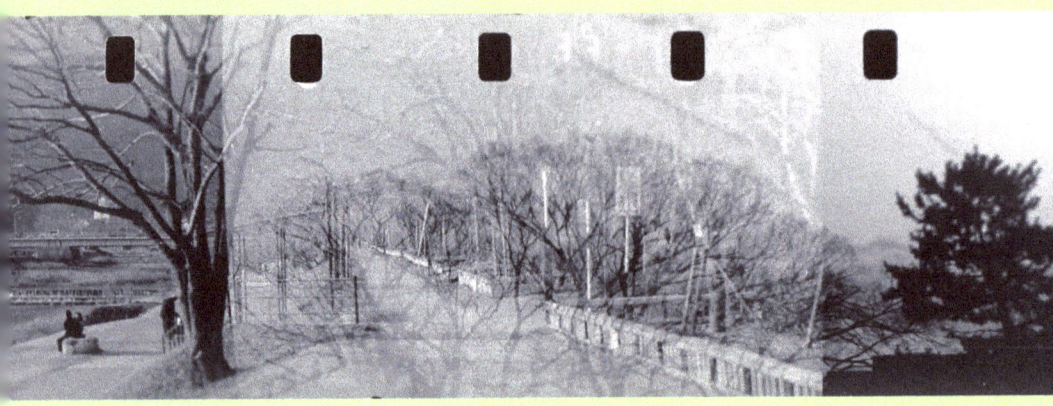

HOMEMADE

How does artistic identity play a part in your work?

I'm not very self-conscious as an artist, but tend to follow my curiosity,
natural inclinations, affinities. I prefer to think as identity something
that evolves according to our situation, actions and experiences.
Artistic activity is part and parcel of a malleable sense of self.

How does the photographic medium lend itself to your mission for the seminar?

My students are mainly interested in moving image and sound making.
Photography is of course basic to the work and I encourage my students
to embrace image-making in all forms as part of their every day practice.

How much is self-reflection a part of photography?

There's that saying about the watched pot that doesn't boil, and another famous one, attributed to Socrates, about the unexamined life. I became interested in photography in my early teen years.
Making images is almost instinctual, but process, experiment, doing things differently for the sake of it, are also important.

What's your favorite film stock to use?

Whatever is available and especially expired stocks I've never heard of or used before. But I grew up using Kodak and Ilford b/w stocks and chemicals.

What camera do you use most when shooting film?

Either my Nizo Pro (Super 8) or Nikon F3 (35mm still film, 16mm and other cine gauges). I have a number of other cameras that I also like to use.

How is teaching part of your own process in forming an artistic identity?

Teaching helps me to be more open to practices and viewpoints that I would not normally consider. I avoid pushing students in any particular direction. I do suggest they commit and see a project though, once they have recognized an interest.

Tell us about your Matcha process. Do you have a recipe you can share?

It's basically the same as a widely used Caffenol recipe but with the same weight Matcha instead of instant coffee. Same development times and temperatures. Anecdotally, I prefer the results I get with matcha. Due to the expense, it may not be practical outside of Japan. There's an inexpensive tea available where I live which works well as a developer and is also sort-of drinkable, at least to make cold matcha soy milk milkshakes in the summer. The good stuff is too expensive to use in the quantities needed to make film developer.

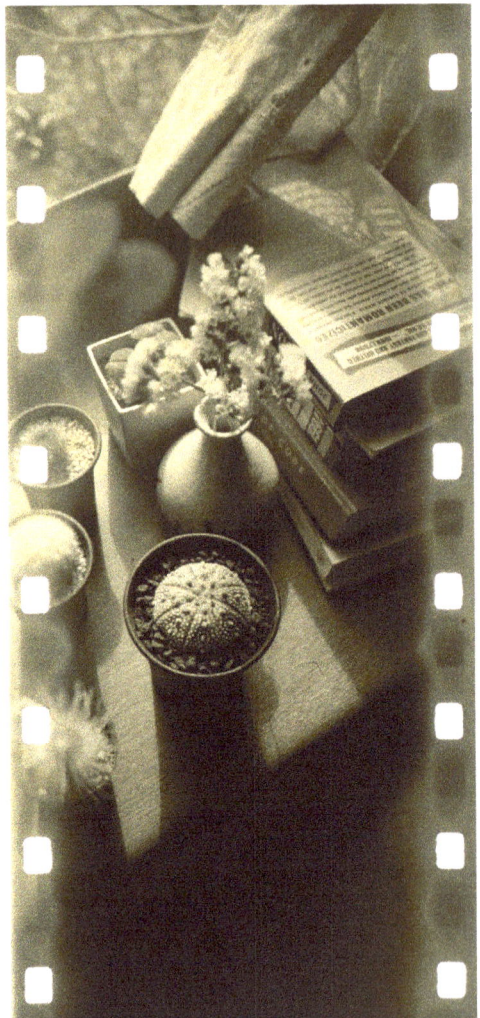

Ingrediants:

Anhydrous Sodium Carbonate 21.6 g
Vit. C. 6.4 g
KBr .4 g
Maccha 16g
15 min @ 20C
gently agitate 5s every 30s

Notes:
- when mixing, add & dissolve ingredients in the order listed above,
- using warmer water then cooling will make it easier to dissolve the ingredients
- use a kitchen scale accurate to .1g or better

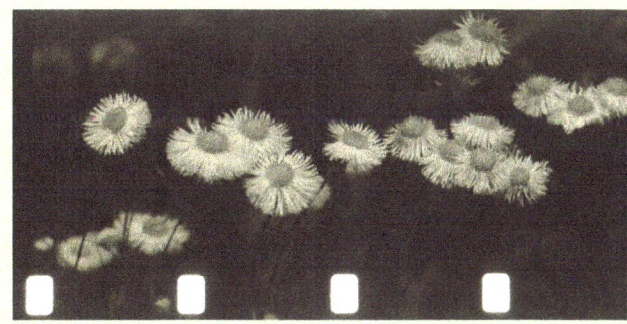

Zine within a Zine

HOME OFFICE CINEMA

By: Karissa Hahn

HELLO & WELCOME!
https://vimeo.com/447317139

DIGITAL TUTORIAL
https://vimeo.com/448026760/10b5feb399

ANALOG TUTORIAL
https://vimeo.com/448115278/a9c9c964b6

Steyerl, Hito. "In Defense of the Poor Image." e-flux Journal, Nov. 2009, https://www.e-flux.com/journal/10/61362/in-defense-of-the-poor-image/

Hito Steyerl

In Defense of the Poor Image

The poor image is a copy in motion. Its quality is bad, its resolution substandard. As it accelerates, it deteriorates. It is a ghost of an image, a preview, a thumbnail, an errant idea, an itinerant image distributed for free, squeezed through slow digital connections, compressed, reproduced, ripped, remixed, as well as copied and pasted into other channels of distribution.

The poor image is no longer about the real thing—the originary original. Instead, it is about its own real conditions of existence: about swarm circulation, digital dispersion, fractured and flexible temporalities. It is about defiance and appropriation just as it is about conformism and exploitation.

In short: it is about reality.

This is to be expected: entire industries (newspapers, magazines, book publishers, movie studios, record labels) are threatened with demise, and most will die. The new model is based on the intangible assets of digital bits: copies are no longer cheap but free and flow freely everywhere. As computers retrieve images from the web or displays from a server, they make temporary, internal copies of those works. Every action you invoke on your computer requires a copy of something to be made. Many methods have been employed to try to stop the indiscriminate spread of copies, including copy-protection schemes, hardware-crippling devices, education programs, and statutes, but all have proved ineffectual. The remedies are rejected by consumers and ignored by pirates. Copies have been dethroned; the economic model built on them is collapsing. In a regime of superabundant free copies, copies are no longer the basis of wealth. Now relationships, links, connection, and sharing are. Value has shifted away from a copy toward the many ways to recall, annotate, personalize, edit, authenticate, display, mark, transfer, and engage a work. Art is a conversation, not a patent office. The citation of sources belongs to the realms of journalism and scholarship, not art. Reality can't be copyrighted.

↳ found in David Shield's "Reality Hunger" (pg. 29)

extracted from:
https://www.wired.com/2005/07/gibson-3/

Gibson, William. "God's Little Toys." Wired, 2005

This is an image of Andy Warhol's 'Black and White Disaster', as seen online in LACMA's permanent collection.

Its public use is protected by the Artists Rights Society (ARS).

The virtual image is not blurred, so the digital pixels seem available for use, but I went ahead and blurred and watermarked them kind of as a joke!

95

1 year
365 strips of film @ 24 frames per day.
Each frame represents 1 hour of day.

12
1AM
2AM
3AM etc...

JANUARY
1 2 3 4 5 6 7
etc....

HORIZON
SUNRISE
DAY
GOLDEN HOUR ↑6°
BLUE HOUR
CIVIL TWILIGHT 6°
12°
18°
NAUTICAL TWILIGHT
ASTRONOMICAL TWILIGHT
NIGHT

• shorter twilight at equator

INKJET AS SUNLIGHT TRANSLATION

2018 FUTURE LIGHT

INKJET AS PRINTER REPRESENTATION

CLICK HERE

This is a way to assess the politics of media saturation at a granular level

2020
Newsreels

Roll 1

1 — Virus
2 — Hazmat
3 — Blue Man sneezing
4 — Painted virus balls
5 — washing hands.
6 — Blue-light
7 — space-age thermometer
8 — thermo-woman
9 — River on fire
10 — tipped boat
11 — painting-something?
12 — handshake

Illustration by John W. Tomac

Create a folder on your desktop. This is where you will store your source material and video-frames.

Open QuickTime Player. Here you can record anything you wish using the 'Screen Recording' feature.

You can record the entire screen, or choose to select a portion. I suggest keeping it more square than rectangle so it fits the film frame better.

No Mac?!
No Worries!

PC screen recording
https://www.pcmag.com/how-to/how-to-capture-video-clips-in-windows-10

How to record your computer screen with varying operating systems
https://www.digitaltrends.com/computing/how-to-record-your-computer-screen/

Video to JPG conversion site
https://image.online-convert.com/convert-to-jpg

Now that you have a video, it's time to turn it into individual frames.

This website is free, and works great because it will also resize each image. This is important because each 16mm frame is tiny!

120×90 pixels will a[...]

The translation won't be accurate, but that is whats so interesting about the internet, indulge in the mystery of the video-frame translat[ion]

Save your video frames to the folder on your desktop

On the internet of Kahle's dreams, nothing decays. No matter how deeply buried, the past waits to be found if you know where to look. On the internet we live with, however, things dissolve all the time. Digital objects decompose faster than physical ones—technology evolves, and files in old formats become unreadable hieroglyphs. Web pages migrate, disappear, or change without warning, on average every hundred days, and no person, or program, can be everywhere at all times. The largely automated Wayback Machine comes the closest—it has crawled more than 339 billion web pages at last count—but its contents remain a sliver of the gargantuan whole.

Caplan-Bricker, Nora. "Preservation Acts, Toward an ethical archive of the web." Harpers Magazine, 2018, https://harpers.org/archive/2018/12/preservation-acts-archiving-twitter-social-media-movements/

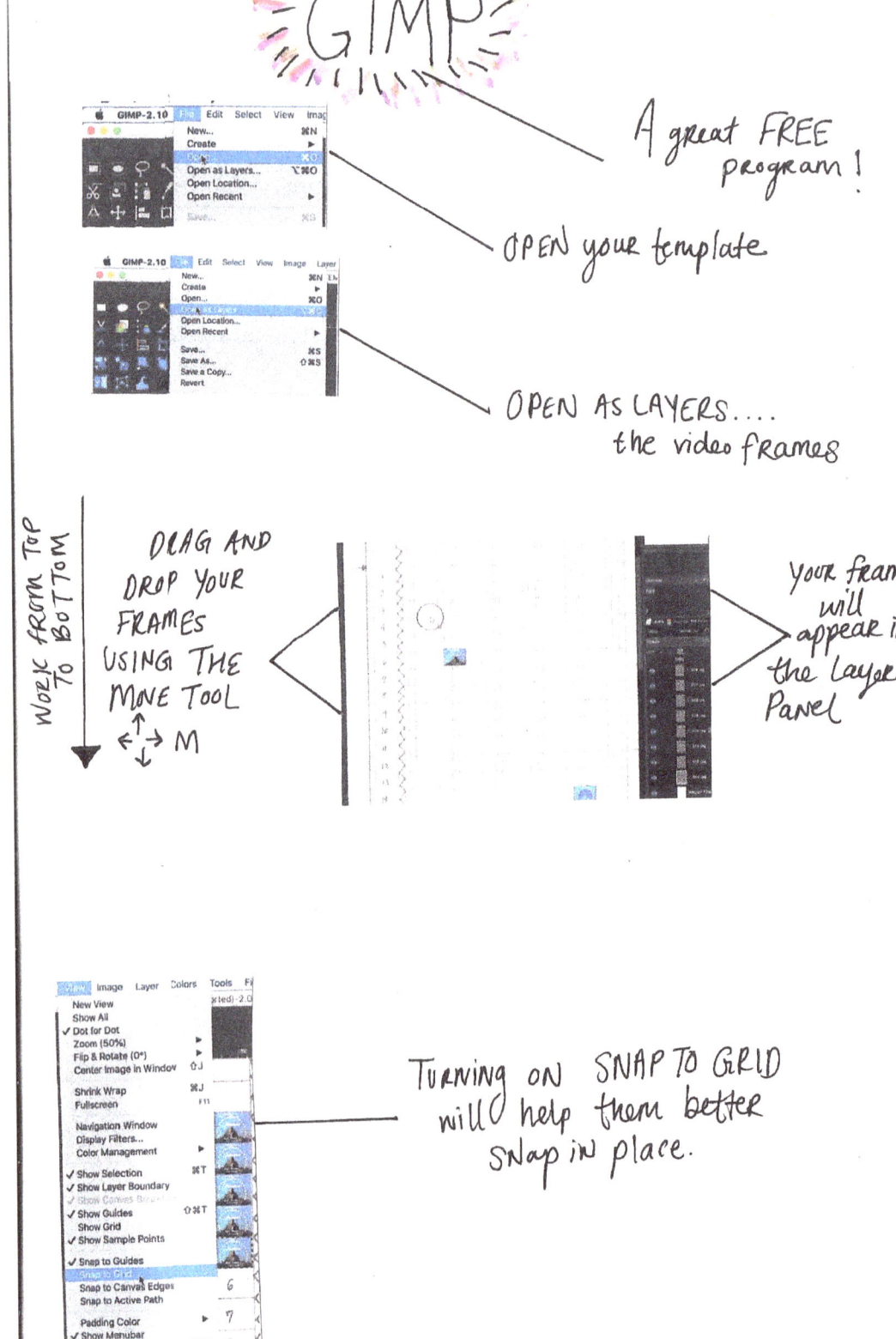

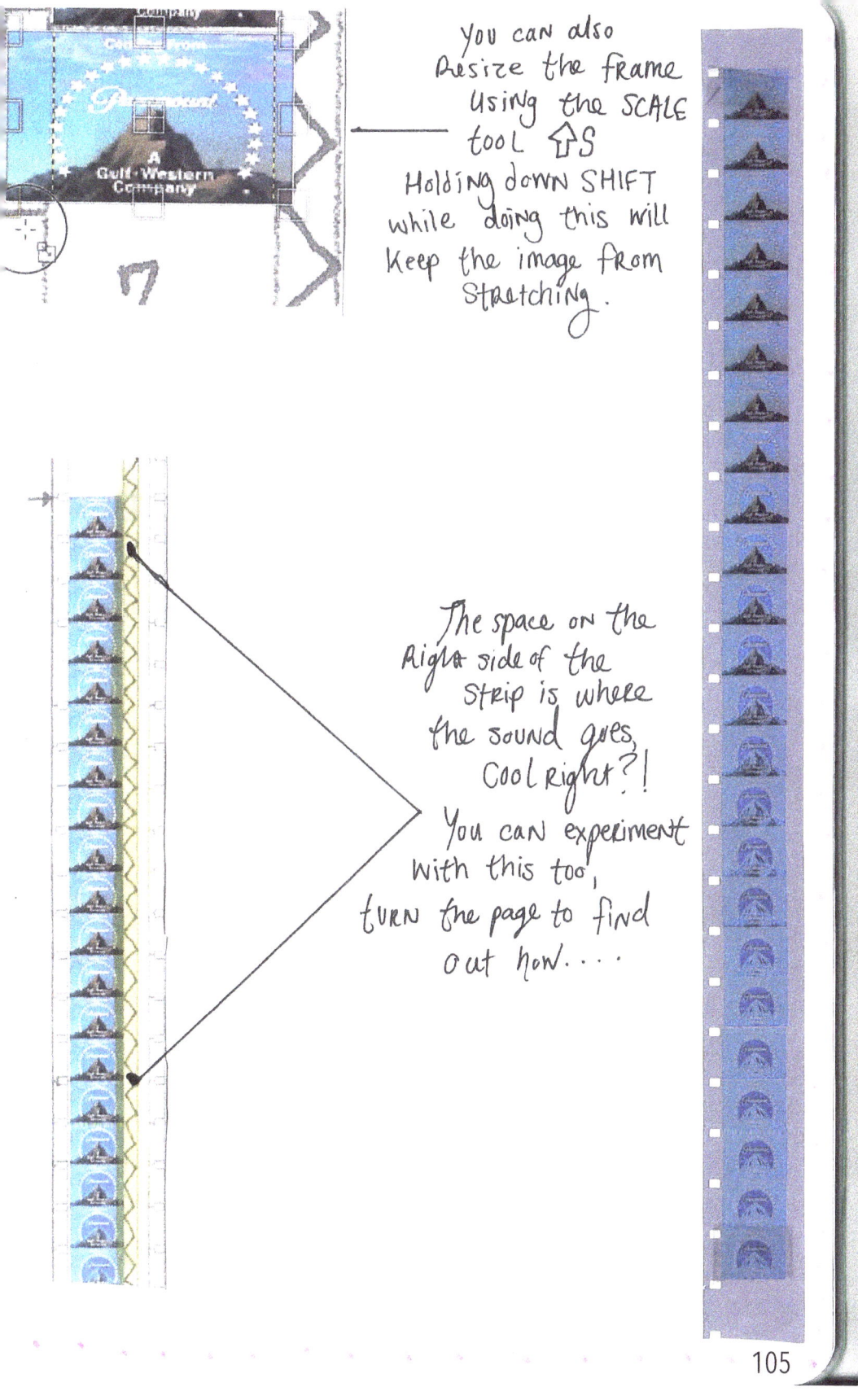

You can also resize the frame using the SCALE tool ⇧S
Holding down SHIFT while doing this will keep the image from stretching.

The space on the Right side of the strip is where the sound goes, Cool Right?!
You can experiment with this too, turn the page to find out how....

— Scissors!

An inkjet printer.
Settings will
Vary

SUPPLIES

Gift wrapping tape slides through the printer best, but any will work!

16mm Film Splicer

Printer Ink! Found at your local Office Depot, Staples, CVS, Walgreens...
It's cheaper to buy Color + B+W at the same time.

ANALOG

Electrical Appliance Instructions – Geddis Electric

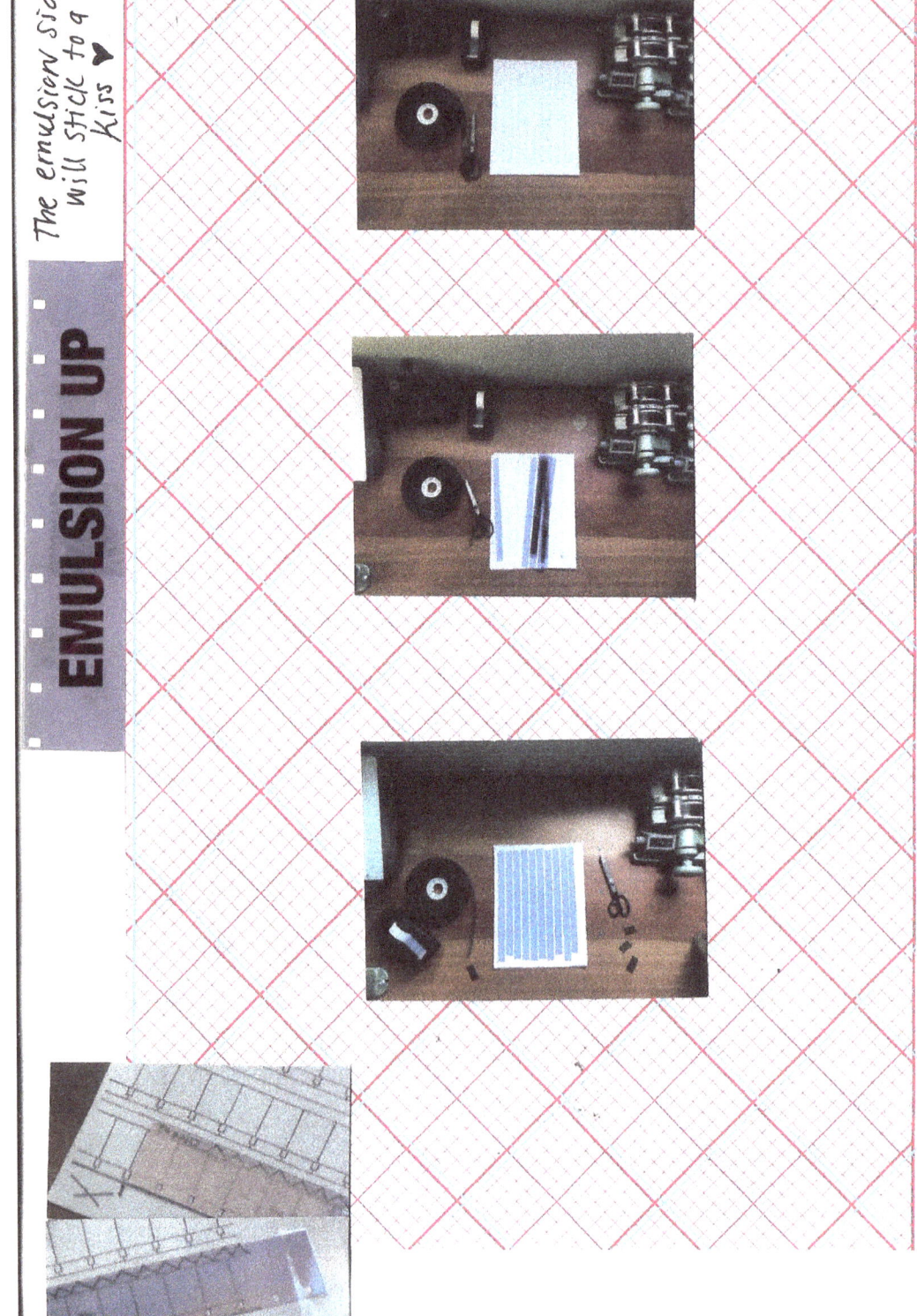

EMULSION UP

The emulsion side will stick to a kiss ♥

TAPING + PRINTING

The film will less likely jam if it starts 1/2 – 1 inch below the top of the page

Place the film in upside-down, you'll feel it latch into the Rollers — which is a good thing!

When splicing, you will lose some frames, so it is good to leave a little extra film.

If you would like to print an entire image over several strips, ignore the template!
(Looks cool hanging in a window, or over a lightbox)

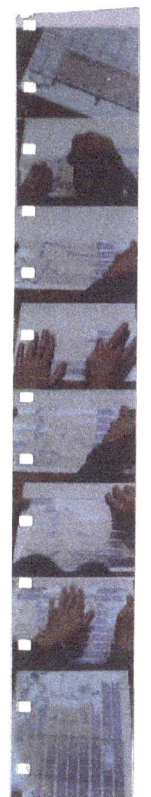
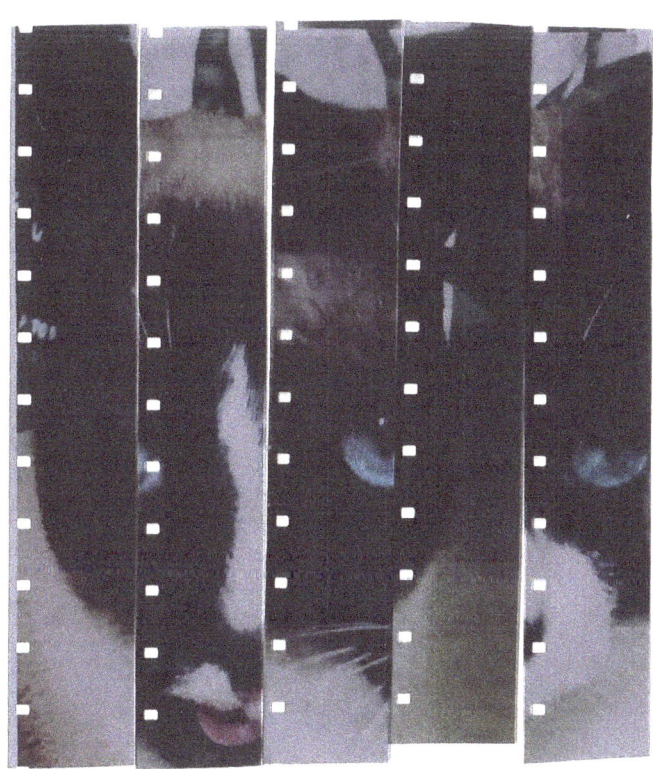

Hang the sheets of film to dry on the wall for 24-48 hours. Depending on your location the drying times will vary. It's Ready to splice when only a tiny bit of ink comes off upon touch.

Seeing it on the wall helps with editing! Move the scenes arou[nd]

You can also leave it to dry on the floor — but might forget and step on it! It might look awesome though!

DRYING + SPLICING

"SPLOICE"

FUN FACT:
Some breeds of cat have the ability to sploice, they just need a little guidance at first - but will remember!

PROJECTING

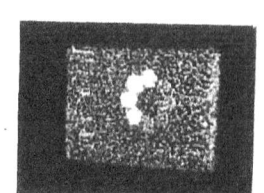 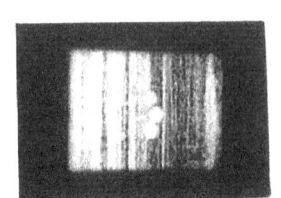

An inkjet original print will melt over time, if constantly projected.

∽ Makes for Cool Looping Installations ∽

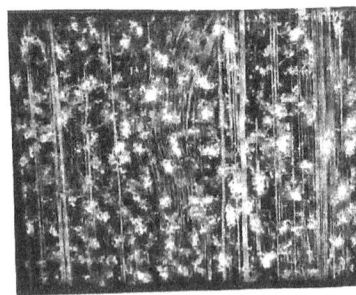

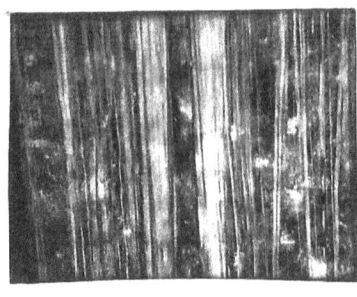

Other Experimental Techniques:

— Right when the film comes out of the printer, you can further manipulate each frame with a paint brush —

HEALTH Bank, Inc. Vol. XX January 1989 HEA 13 copyright 1989

— COPY OTHER FILMS ONTO YOUR FILM! —

> DOES YOUR PRINTER ALSO HAVE A SCANNER?
>
> YOU CAN SCAN DIRECTLY ONTO THE FILM!
>
>

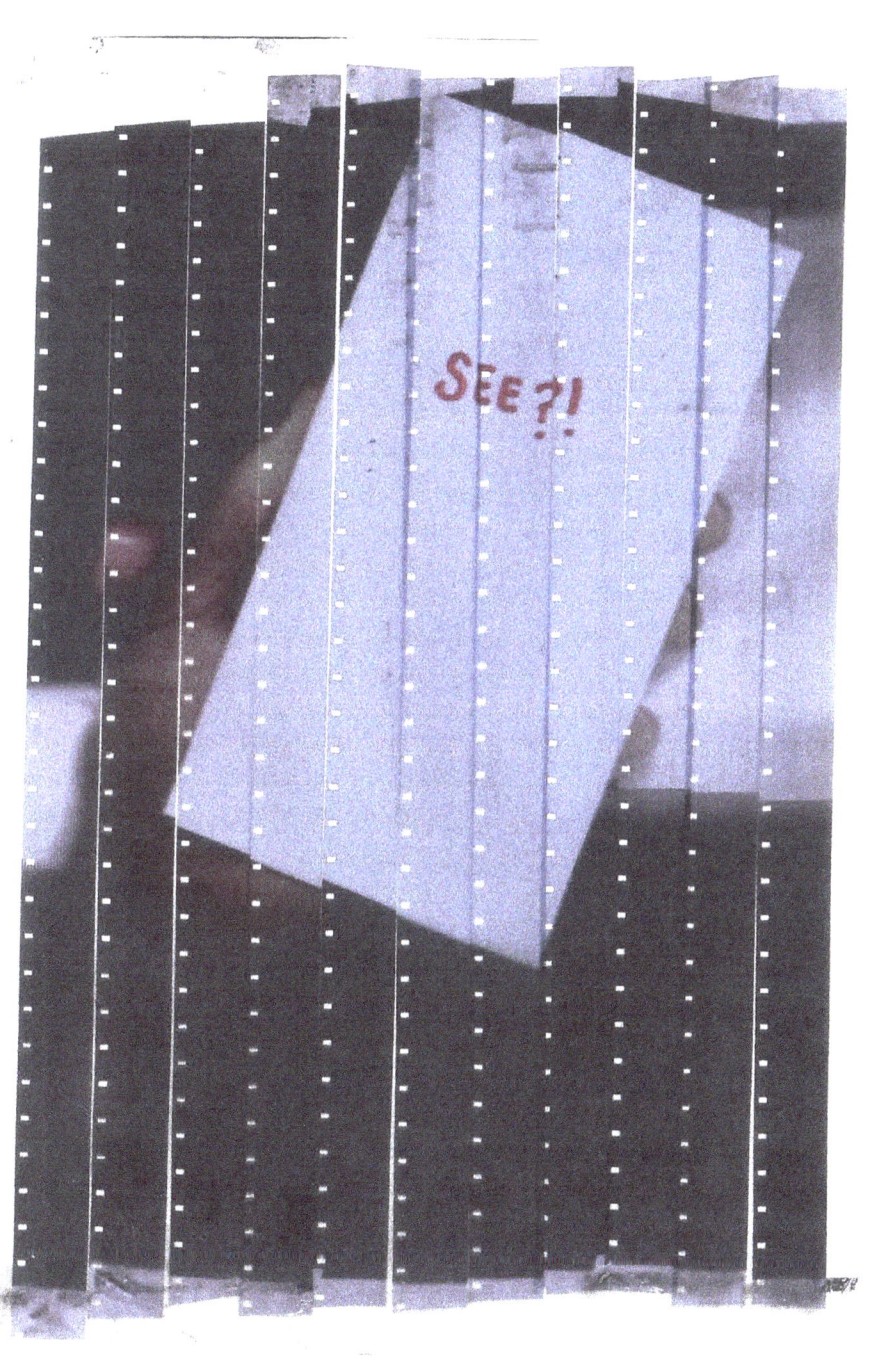

HUMAN &&&&&&&& COMPUTER

ERROR

A Celebration!
There are so many variables that it's bound to happen, and it's the best!

Often the mis-prints and jams look pretty neat — and even end up informing the final piece.

NEWSREAL

Reticulation

as a tool for queering the body: compulsory heterosexuality

Authors note: Compulsory heterosexuality is a term coined by Adrienne Rich. Since writing this piece and making the film compulsory heterosexuality, it has come to my attention that Adrienne Rich was associated with trans exclusionary radical feminism, which regards trans folks violently. As the author of this essay I would like to acknowledge the error of holding Rich in such high regard. I believer that trans women are women, trans men are men, and non-binary people don't owe anyone androgyny. Trans rights are human rights.

How can we queer a body in solitude?

Throughout mainstream media, a body with a vagina in pleasure is coopted by white cis heteropatriarchy for its own desires, and the desires of the person to which the body belongs goes by the wayside.

So how, as an independent filmmaker who happens to own a vagina, can I present my body in pleasure and disrupt the desires of heterosexual men to coopt my body for their own pleasure? How can I take back control of my body in pleasure? As a survivor of sexual assault and a queer person, this desire to take back my body is integral to my own self-actualization. Compulsory heterosexuality (2020)[1] employs strategies of erotic self-portraiture and analog alchemy to reclaim a body that has been coopted from many angles. In her essay, Carolee Shneemann's Fuses as Erotic Self-Portraiture[2], Shana MacDonald outlines the three elements that delineate a film as an erotic self-portrait. Erotic self-portraits are marked with self-shot images, "the female [sic] body as a site of pleasure and desire–as something to be celebrated, not merely consumed", and hand-processing techniques. In my film, I employ hand-processing techniques not only to the end of creating an erotic self-portrait, but also to the end of queering the body that is presented.

I employed a technique called reticulation, which involves boiling the film with soda ash (also known as washing soda or sodium carbonate). I boiled a pot of water (an action I link with sexuality in my film *A Watched Cunt Never Cums*[3]) and add an amount of soda ash (the more you add, the faster and less controlled the reticulation becomes). I then placed my images (of my body in solo pleasure) into the pot and stir. After a time of continuous stirring and closely watching so as not to overdo it, I removed the film to see my results. After the film was hung to dry, I scanned it to digital so as to preserve the now very fragile film.

In the highly reticulated images, the emulsion has lifted and replaced itself in veils that abstract the imagery. In the less reticulated images, fractal-looking bubbles have appeared to create patterns within the image. In abstracting these images of my body in pleasure, I add the nuance of identity and sexuality. It is not allowed to be simple, easily understood. It takes a close look to see what is hidden, a queer, historically victimized body reclaiming itself for its own pleasure.

By Emily Van Loan

[1] https://vimeo.com/399480757/55f00c101e
[2] MacDonald, Shana. "Carolee Schneemann's Fuses as Erotic Self-Portraiture." Cineaction! 71, no. 71 (2007): 67-71.
[3] https://vimeo.com/369177929 Password: AWCNC

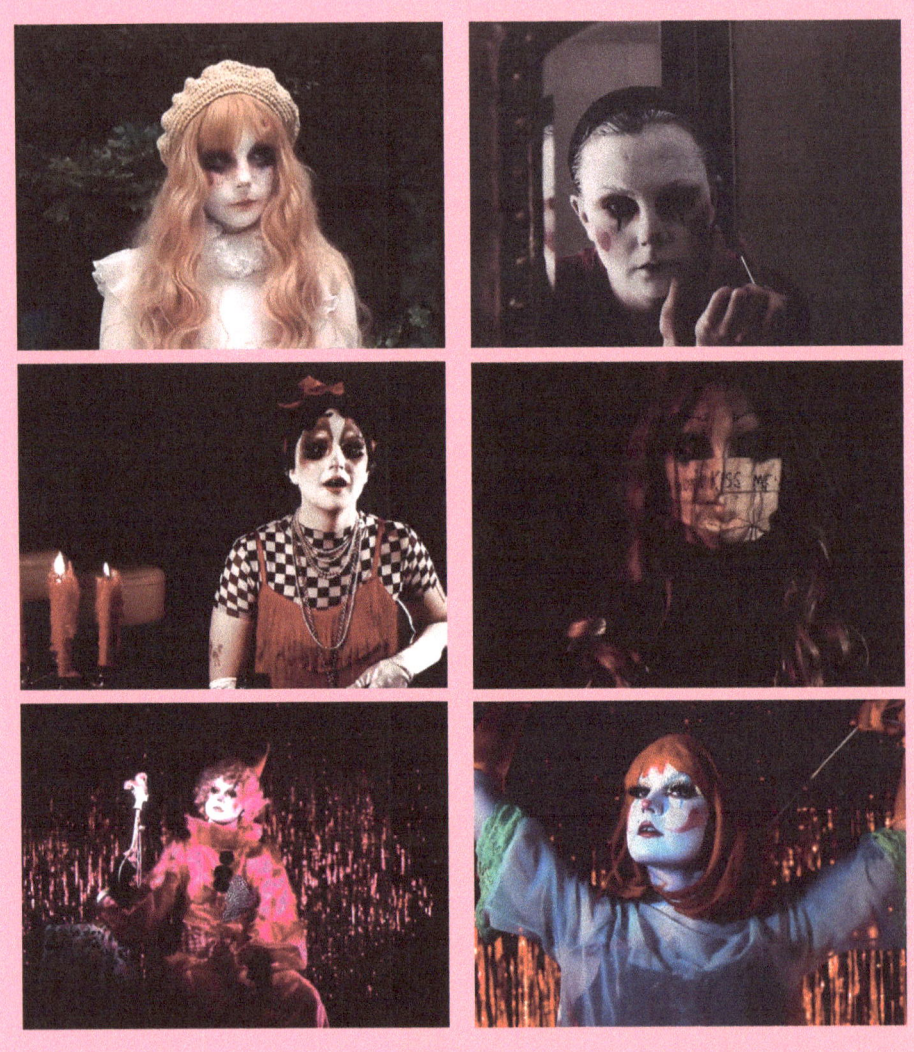

FOLLY SHANE DEDMAN

The Making of *Folly*

BACKGROUND — co-written by TK Smith and Shane Dedman

Folly is the third installment of the trilogy, ***PHYSICAL BODY OF WORK; a love letter to an evolving self***, which conceptually asks whether the loss of an archive is a rite of passage or a tragedy. As the title of the trilogy suggests, the personal archive acts, not only as a compilation of knowledge and artistic expression but as an embodiment of one's very identity, mirroring within it the pleasures and pains of the maker's sentient flesh. Collectively, the films document and analyze the ruin of Dedman's archive, created from 2004-2018.

The archive was lost to the waters of a basement flood, inciting within the artist an existential crisis. Without the physical evidence of who they were in the past, they were forced to confront who they are in the present. The films are an elegy, giving visual representation to the death and decay of the archive. Together they offer reverence for the ephemerality of thought, material, and life, ultimately resulting in the birth and rebirths of new and ever-evolving selves.

Written, directed, and starring Shane Dedman, *Folly* is a fantastical leap into the rabbit hole of personality distortion, presenting a departure into the psyche where the artist confronts memory as the final site of the lost archive. Dedman uses drag and the jester figure as tools to personify their various personality interferences as a trans-masculine non-binary survivor of PTSD and Borderline Personality Disorder. Known for both the jovial and the sinister, their foolery and wisdom, the jester reveals the most complex, contradictory, and controversial aspects of the self. Referencing the histories and methodologies of experimental 20th-century film, *Folly* is a tantalizing journey away from singular conceptions of the self toward the infinite.

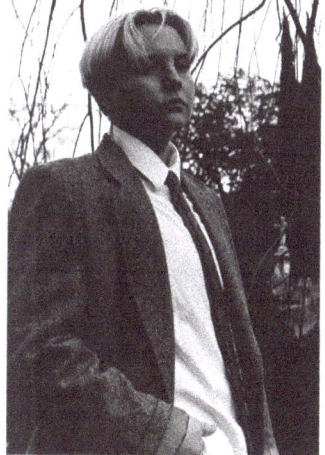

(Headshot by Jon Sanchiz)

REFLECTIONS FROM THE DIRECTOR — by Shane Dedman

The genesis of this work was a result of a year-long therapeutic artist residency with TAR Project, run by Orion Crook. The non-traditional residency offers free therapy for a year, a solo show, and a monthly meeting with a cohort of fellow artists where we discussed our creative hang-ups. It was the first time that I truly felt held as an artist and was receiving therapy from a fellow non-binary person.

It was a 5-day shoot during the hot summer of 2020, and my first time directing one of my films with a crew. Previously I had worked on music video shoots as 1st AC, as well as Producer, AD, and PA for other director's films, but my video work had always been made in solitude. I felt confident in my abilities because while on one of my previous sets, a green crew member remarked "I hope all sets are like this."

I knew my crew needed to be trans-inclusive and small enough to establish a safe production pod of containment during the pandemic. We needed to have mutual trust and commitment to each other's health, so I asked my friends involved in the long stint of the Summer 2020 protests.

While on set, we were able to feed our creative minds and muscles so that we might process our feelings in solidarity. It was a supportive collaborative process, given the sensitive content and our emotional states, and we tackled every issue as a small team.

Crew

Saige Rowe (Director of Photography) and I have known each other for years previous to this collaboration. We hung out after work at her house, kept each other in the loop with our various projects, and went on road trips together that I documented in my film *Anamnesis; from before solitude* (2019), in which I carried my camera around for a year to experiment with footage.

She saw my camera style develop in real-time, and we both showed work and participated in Camayuhs Gallery's Drunk Critique series, curated by Jordan Stubbs, only a few months before the outbreak of the pandemic. I've always been captivated by her experimentation with the surface of video. I knew I wanted to work with her not only because of her artistry but also because she is a dear friend and fellow jokester.

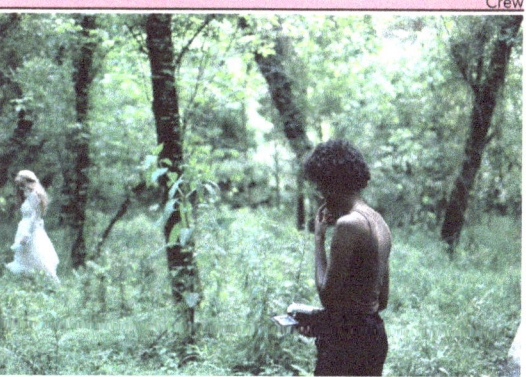

(Saige Rowe sets up the shot with the Panasonic Palmcorder.)

(Sydney Kosse, making sure I look my best.)

Sydney Kosse (Co-producer + Costume Designer) was the only member of the crew that had previously worked on a union set. They helped to quell any uncertainty and always have a solution. They are meticulous and talented at making garments and styling films and helped bring my vision fully to life.

While shooting on location at Blue Heron Nature Preserve, I fell in the mud in full costume, and without a beat, Syd howled with laughter, reminding me not to take myself too seriously, to laugh first at my mistakes before feeding the beast of self-criticism. We then had a short sojourn to their grandmother's house to use the washer, regroup, and eat some pizza before continuing the shoot.

A few months after we wrapped, we were sitting on their porch catching up, and they came out to me as non-binary, and I felt deeply honored to witness them. We continue to support each other's journeys with gender.

Spencer Maxwell (Key Grip and Electric) and I are alumni of Georgia State University's Photography program. He graduated a year after me, yet I was always very observant of his shy, eager nature and his expertise in lighting.

When I asked him to be a part of this project, he jumped at the chance and expressed that since graduation, he had felt creatively drained from the expectations and upkeep of post-graduation adulthood.

He had all of the knowledge and enthusiasm to uplift my vision. While working on the color correction in post-production, we had endless conversations about our dreams. I always look forward to catching up with him because of his honesty and consideration of others.

(Key Grip & Electric, Spencer Maxwell, sits in for a test shot.)

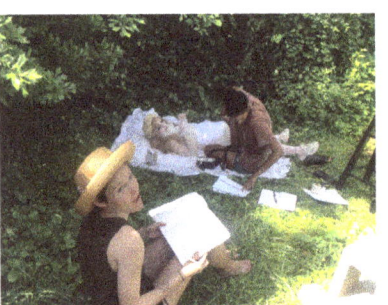

(PA, Leanna Usher, being a goof on set.)

Leanna Usher (PA) was my roommate at the time of production and is a member of my chosen family. She's acted and been behind the scenes for music videos as well as touring musical acts. She flawlessly executed her role and made everyone feel cared for, making sure we were hydrated, fed, and assisted in whatever task needed.

It meant a lot to have her support on this project as someone that I look to for mutual advocacy and advice. The way that she jokes and spreads joy was a great benefit to helping me be playful and to do my best in my performances.

Locations

We shot at three locations, including my backyard, Blue Heron Nature Preserve, and in the former DIY space, Mammal Gallery Food Court. It felt surreal to shoot in Mammal Gallery because when I secured location permission, I was told that the venue would be closing inevitably due to the pandemic. Mammal Gallery was a staple and home for the DIY underground in Atlanta. I had my first solo show with them, performed with since deceased friends, hosted poetry workshops and readings, as well as danced endless nights away. I had spent New Years 2020 there, and while shooting in July 2020, I got the chance to memorialize their legacy on film and say a little bittersweet goodbye.

Premiere

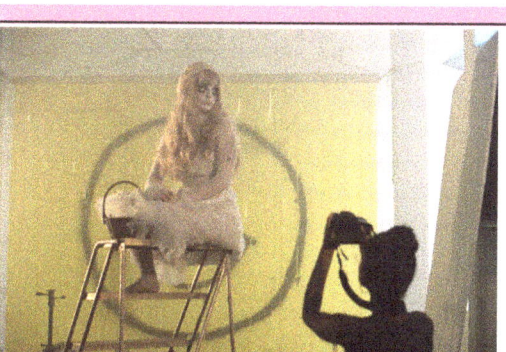

(On location at Mammal Gallery Food Court in Atlanta, GA.)

In mid-2020, the trilogy was due to premiere at a local gallery in a solo show in conjunction with the ending of my residency with the TAR Project, but as COVID-19 spiked, plans were delayed.

When I met curator and cultural historian, TK Smith, in 2018, he was completing the inaugural Tina Dunkley Fellowship at the Clark Atlanta University Art Museum. At the time I was working as an art handler with Bonsai Fine Arts and happened to deliver a sculpture to Clark's Museum one sunny afternoon, prompting our introductions.

We kept up with each other after meeting and made loose plans to collaborate in the future. When he was given the chance to co-curate the 2021 Atlanta Biennial, with Dr. Jordan Amirkhani, I was ecstatic to be invited and involved in the exhibition, **Virtual Remains**, to premiere at Atlanta Contemporary.

ATLANTA CONTEMPORARY

VIRTUAL REMAINS
Curated by TK Smith
featuring Danielle Deadwyler, Shane Dedman, Adam Forrester and Artemus Jenkins

February 20, 2021 – August 1, 2021

"***Virtual Remains*** bridges these marginal and unconventional spaces to examine how contemporary artists are experimenting with technology to contend with flawed and fragmented archives. Each artist tends to their own interdisciplinary repositories of ephemera —documents, film, and audio— that they then redact, manipulate, and fabricate to uncover the truths that lack material evidence. The works presented in *Virtual Remains* are malleable and evolving accumulations of the artists' continuous labor, introspection, research, and engagement with their communities. Exacerbating the tensions between memory and history, truth and myth, the exhibition privileges the experiential to simulate what feels most true, instead of literal truths. Together, the artists engage in a non-linear, fragmented, and inconclusive conversation on absence, memory, and the fidelity of technology."

— TK Smith, co-curator of the 2021 Atlanta Biennial, *Virtual Remains*

Afterthoughts

I edited the trilogy from the early fall of 2020 into 2021 with the deadline of the Biennial premiering in mid-February. I stared at my physical form for months and a slow-burning acceptance came to a head. I finally felt ready to investigate medical transitioning after archiving my born-body through the art of drag and clown performance.

As I completed the various stages of post-production, I held zoom screenings with my chosen family in which we were able to catch up, lightheartedly, with the comedic catharsis of the content. I'm very critical of comedy because of its history of oppression, and I hope I've put an enchanting new spin on physical comedy and dark humor with this work. My support system has continued to assure me that the work was worth the two years I spent cultivating it, and I am eternally grateful for their reflections, advocacy, and affirmations. I hope **Folly** incites joy in those that sit with it and provides further opportunity for every individual involved in the process to share their voices.

While completing the work for the exhibition, I circled back with Orion, who wrote me the required letters to start HRT and to get top surgery. As I now have accepted, this film will forever immortalize my pre-transition physical form and has given me the space to both mourn the loss of an archive of writing as well as celebrate my continuous evolution and transformation through the lens of ………………………………….Trans Drag Cinema~~~~~~~~~~~~~~~~~~~~~~~~~~~~~~~~~~~~~~
visit www.shanededman.com to learn more.

Interview with Shane Dedman

How did you select the music for this piece?

I consulted with my sound-based friend Chris Hunt while Folly was in post-production. He was then working for Tyler Perry Studios as a Production Mixer, but is a talented Sound Designer and musician with many self-directed projects under his belt. I initially was going to pull from my personal sound archive and record the foley for Folly (lol) myself with my field recorder, but Chris mentioned a really amazing Creative Commons website called freesound.org. He allowed me to ask questions about workflow efficiency and encouraged me a lot since the sound design was the most daunting part of the project. I was preview screening and editing the film without sound when it was initially cut.

One of the major influences for this work is the Czech film Daisies (1966), directed by Věra Chytilová, and when I was in the sound collection phase, I came across a lot of results tagged 'Czech' 'Cz' or 'panska'. I used a lot of those clips because there was a certain clarity and front-'n-center-ness about the sound quality. I also happened to watch the surrealist Czech film Alice (1988) while in post-production and was really inspired by the avant-garde sound design.

The rest of the open-source sounds were a result of me searching gay, queer, trans, etc. (a common cyber-queer practice; searching for buzzy type words to find each other's content across platforms). The "gay club music" that plays during Peitho's striptease was selected because of the repeating line "DON'T STOP" which, for me, alludes to consent-informed play as well as existing as a mantra for queer resilience. I also searched for clown, jester, circus etc. All of the risers, sweeps, rolls, transitions, atmospherics, etc. are from freesound. I used a lot of multi-layers when I was mixing in order to create unique sounds from the combination of these found sounds. All of the bodily sounds of the characters and the invisible audience were found as well.

Maurice Ravel is my favorite composer and when I searched him in freesound, this gorgeous take by pianist Vladimir Oppenheim popped up. Ondine is the first movement of the suite titled Gaspard de la Nuit (or treasurer of the night), which was inspired by three poems by Aloysius Bertrand.

"Ondine is a tale of the water nymph Undine singing to seduce the observer into visiting her kingdom deep at the bottom of a lake... Of the work, Ravel himself said: 'Gaspard has been a devil in coming, but that is only logical since it was he who is the author of the poems. My ambition is to say with notes what a poet expresses with words.' [1]

As a kid, I grew up in Florida and would go to the beach with my dad a lot. Therefore, I'm fascinated by the history of our knowledge of water worlds. I'm inspired by pirates, the mythic siren, the nymph, and the mermaid that lures observers into the abyss of sacred femininity. According to the article "The incredible true history of gay pirates and their strangely modern world" on Gay Star News, "'They [pirates] never engaged in combat without embracing each other.'" [2] I'm inspired by imagining the queer occupation of space and interested in entertaining thoughts of spatial queer separatism and escapism. When I read about I. Ondine, there was much talk about the solo piano's imitation of waterfalls. I knew it fit perfectly with the closing scene (no spoilers hehe).

Once all the sounds were selected, I organized the options into folders, dropped them into Lightworks, and began experimenting with workflow. The dialog was all dubbed since none of the original audio was used from in-camera. As a vocalist, I really enjoyed playing around with the textures of the character's voices. There are parts that I sourced directly from my personal field recording archive that features sounds from various environments such as the wind chimes on my street, breathing in my bedroom, the cliffside of Tenerife, etc. that I chopped and screwed for Artemis' retreat in the final act. The credits track Internal Storage is a song produced by my friend Nick Shea that I wrote lyrics for and sang on which'll be released for streaming very soon.

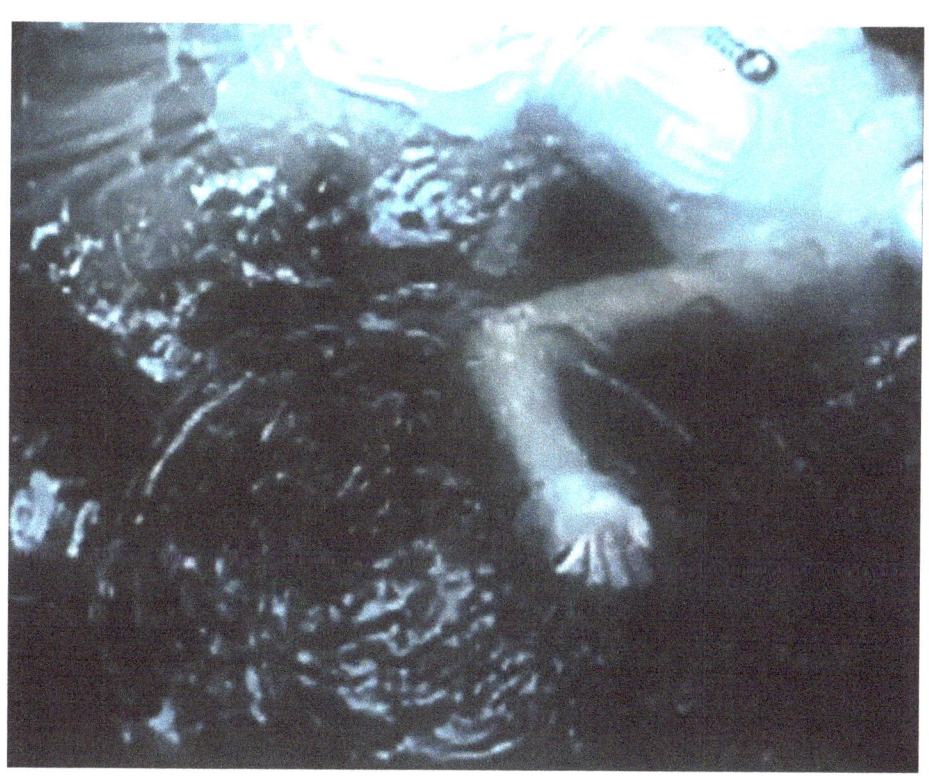

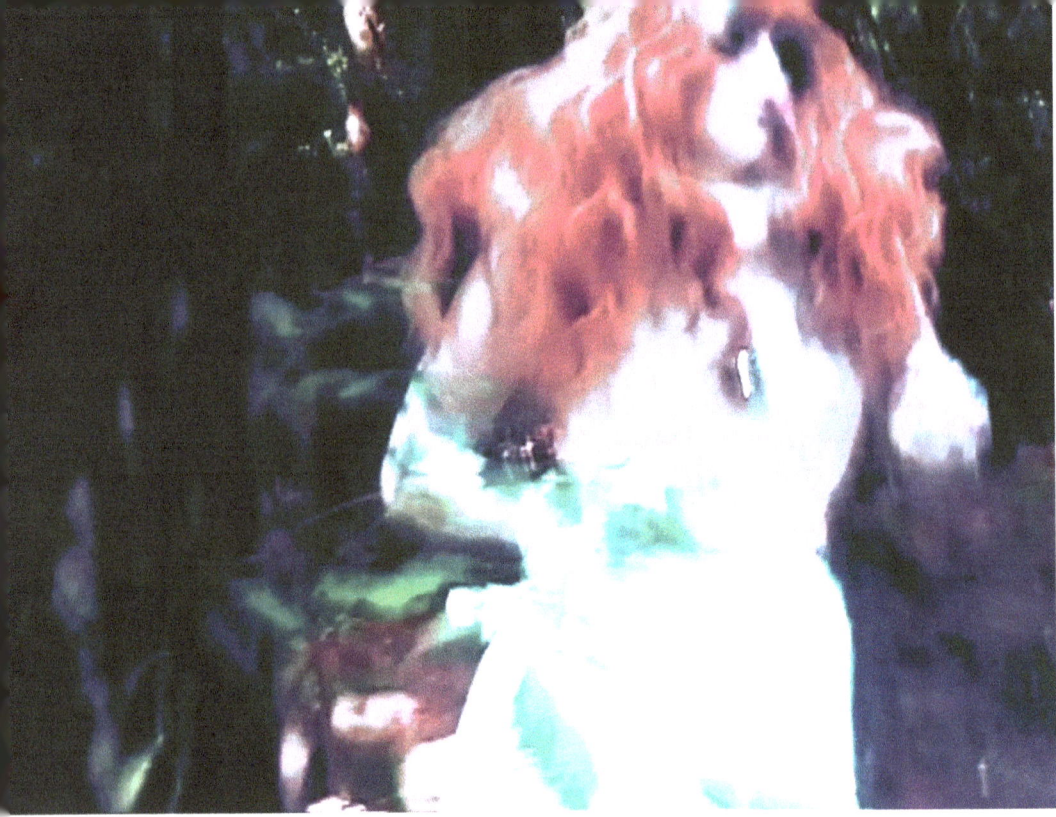

What part does play have in your piece?

Play and experimentation holds a large part in my process. As a director and producer, I strongly believe in providing the container of structure in order to allow the child-self (imagination) to emerge and maintain grounded-ness. I'm a strategic planner, yet I know there's always going to be a need to radically accept margin of error and developments that will want to be explored in further depth in the moment. I account for and embrace the unexpected. The Structuralist filmmaker Peter Kubelka refers to the film as a metaphorical meal and filmmaking is an act of cooking in which the preparation of the ingredients and incorporation together make up something larger than what they are individually. His films "emanate from the materials and basic elements of the medium, emphasizing both the handmade aspects of film and its capacities for (philosophical) playfulness." [4]

I'm also immensely dedicated to interdisciplinary practices and study; film as poetry or poetry as film or presentation of a performance document, etc. The magic of cinema is the record of existence. I'm reminded of the moment in Waking Life that Andre Bazin's ontology is referenced: "...what film is actually capturing is, like, God incarnate, creating... and God is you and God is me... so film is like a record of [...] the face of God... the ever-changing face of God." [3] While I'm not into capital G, GOD, I've come to a place of 'a grain of salt' mentality with my upbringing within

a Southern Baptist cult that allows me to translate the intention of Christianity into my own understanding of spiritual existence. If I refer to a singular higher being in any regard, I'd call them Goddess if nothing else. The verb queering is the ultimate legacy of subversion that I strive to enact and contribute to canonically.

How did you select a color palette for this series?

Having been trained in Photography, I have a keen eye for minute shifts from pixel to pixel and possess the knowledge of aesthetics throughout photo history. Spencer Maxwell, a friend from photo school, did the color correction and I did the grading. I used the surface of the moving image much like painting celluloid and was inspired after contributing to the Death Valley Girls music video for Hold My Hand that Analog Cookbook invited me to paint celluloid for. I was also inspired by the experimentation of color blocking in Daisies. When Daisies was initially released, it was seen as whimsical and blasphemous because of its anarchic color play and content. The abrupt switches of colors, the sequencing, and the rhythm electrified me.

Within *Folly*, I decided to give each character their own treatment that would develop over the course of the short. All of the mini DV footage was shot with a rainbow photo filter strapped down with artist tape because it was too large for the lens. When I use camera filters, I like to apply a bit of glitter gel for added texture. I downloaded a library of open-source 3D LUTs that allowed me to layer and experiment with the order of layering various color gradings. In post-production, I spent a lot of time fidgeting and dragging through the values of each component of the software until it felt like my eyes were going to bleed.

How do textures influence *Folly*?

Tremendously. I like to feel my films as if they were abrading my flesh. The more sensory transference, the better and more honest to the phenomenological. I was one of the last classes trained in darkroom photography at my college alma mater. I think I'll always go back to the grain of celluloid as THE epitome. Digital has only recently caught up to full-frame sensors and the buy-in rate to start-up in digital photography is outrageous. Analog is for the people.

How did costuming play a role in this piece?

I needed each character to contrast (since they're all played by me), yet somehow relate aesthetically with the visual language of queerness, camp, drag, and the jester figure. Each character vaguely has their own age, behavioral language, and intrepid gender performance, but they are all a reflection of the multitudes of self. For the costumes for the film, I was really inspired by the costuming in the self-portraits of Claude Cahun and the Dadaists of the 1920s. I'm also endlessly inspired by Cindy Sherman.

It was really important for me to imbue the characters with signifiers of classic

archetypes, but to queer them with disidentification. I created a look book with a description of each character, what their names mean (Greek Mythology) and a collage of screenshots from google images of costume elements to incorporate. When Sydney Kosse (Costume Designer) and I came together for a costume fitting, we accessed the options that we already had and layered a lot to create the final costumes. Sydney designed and sewed the pink transparent garment that Ate wears. I then scoured eBay for things we needed to pick up to complete the looks. The most difficult part of the production was doing multiple takes of the striptease and having to re-corset while we were on location at the Mammal Gallery Food Court warehouse in the middle of a hot Georgia summer. Ooooof. I also fell in mud while in the all-white costume on location at Blue Heron Nature Preserve.

What filmmakers are you most inspired by?

I already mentioned Věra Chytilová and Peter Kubelka. I'm also inspired by the video art of Legacy Russell, Dara Friedman, Carolee Schneemann, Sara Hornbacher, and Nelson Sullivan. Other films that inspired me for Folly were Looking for Langston (1989) by Isaac Julien, Tarnation (2003) by Jonathan Caouette, Fallen Angels (1995) by Wong Kar-wai, Pink Narcissus (1971) by James Bidgood, Meshes of the Afternoon (1943) by Maya Deren, and He Who Gets Slapped (1924) by Victor Sjöström. I enjoy horror (especially Dario Argento's work), future fantasy, and femme fatale revenge flicks. I'm looking forward to Olivia Wilde's directing career after interviewing her about Booksmart (2019). I find a significant amount of my inspiration from film theory because it lights my brain on fire.

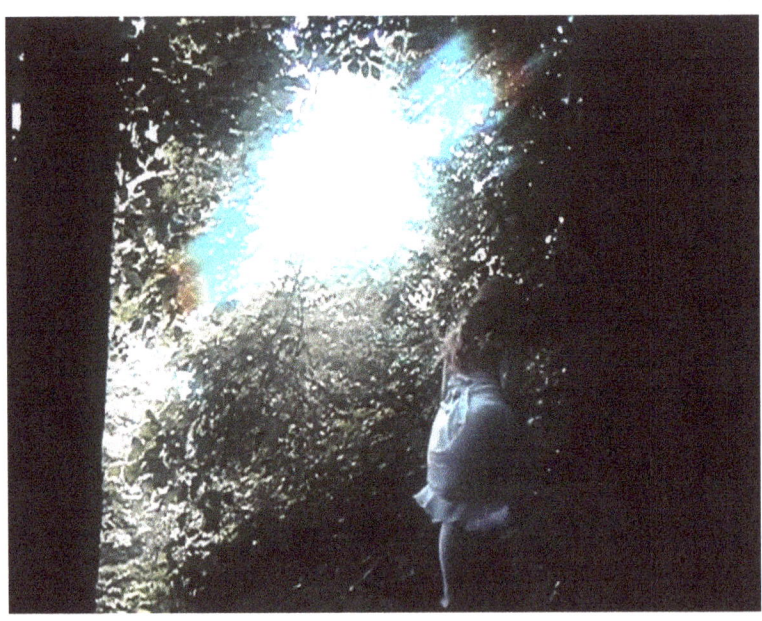

RECIPE
— made with love —

Shane's Mini DV tips

* Take it everywhere. Life is precious, and we all need someone to cheer for us from behind the camera.

* Make an archive of your most affirming moments.

* Zoom in a lot (the quality degradation is SOOO beautiful).

* Do not update iMovie past version 9.0.9 because your camera capture will not work for minDV.

* You will need these for digital conversion: FireWire 400 to 800 adapter, FireWire (1394) 800 to 400 9 to 6 pin cable, and Thunderbolt to FireWire adapter.

* Remember that tape is material. Each tape I have has its own distortions and visual warble. Embrace the glitch!

SIDE EFFECTS MAY INCLUDE:

CLAIRE

A short documentary shot on super 8 film that explores intimate narratives detailing side effects experienced while taking various types of hormonal birth control. The piece is told from the perspective of 12 young voices, accompanied visually by super 8 film that has been manipulated using bleach, paint, and etching.

What were some of the tactile methods used in this piece?

This project was my first time messing around with physically altering film. I didn't really have any equipment so I taped up 50 feet of processed film to the sliding glass doors of my bedroom and waited for the sun to hit the right angle and light them up. I used acrylic paint, bleach, an Exacto knife, nail polish, and a sharpie to alter the frames. I think I lost part of my security deposit from paint residue on the glass.

How did you select the color palette for this film?

The colors and fonts were inspired by a very specific genre of educational videos I watched on roll out TVs in grade school health class. Birth control and sex education hasn't evolved radically since then so the muted colors and mildly outdated fonts felt right.

How did you choose people to interview for the voice-over in this piece? Why do you find this subject matter particularly important?

The idea for the film started from conversations I was having with close friends early in college. I'd had intensely negative experiences with the pill and it took me a long time to realize it was a shared thing. I put a call out initially on social media and from there it became a word of mouth chain. I'd interview someone and they'd tell me their partner or cousin or house mate had a similar experience. Everything was recorded on cell phones (mostly in dorm rooms and my car) with really loose guiding questions. I was interested in the idea of the sound bites feeling like unpolished voicemails. I think avoiding the video element made it easier for subjects to open up.

How did you begin painting on your film stock?

Rick Prelinger taught this found footage workshop at UC Santa Cruz that, although I didn't actually enroll in, I heard about through some friends. They told me they got to cut up and draw on film and project it back. I was immediately interested (and jealous). I think I convinced one of them to bring me to his office hours. He graciously agreed to scan a roll if I wanted to give it a shot. I didn't really know how it'd turn out so I tried a little bit of everything.

What part does symbolism play in your film?

The testimonies are all memories so the medium felt symbolic of that sort of hazy home movie-esque dream. I knew from the beginning that I didn't want to film

Over 100 million people worldwide currently take hormonal birth control pills

*according to a 2013 study in Best Practice & Research Clinical Endocrinology & Metabolism.

the interviews but also wasn't big on reenactments, so needed to find something else to fill the visual space. Some of the imagery feels literal (especially the arcade and amusement park footage), but having the freedom to use paint and color for the more emotional lines seemed fitting. I tried to keep some level of visual abstraction so that the voices felt like the central focus.

How much research did you put into this production?

I spent a few months in the research and initial interview stage. I came at it from two sort of contrasting angles. On one side there were these really intimate and shocking conversations I was having and on the other there was this real lack of published data supporting the subject (especially coming out of the US). It's definitely not a research documentary and I went in with a really clear position and emotional investment. I know I can find hundreds of people who have had totally fine experiences with birth control, but I didn't necessarily see a point in highlighting those experiences or studies. It's biased, but I think there's value in amplifying individual voices if there's a genuine lack of data and evolution on a topic.

How did you choose the titles for the chapters the film is broken up into?

Similarly to the color palette I think there was a lot of inspiration drawn from those sex ed style educational videos. They felt so calculated and organized. Taking a similar approach to such a broad and complicated subject felt like an act of control. I think I also went into my interviews without much structure. I was really passionate about so many aspects of the issue that in the end I

just needed to give myself some categories to clip audio for. The amount of film I could afford to process really dictated the length and structure. There were so many sound bites I wish I could have shared.

How much luck have you had reaching audiences with this piece?

I made it in an academic setting (during my last year at UC Santa Cruz), so it was screened a few times within that community. I've had a lot of people my age tell me they're having similar conversations with their peers and express excitement about the documentation of it! But it hasn't really circulated outside of this younger Santa Cruz/San Francisco scene.

Would you consider this film an educational documentary?

I hope it's educational but I'm not sure if I'd consider it a part of that genre. It's fairly one sided and comes from a place of genuine frustration. From what I've experienced at screenings this information isn't new for lots of viewers. Nearly everyone I've watched it with has been like, "That sounds like what happened to so and so," or more often, "Oh my god, me too!" It feels like a topic that exists one layer under casual small talk but is really easy to relate to once someone brings it to the table. Try it at your next dinner party.
Anything else to add?
This is a project that I'm working to expand into a longer and more Inclusive piece! If anyone reading is interested in sharing an experience please reach out -

b.claire.d@gmail.com or @clairedonohue on instagram.

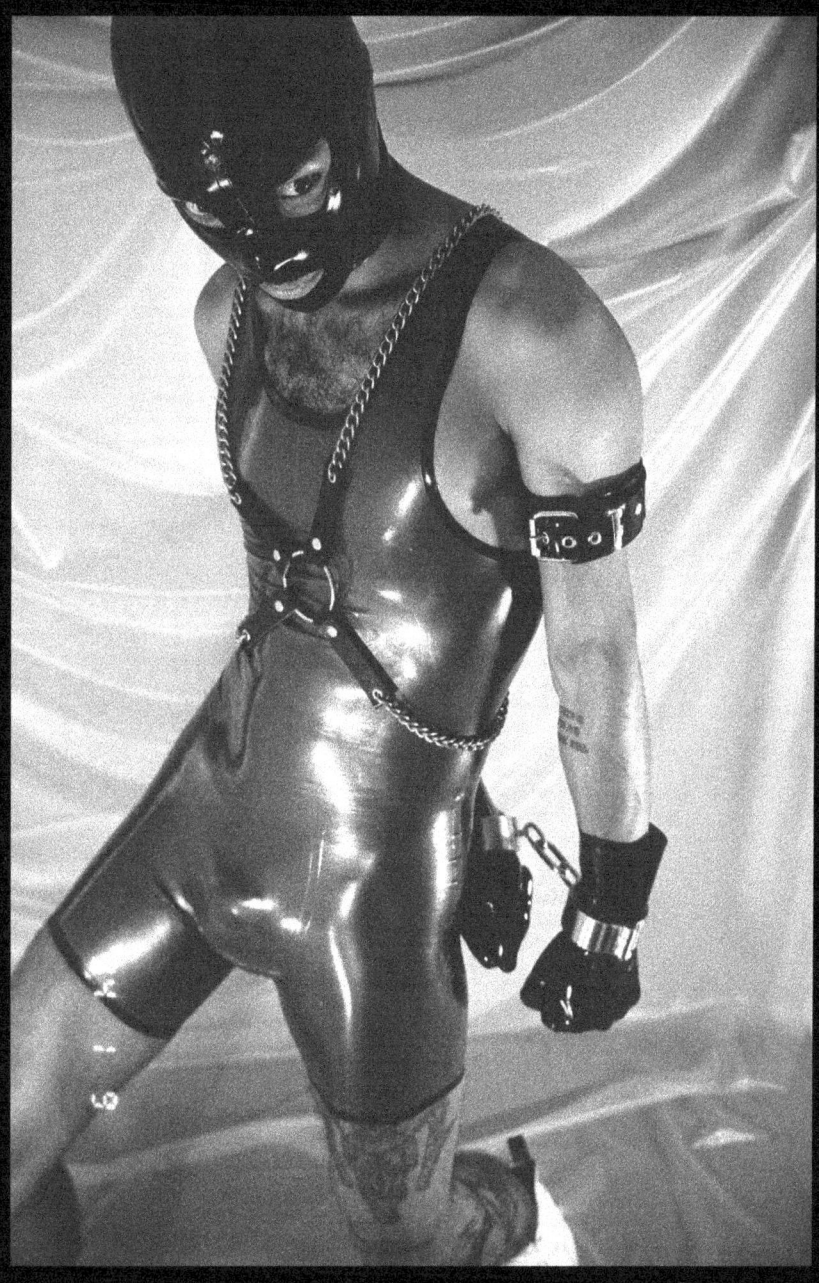

Kinky Paradise is a series under construction featuring portraits of members of the LGBTQIA + community, some of them are sex workers. The intention is to make visible their aesthetics, their looks, their thoughts and generate a dialogue with different audiences so that their identity is not discriminated against and the change of some thought allows a free society for new generations.

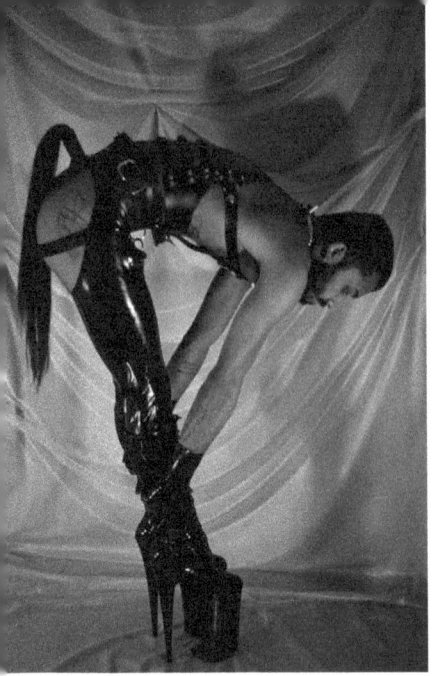

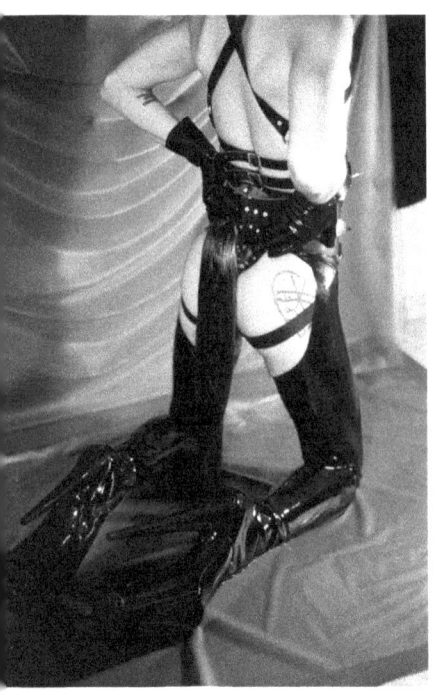

What was the reasoning behind using black and white film?

I used *Kentmere* film to capture the shine of the latex and different accessories of the cat suit, the mask, chains and gloves. I wanted to create a timeless set inspired by the 70's rubber and sex magazines.

How do you define "experimental" in the term experimental photography?

For me is an exciting game, a lovely error with multiple possibilities to make unique photography. There exist different techniques, and the film only has one chance to develop, but of this, you can play with the temperatures, times, and exposures. You can mix substances to paint the film with rare colors. It's always a surprise.

Who are some artists that you rely on for inspiration?

I'm in love with photographers like Araki, Daido Moriyama, and Debora Turbeville. I share with them the erotism and the idea of photography as a sentimental journey. In terms of techniques and image treatment, I like the work of Julian Klincewics and Lea Colombo.

What's your favorite mistake you've ever made using film?

Maybe when I used high temperatures during the process of development. The colors changed creating a surreal landscape.

How much is trial and error part of your artistic process?

I'll start by saying that I appreciate the error. It mostly depends on the experimental techniques I use such as film soup, double exposures, and what happens during development and digitalization.

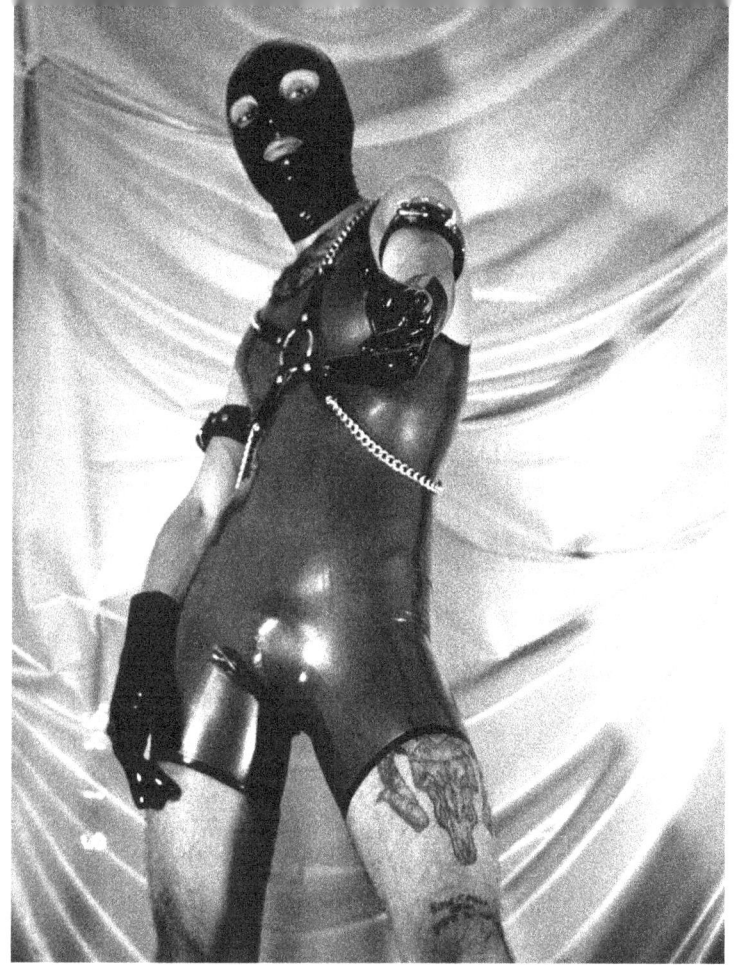

How do you choose subjects to work with in front of the camera? What are some tips you would give to someone who is just starting out working with film?

In my work I ignore stereotypes. What really attracts me to people are their unusual features, who in general I find spontaneously. To me photography is a matter of feeling. It is okay to start with a point and shoot camera to identify what catches your eye and go ahead and experiment.

What camera do you rely on the most to shoot film on?

My first camera was an Olympus Om10. It is easy to use. I like light cameras and luminous optics. For its necessary functions at this moment I have a Nikon Fe2, which is more complete and professional.

How do you develop your film?

For black and white films I use Kodak developer and for color films I use chemical at 38 °C, then I scan the negatives with an Epson scanner.

Do you have a special place you go to or are you developing it on your own at home?

I'm part of an audiovisual project named isla, we develop in our home laboratory.

Coversations

THE MATTERS OF BLACK SKIN: A COMPREHENSIVE CONVERSATION WITH FREDERICK TAYLOR

Black lives matter. Black is beautiful. Important phrases to say out loud, but filmmakers in particular need to educate themselves on ways in which they can show these statements on the screen. So, how does a cinematographer capture Black skin on film? If you have ever taken photographs with subjects of contrasting skin tones, especially on film, you understand that ignoring the Black person in the room will only result in images where the white people are too white, and the Black people are left in shadows. In order to do the opposite--to pay attention to the Black skin tones in the room--one thing's got to happen: you have to suck up your pride, your shame, your need to be right, and your desire to be lazy or fast. After you've done some self development, you should be ready to ask an expert. Unfortunately, not all of us are connected to filmmakers who have successfully captured Black skin on analog film. Fortunately, you have Analog Cookbook in your hands, and we've reached out and spoken with an expert for you.

Frederick Taylor is an award-winning and critically acclaimed cinematographer and documentarian based in Atlanta, Georgia. He cut his teeth on analog film when he attended Temple University's undergraduate film program and continued his film education at Georgia State University. Taylor is the founder of Tomorrow Pictures, where he creates content for television, corporate clients and the interwebs. He's the king of passion projects and has traveled around the world to film and screen his work. His recent credits include, but are not limited to: Counter Histories: Rock Hill, Transmission.Love, and America_Asian.

BY: B. SONENREICH

Frederick Taylor: So the audience for this is people of color that shoot-- and people that aspire to shoot--people of color in a more dignified manner?

AC: Yes.

FT: So not like the old Hollywood movies, where you'd see like Clark Gable and Katherine Hepburn standing there at a cocktail party and then Mantan Moreland walks into the scene and it looks like a cut out of a black construction paper with two white eyeballs and white teeth--literally glued on it? (Laughs)

AC: This is what we want to avoid!

FT: Well this is the bottom! We'll start at the bottom and then work our way to the top. But the bottom is pretty much anything shot of a Black person between 1920 to about 1960. After that, there was an independent Black film scene. '55 is the AD-BC for Black people. Everything happened in 1955. It changed so much for Black people. It's kind of like Rosa Parks, Martin Luther King, Jr. is a Christ, and Rosa Parks is sort of the Mary Magdalen, and 47 is Jackie Robinson-- that's kind of your John the Baptiste. There was some level of discussion or consciousness that Black people believed they exist, and that is what is essential and is at the top of the list of filming Black people. You have to decide in your mind, do they exist? And then what is existence to you? It's more than just your physical embodiment. It's your characteristics. Essentially it's your aura. This is what we're filming, constantly as a cinematographer, of any living creature. A flower has an aura. All human beings have an aura and you have to find your way into that particular aura. If you are not predisposed to thinking that Black people aren't people and they don't have auras, then it's going to be very difficult for you to photograph it, and these are things that you have to come to terms with for yourself.

It's the same when we look at a white woman, and we go, "Oh she's so pretty." It's automatic, you know? Think about when you're scrolling through Instagram and you run across Charlize Theron's page. "Oh, she's so pretty." Cameron Diaz. "She's so pretty." And then you hit Lupita Nyong'o. You have to evaluate whether she is or not. You have to look deeper. You have to decide for yourself. You start looking at other physical characteristics. What are her features, the proportions of things? Lips, nose, eyes. There is a perception that people of African descent have broader features, versus more "subtle" or "softer" features. The Africans that have a tendency for more "softer" features have some history behind them that there were some people in their family that weren't specifically African. But then you examine it deeper. I do this all the time, especially with my friends that are Mediterranean and things like that, or North African and Jewish. I play a game with them. I show them the African that's inside of them, just by changing color temperatures, I can make you look more African. I can make you look more European. They always laugh and they think it's funny, because it is. You make select choices as a cinematographer, as far as how you want to tell the story.

AC: So you're saying that the first step is breaking our normal conventions of beauty?

FT: It's so weird that we have to have this conversation in 2021 of breaking the normal

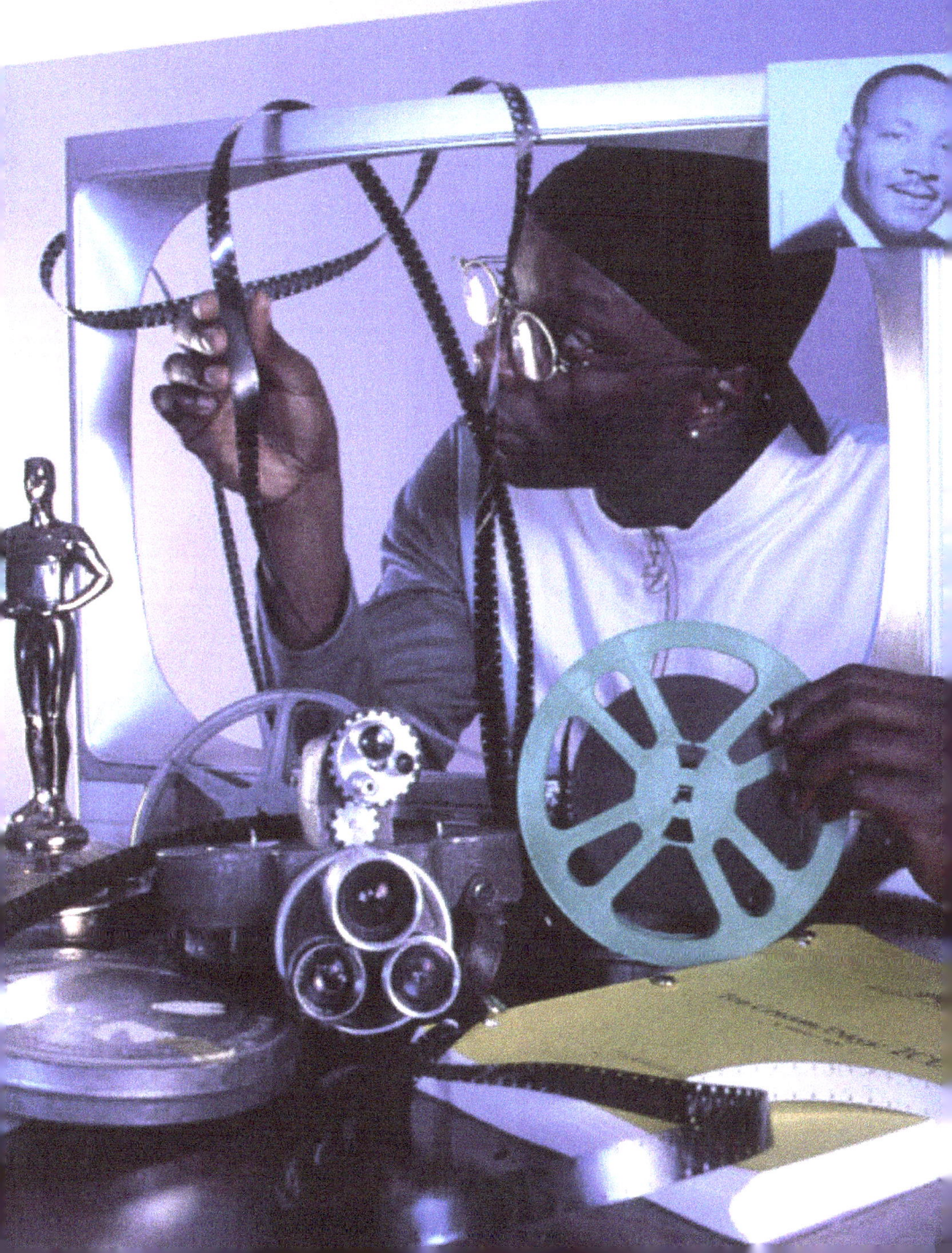

conventions of beauty, and that's the first thing you have to do as a cinematographer that says, "I'm gonna be able to film people of color, specifically Black people." You must decide on the scale of beauty where you fall, 10 being you think all people are beautiful, 1 being I only think blonde hair, blue-eyed white people are pretty. And there are people that think that they live in that space.

Am I missing something here by really being interested in photographing Black people in a dignified way? The answer is no. If I'm an artist and I think about things from a surface standpoint - that the only thing that matters is how people look to me initially - in that first reaction, that scrolling down the Instagram--for me, Iman was a poster I hung in my room. That was my definition of beauty. Reactive beauty. I see it and I'm swept away from it. If you had to give me a bag of lights and I had to go light them, and I had to pick which one to light, I would pick Gal Gadot, not Scarlet Johansson, because the palette is limited.

AC: The palette is already there for Gal Gadot.

FT: The palette is there … Dignity is a color temperature. It does exist in the tangible universe. Dignity is not a falsehood that people would like to think that it is, or that it can be eliminated or kicked to the side. If that was the case, the legacies of Ghandi, Martin Luther King, Jr., Golda Meir, Maya Angelou, would fade away when they died. And in fact they grow and become even more luminous. Their auras become even greater and they become absorbed into other people and those people are able to radiate that same level of dignity. And then once again there you are setting the shot up, you're trying to find the dignity in this particular person, and a part of that is you have to decide where you're going to put this camera, what is the angle, because every time you change the angle the light changes. Do you keep the light where it is or do you move it a little more? Or now that we're over here looking at it from a different angle, is this the same color temperature?

AC: We approach the point where we're like, "OK, we agree that Black people are beautiful, and Black skin is beautiful, and I want to shoot Black skin. I don't want to be in my Wes Anderson movie anymore. I want to be in a world that has melanin." What's the best film stock to pick out?

FT: 5245. 200 speed ISO film stock. It will make a Black person look exquisite, I mean breathtaking. Stop the show.

AC: Brand?

FT: Kodak. I always felt that Fuji never reached that pinnacle. I always defaulted back to Kodak. 5200 series is 35mm. The equivalent 16mm is 7200.

AC: Is there a reason why Kodak always gets it right?

FT: They've been doing it the longest! Fuji has only gotten in the game since the mid 20th century. Kodak was there in the beginning. Eastman, Kodak, New Jersey. Thomas Edison. Blah, blah, blah. There's something to be said for being in the gestation period of something that's creative, or being in the

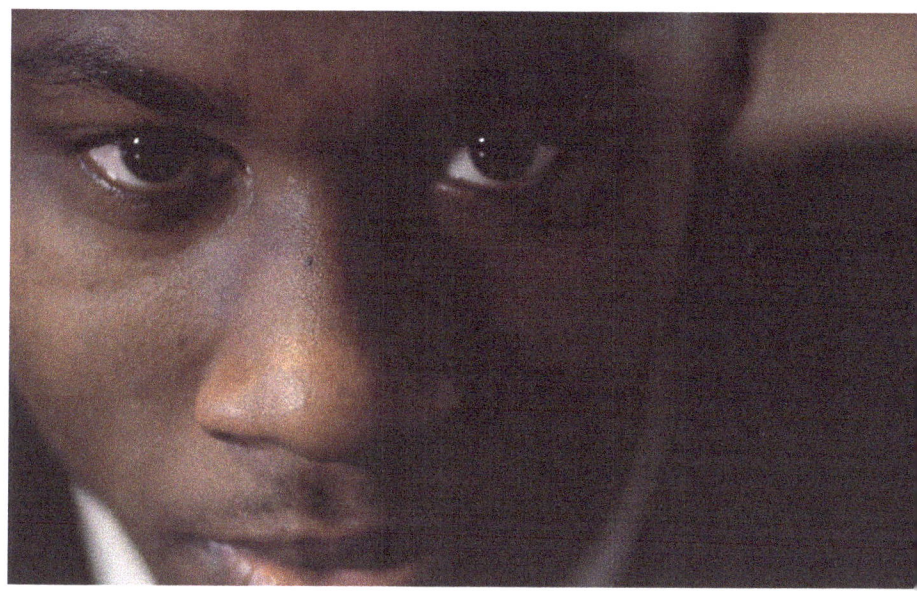

inventive stage of it, that you can continue to carry with you as you continue to develop versus you kind of come in the middle of it.

It's like when you watch Asian films, it's like Asian directors crush American directors when it comes to making things that are Asian-centric! Especially when you get into the martial arts films. Like we try to make martial arts films all the time; we're using that trope. Crouching Tiger, Hidden Dragon, we stole the wire thing from them! And I still don't see that type of film made through optical effects in America. Even when Neo was fighting half the dudes he's fighting, it's just CGI. Bruce Lee's whooping everybody's ass real time! That's all blocked action. That's all cinematography. It's the camera person deciding where the beauty is. And that's where we go into the next thing: it's also movement. It's motion. It's mise-en-scene. It's cinema verite. As a cinematographer, you have to know how to move that camera and different people in different ways. Different cultures move in different ways. Walking down the street with my Jewish friend is different from walking down the street with my Black friend. Just in rhythm and pacing and what they say, what they do and how they hold their body. All of that goes into where is this camera gonna go? How are we gonna light this?

AC: The first thing I'm thinking of is Steve McQueen's film Shame, and I have this one scene in my head where it's Michael Fassbender, a white man, and there's Nicole Beharie, a Black woman, and they're lit perfectly - but it's an interracial couple. And I'm wondering how you light interracial couples or scenes and make them both look great?

FT: It's a challenge. That was the joke I made in the beginning. No one knew what to do. Then, slowly, the political atmosphere of America in the 1960s and '70s challenged cinematography. So now you can't be a cinematographer the way you were. Imagine the cinematographers who shot Black people in the 30s, 40s, 50s, and now here they are shooting something in the 60s and 70s. Our sensibilities as a culture has changed. Black is beautiful. We had to

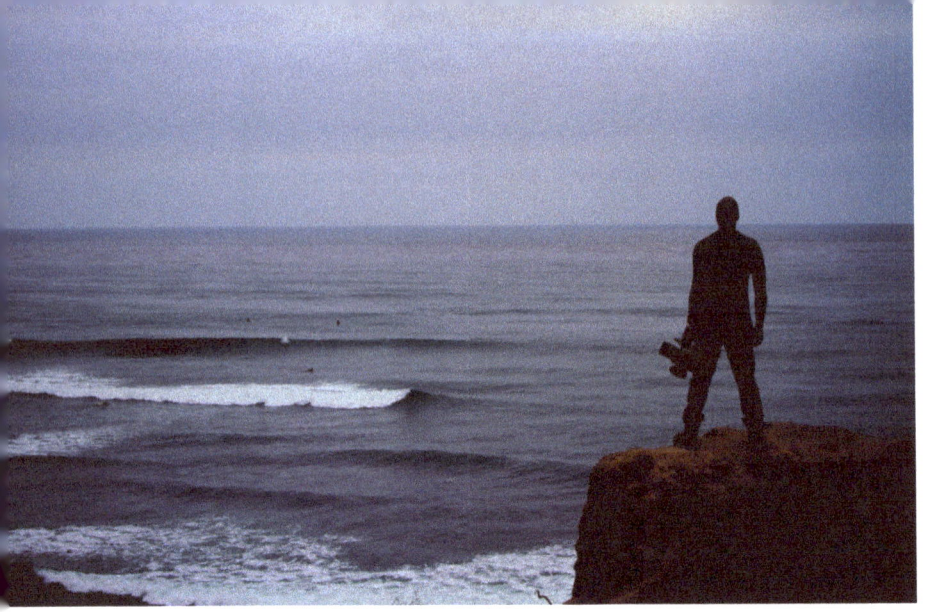

tell people that for people to know that. And there's still people that are uncomfortable with it! And they don't want to talk about it, they don't want to discuss it. Black Lives Matter of today is the Black is Beautiful of yesteryear.

AC: It's not just saying it, it's showing it at this point.

FT: Exactly! So the way that you make Black beautiful when you've got white people in the shot is that you start doing what I call splitting light. It's a split universe. Cameras can adjust. Cameras are a mechanised machine. The way that we adjust is in our conscious and subconscious mind, as far as what we're looking at. You have to be the conscious and the subconscious when you're shooting in cinematography. Especially when you're talking about the challenges of POC. Every time you block a shot that's got a Black person in it, it's political! It's always political, just like every time you block a woman. It's political.

That's the thing when you're talking about cinematography. You have to be more animated. You have to be more full of energy and life. Your camera work has to be energetic to be able to find the truth. You gotta go towards it, it's not gonna come to you. You've got to split the universe and split the light. You're coming in with a base light that just sort of fills the room, softens everything. That's going to initially luminate the white person more because the white person's going to reflect light. The Black person's going to absorb it. The way that I get this point across to people is I say, "What happens to people in the summertime when you get into a black interior leather car?" It's hot as hell in there because those black bucket seats are absorbing and holding all of that light! And light is heat. Versus white interior, it's not hot. It's interesting, but there is physics involved here! So if the black in the shot is absorbing more light than the white in the shot, the initial challenge after setting the base light, key light, whatever you want to call it, is where's your next light going? This

"5245. 200 SPEED ISO FILM STOCK. IT WILL MAKE A BLACK PERSON LOOK EXQUISITE, I MEAN BREATHTAKING. STOP THE SHOW."

is the crux of cinematography. It's not about the first light you set up, it's the ones after. You set up the base light, and then what's the next light you're gonna light? What's the next thing you're going to prioritize in this shot? What's the next thing that needs to speak to the audience? Where's the focus of the scene? Who's got the lines? What's the important point in the story here?

Let's just say the Black character is confessing something. They're talking, so OK, now you do something that's called a push. You're going to push on the Black person. I call it a secondary key light. You're coming with another key, and for me it's like the Black key. This Black key is an ISO key. It's only for this Black person. Now, with this Black key you have some choices here because when you say you're comfortable with Blackness, that means that you can engage with it. You can look at it. You go to a gallery show of a Black photographer and you look at images of Black people in color, in black and white, in all these different varied environments interiors, exteriors, high light, low light - when you really look at Black skin you literally see the colors of the world. It's not a coincidence that so many flags from Black countries have the primary colors in the flag! It's not a ghetto thing, it's not a Black

thing. It's a logical human choice. Those are the colors that they see around them on a day to day basis. Those are the colors in their skin when they're looking at themselves. We all know who we are, we all have a level of deep penetrating self examination of our own bodies. And so you start to see the yellows and the greens and the magentas - all this stuff that's in there. So the whole idea is that it's not Black; they're earth tones that are a huge swath of the color palette.

AC: Which brings me to wardrobe...

FT: Right. You've got to pick color. This is the other thing that helps you when you're setting a scene. What's the Black character wearing versus what's the white character wearing? Do we want the white character wearing anything that's reflective? Because they're already reflective. I'm not going to put reflective on reflective. We're not going to put a white person in a white outfit. I'm going to give them something that's going to absorb more light. In contrast, I would be interested in dressing the Black character in something that's more reflective, more luminant.

AC: I'm thinking about Daughters of the Dust - why did Julie Dash and Arthur Jafa

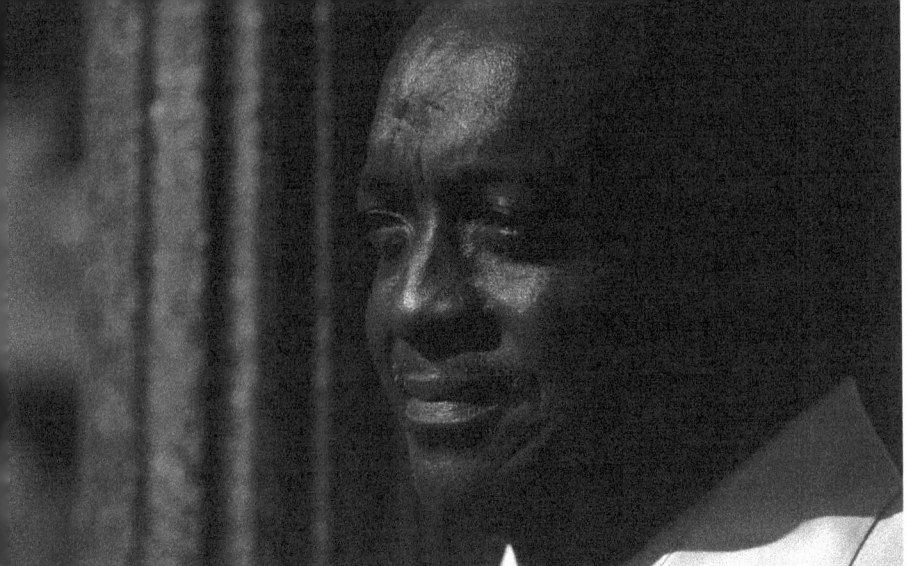

use yellow linen instead of white?

FT: Because it's splitting the difference between the two. Yellow is luminant. It's not as luminescent, and yellow falls into the color palette and the color spectrum of Black skin, so it looks more radiant. White light doesn't really assist with Black skin unless you go black and white. When that white becomes a corresponding gray, then that Black starts to leap and jump again. When it's white like in color, it just gets absorbed and it holds it.

AC: What doesn't a cinematographer capturing Black skin want to do?

FT: The not-to-dos? Ignore it. Don't think you can skate by it. Don't do that. Don't try to balance the lighting to accommodate both parties. You'll be there all day long tweaking. Accept the fact that you're splitting the light, you're splitting the scene. Because number one, film is an interpretation of reality. It's not a reflection of it. It's not. It's an interpretation. It's that particular filmmaker's belief about, this is what I think reality is, was, or can be.

The most powerful filmmaking is in the "can be." And we've become obsessed in our generation of is and was, and we don't focus enough on "can be " and it's affected cinematography. We no longer get lost in our imaginations from a visual standpoint. We get lost in our imaginations in the sort of character analysis and universes, like with Avenger movies, where we've worked out all of the discourse of society. Everything's equal. It's a lot of territory between A to B here. It's a great story we keep bypassing with the movies that we make. Like we reboot something that's already been done because now it's safe and now we can just reboot it, throw a bunch of Black people in it and it's acceptable. People are comfortable with it, because we've already test-driven it. We've beta tested it 20, 30, 40 years ago.

What can be? We want to see a film about someone evolving. The evolution of someone. It's evolution. It's a "can be" film. Someone's going to see "Unorthodox" - an Orthodox Jewish girl in New York - and she's gonna be like, "You know… I can do that." That's what this is about.

Probably one of the greatest "can be" films

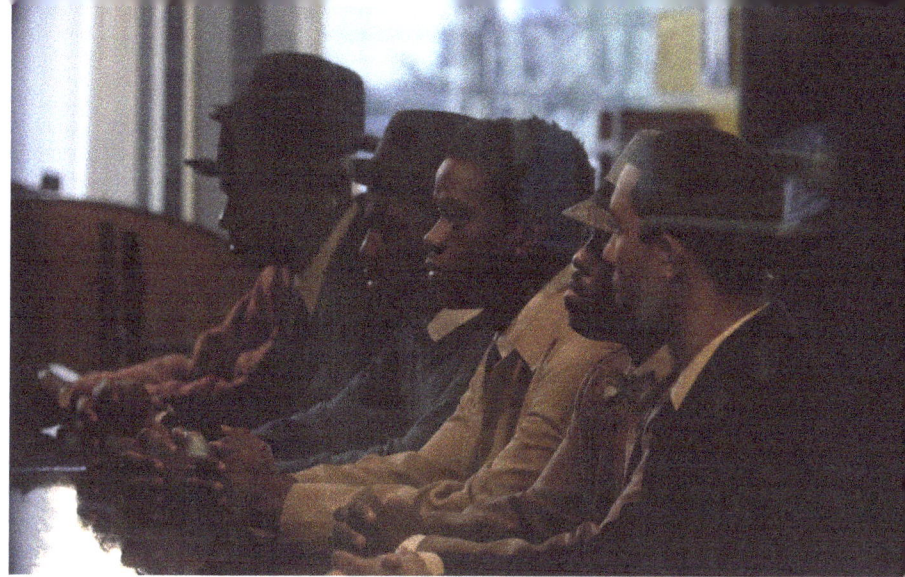

of all time is Do The Right Thing. I mean, that film - and this is where all of those things work in concert with one another, everything that we're talking about - was the quintessential film. What's the one that's on the Mount Rushmore of this discussion? Do the Right Thing is one of those films. It jumps at you like it was made yesterday. The fact that Hollywood has missed the cinemagraphic accomplishments of this film is ridiculous. That was the best photographed film of 1989, period. The next closest film of 1989 was Driving Mrs. Daisy. Those two films were way ahead of everybody else. Driving Mrs. Daisy--they had the same thing, they had a Black person and they had a white person--and the added bonus of they've got to go through years in these people's lives. So you're doing all kinds of stuff. Splitting the stage, as far as light is concerned, lens choices for her that are different from him. You're putting gauze on the back of the lens for Jessica for her close-ups. And then you don't do that for Morgan.

AC: What are the best lenses to use? What are the best things to do with your lens? You said analog lenses, right?

FT: Right. I don't think there's any other choice. I think digital lenses suck. There's a new series of Sony studio prime digital lenses that are pretty good - they're OK. They're not bad. I can live with them, but I'm not in love with them.

AC: What are your favorite lenses?

FT: My favorite lenses of all time are the Panaflex lenses. Panavision lenses. I'd kill to get a Panavision lens on a digital body. You just have to buy the conversion mounts, and the mount costs like $250, $300. So there's a little bit of an investment there, but I think it's just night and day. Like hands down. Older film lenses, even old dirty film lenses look better. They have more of a distinguishing characteristic to them. Old analog lenses age really well. Their imperfections become perfections.

AC: Do you have a certain lens that you prefer when you're splitting?

FT: Yeah, I would say like something fast and sexy. When I say fast I mean it's got a T stop that's down in the 1.5-1.8 range. No more than 2. Because what it does is it allows me

to have some latitude within the spectrum, so if I'm really pushing and I've got a lens that can handle a 2, I can push with the aperture at that point.

Let's say I'm at a 4 and I want to get some more style on my Black person and I don't want to march in more light, I don't want to pump more light on that Black person, because I don't want to get too much spill on the white person. So I'm going to open up from a 4 to a 2.5 to give me the stop I need on that Black person. Now, I'm gonna go nuclear on the white person. The white person's going to go up because I'm opening up more. But then I can come in and I can flag it down, I can knock them back down physically by turning down the intensity of their light. Take some light away. So you're always adding light to the Black person and taking away light from the white person. If you're in a situation where you feel like you need to add to the white person, you're backwards.

AC: What are the best locations and when's the best time of day to capture Black skin?

FT: The best time of day is 3 o'clock. The sun's at a 45. Noon is terrible. You're just kind of dead in the water between like 11 to 2, it's just kind of a shit show. Everything's top-y. It doesn't look cinematic. It just looks dramatic. There's a difference between cinematic and dramatic. Dramatic is just very heavy handed. It's very obvious, it's very in your face. If I was going to shoot a car chase, I'd want to shoot it between 11 and 2. If I want to shoot two people having an intimate conversation outside, I'm going to decide, "Is this a morning thing or a late

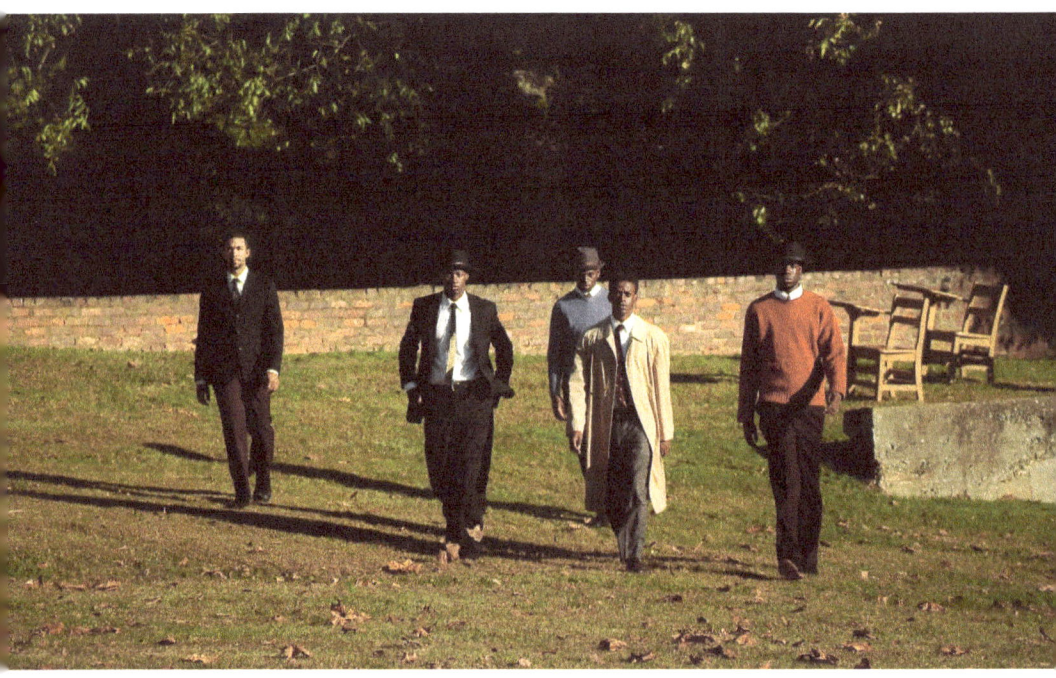

afternoon thing?"

AC: And shooting Black skin at night?

FT: You've got to give it some hell. That's just the nature of the game. You get back some of that spontaneity with Black skin at night, if you go black and white. I'm a huge advocate of black and white. If black and white can tell the story, go with black and white, don't be afraid of black and white. This obsession we have with color is ridiculous.

AC: Black and white is cheaper?

FT: Always. It's more forgiving. More latitude. You can risk more. You can save more. And for whatever reason, even if you bleep it up, for whatever reason, it still looks interesting. If you're over exposed in black and white, if you're underexposed in black and white, there's still something there aesthetically. Color has a narrower aesthetic palette. There's a cliff with color. If it's over exposed, you're done. If it's under exposed, shitty. Can't use it. Black and white - you can creep into those realms. It's kind of cool. It's kind of interesting. I like that. Everything's blown out. Black people blown out in black and white? Amazing. You're making New York 1975 art at that point. It looks super interesting. Black people in black and white, in low lit situations, where the only reflective quality is the eyes? Haunting. Unbelievable.

AC: So black and white over color film?

FT: If it calls for it. If you can tell the story in black and white, tell it in black and white. Especially if you're challenged with budget. What you will need to shoot in dimly lit situations in color with Black skin is light and you are trying to light in the dark but you're shooting something that's supposed to be in the dark, but you've got a light in the dark.

AC: Are we using a blue gel?

FT: Exactly. You have to start to distort the color palette. You are forced outside of the box. The box explodes for you at this point. If you do not have the ability to think beyond reality. If you do not have the ability or a fear threshold that allows you to step into the fourth dimension, you're screwed. Because you can only do something that is representative of a Black person in the dark. The only thing that can see a Black person in the dark is another person. And if you've ever sat intimately with a Black person in the dark, you've seen that. That cannot be captured on film in its raw form. It would artifact on you. The amount of Da Vinci you would be attempting to do to try to bring it back, you would spend a fortune! It doesn't even really serve you.

In that particular case, you have to go with more intimate lighting, and then once again we're getting back into the political realm. When we're talking about films, how many films are there where you have a Black person and a white person and they're in an intimate setting, having a conversation, and you have to light it? You don't see it because people don't do it. Because they don't put Black women and a white man or vice versa - the closest thing was that Steve McQueen film, Widows, with Viola Davis. It opens with Viola Davis and Liam Neeson in bed together. It's gorgeous. But he made the

choice of shooting the intimate moments in the morning. But the thing about this - they thought it through, because the linens were all white. The room was very white as well. So she pops immediately. And then they're just in there, strategically knocking down light on Liam to make it work. And it looks great. They didn't need a ton of lights to make that work.

The issue here is when it's two people. There's maybe one love scene shot at night between a Black person and a white person. The closest is Monster's Ball with Billy Bob Thorton and Halle Berry. But it's not a love scene, it's a rape scene. But it's all super dimly lit. Halle's biracialness helps because she's reflecting some light. She's not totally dark. If that had been Lupita Nyong'o she would have faded away. So they kind of squeaked by. It looked like a snuff film, it didn't have depth to it. It felt very flat. There was no beauty. Maybe that was the point. It just felt very raw and dirty. And maybe that was the point, but let's go back to this again and say, "Who's our Idris Elba?"

AC: What if you have two Black characters? You have Idris Elba and Lupita Nyong'o.

FT: That's exciting because then you start picking a palette. You just decide, we're coming in here with blue light. We're coming in here with yellow light. We've got all these other choices to shoot them, to make it work. We also can enhance the reflective quality of their skin if we blow them up a little bit.

AC: I love these tricks.

FT: They're amazing! So yeah, you would make the Black skin more reflective. Now imagine them intertwined in a romantic moment, oiled up. That would look amazing. You see that in that movie Belly. There's some shots in there of some Black girls. Mind bending. They made their skin reflective as well. There's a film called A Bronx Tale-- the Black girl in that, the way they lit that, she's breathtaking. Like literally just… good lord, that is a beautiful girl. And they were very conscious and mindful of that. Eve's Bayou is another example of a film really dealing with filming Black skin. Unfortunately, these lists are short. We're naming films that span decades here. It's ridiculous that there's not more films. And Julie Dash should be Ava DuVernay.

AC: Julie Dash walked so Ava DuVernay could run?

FT: Yeah, and that's a bitter pill to swallow. Julie Dash is still alive. She deserves more. If I had all the money in the world, I'd hire her tomorrow. If I was Tyler Perry, she'd have an office on my lot.

HAI! OUI!

A DANCE BETWEEN COUNTRIES: FRENCH AND JAPANESE PIANO COMPOSITIONS

CHRISTINE A. BANNA

IN COLLABORATION WITH PIANIST CHRISTINA WRIGHT-IVANOVA AND ANIMATION INTERNS AMANDA CONNELL & REN LOUREIRO

Hai! Oui! A Dance Between Countries: French and Japanese Piano Compositions is a collaboration with Christina Wright-Ivanova, an internationally renowned concert and collaborative pianist and Christine A. Banna an internationally showing multidisciplinary animator.

Entirely animated direct on 35mm film with found footage and laser printed transparencies, the piece responded to not just the music itself, but the cultural exchange between France and Japan. Each song in the program has a unique loop of animation ranging from paint and marker on film, bleached emulsion, scratched emulsion, collaging of laser prints and replacement animation, and combinations thereof.

This program is 1 hour in duration and highlights the influences between Japanese and French musical and visual art culture, with representations from 19th century classical piano works and 20th century new music. We are highlighting the relationship between two cultures that are far-removed geographically but have so much in common musically and artistically.

Why did you choose to paint on film stock?

I wanted to showcase all the methods one can manipulate the physical media of film with. The digitization of the paint marks and the pooling of the liquid is so compelling when scaled up. You see every smudge, every bubble, every stroke. We painted with bleach directly onto the emulsion of some of the found footage and we used acrylics, alcohol-based markers, and ink to paint on clear leader.

Can you tell me about your process of gathering found footage for this piece?

We had three main methods of gathering images: we used existing 35mm film with found footage, collaging imagery printed on transparencies onto film, and adding digital found footage that we sequenced and printed onto transparencies the size of 35mm film. It was important that all imagery was the same physical size so that when it was digitized it would have the same sense of tangibility. Another direct on film animator gifted me a generous amount of trailers from the 90s and early 00s printed on 35mm - I would comb through those trailers for shots that could work with the visions we had for each song.

Why was this music specifically selected to accompany the film?

Actually the other way around! The animation was made to accompany the concert as a collaboration with pianist Christina Wright-Ivanova. Christina included me in selecting the final piano compositions, sought my feedback for the songs, and choosing the performance sequence. From there, as she practiced the pieces, myself and a small team of two assistant animators dove into planning and creating imagery for the concert. Unlike other projection design projects I have worked on - where typically the visual projections tend to take a supporting role to the live performance

- with this collaboration we wanted our work to be more of a duet with each discipline equally showcased.

Was there a method to the color choices made in this film?

So in our pre-production process - myself and my two assistant animators sat down for multiple sessions and simply listened to the music. We would open ourselves up to the music, take notes, and discuss what came to mind as we experienced the music. Those discussions were where we made these color choices, as well as determining mood, pacing, imagery, and themes.

There are moments where you focus on Japanese architecture in the film; can you elaborate on this choice?

We were looking to draw corollaries between the material culture of France and Japan as with the music itself. We juxtaposed Japanese temple architecture with French Gothic cathedrals, and expanded to other material cultures as well, such as tapestry patterns from both cultures and French paintings of women alongside Japanese ukiyo-e prints of women.

Anything else to add?

Direct on film animation was a medium I was exploring in my art practice for a couple of years prior to this project. Christina Wright-Ivanova and I worked together for the National YoungArts Foundation, where I paired direct on film animation with a classical concert to create a dreamlike state - the physicality and alchemical nature of working with the film gave us a lot of flexibility to repeat and remix footage for the hour-long concert as ways to subtly highlight recurring themes. After working together on that project, Christina approached me to collaborate with her on her solo piano concert, which became "Hai! Oui! A Dance Between

Countries" which envisioned a similar approach to that previous collaboration.

I couldn't have completed this project without the help of Ren Loureiro and Amanda Connell, both former students of mine who applied to work their internship with me on this project. They both worked tirelessly and quite literally had their hands in every part of the process - from its conception to execution, and through the post-production process.

SAINTE-CROIX

Sainte-Croix sheds its lights on an artist who has chosen slowness in his creative process. His philosophy goes against the very essence of what art is in this hyper-productivity era. Such a stance is not without risk of falling into financial precariousness. This film shows us how an artist defines his life through creation itself and how he has been able to turn his handicap (Asperger's syndrome) into an asset to materialize his artistic projects against current economic and social expectations.

How does the sound in this film transport the viewer to another time and place?

The film opens with the melody of a music box. The familiar sound brings us back to childhood, our grandparents, to objects we find in flea markets. Then, Pierre's voice takes over. He lays down his words and easily captivates his audience. His deep and comforting voice holds us in. The first time I heard him storytelling (he is also an actor), I was transported into his story like a child. Ultimately, the music box's notes come back to close the excerpt and end the film.

Most of these images in the beginning are static; how does stasis play a part in this piece?

Socially, I tend to stay back a little; observation is my way of understanding the world. At the start of the project, I thought I would simply take pictures of Pierre's workshop. In the end, I felt the need to film and record him. To open with photography was a way of easing ourselves into his universe, of greeting his world with curiosity and kindness, of setting our gaze, and maybe of recreating the initial impression I had observing it all.

Do you draw inspiration from other filmmakers? If so, who?

Yes, I'm very inspired by the work of Québec experimental filmmaker Karl Lemieux. I've also recently discovered Bill Morrison's work, which has absolutely captivated me. Four years ago, Quebec filmmaker Guillaume Vallée (Analog

ALIX GALDIN

Cookbook issue 3) made me want to try video. I also feel very close to the art of Sarah Seené (Analog Cookbook issue 3 and 4), a french filmmaker and photographer.

How would you say talking about mechanisms in the film becomes self-reflective to the process of working with film?

A music box, much like a clock or watch, will not work and can break if the gears aren't properly made. Therefore, you have to use extreme precision and acquire artisanal know-how in order to build the components. Working with film is largely similar. Super 8mm film, for example, is very small (8mm). You have to be very meticulous to use it. Even more so if you're developing it yourself and making modifications later, with paint for example. When I looked at Pierre working in his workshop in silence, fully concentrated on his small pieces, I was reminded of working in a darkroom. It's long hours without talking, moving very little, in uncomfortable positions.

In both cases, it is based on movement. Without these gears, there wouldn't be moving images. In fact, there's a whole part towards the end of the film where the camera jumped a few times, probably due to a manufacturing defect in the film. Instead of throwing that part out, I used it and found that it gives a ghostly angle to the images. It corresponded well to the ambiance of Pierre's workshop when he left it. With experimental cinema, we can use mechanical defects, something that isn't possible for clock or music box making.

How do you find melody within the film medium?

The film's melody is the one from the music box we see at the end. It's a box from the 1950s Pierre bought in an antique shop. It presents itself like a carousel with doors that open and

close. Inside each door, there is a small space where you can place a cigarette. It's curious and amusing. It must have been a music box that would be put on the table at the end of a meal to offer cigarettes to guests. The mechanism wasn't inside anymore, so Pierre built it back up again. When leaving Québec to go live in France, he gave me the box. I was really happy!

Does the film medium also require you to develop extreme patience?

Yes, when using film, you have to expect a very long period of time to pass between the moment you buy it and the moment you can see the final images. It can take multiple weeks, months even, if you work directly on the developed film (paint, montage, etc). With regards to the medium itself, there are many steps where each decision will influence the result. I'm rather impatient by nature, so it gets stressful sometimes. I'm flying blind a little and have to stay open minded to what mistakes can bring.

BAD DREAM

Here's to bad dreams being just that—a dream. This spoken word piece written and narrated by Colby Hollman (Fear the Walking Dead) is juxtaposed with documentary footage and portraiture captured by the filmmakers. Together, they create a visual representation of the black zeitgeist processing the violence of white supremacy. Impressionistic, yet visceral in nature, Bad Dream is not only a representation of this experience, but a confrontation that forces viewers to consider their role in the racial structure of America.

Camilo Diaz

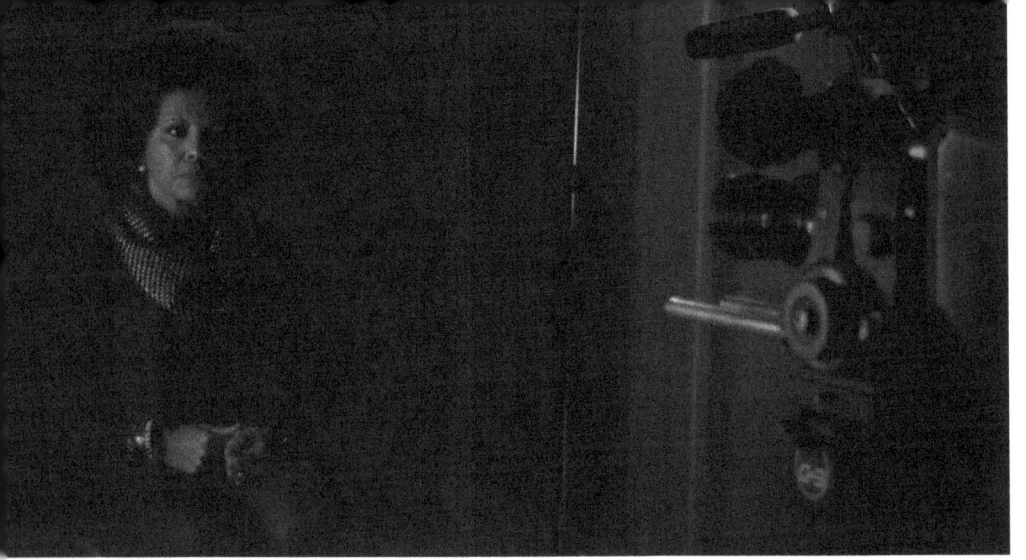

How did you gather the audio for this piece?

The spoken word was written and recorded by Colby Hollman. The actual audio of the events were sourced from different public domain websites, along with the actual audio from our documentary work.

How does fear play a part in this film?

Our fear makes us weary of the future, whether it is the last time we see our child walk out the door or we hear the tires of a truck following us as we enjoy our daily run. Unfortunately, there are certain people that overlook their entitlement in such occurrences. The film itself uses that fear to stare back at those who do not realize and even ignore the privilege they have in their everyday lives.

How was the casting process for this production?

It was important for the film to have a generational perspective, from childhood to adulthood. Our casting process was based on that. We had little contact with the cast prior to being on set, which allowed us to have a fresh slate and truly connect with the piece in a closed and safe environment.

What are some tips you have for shooting on film?

Test your camera and the stock that you have decided on when it comes to shooting on film. The last couple of projects I've done on film have been on Arris or Aatons that haven't shot film in many years. I've found myself not only cleaning them, but testing each magazine and motor to ensure that they work properly. Once those film tests come back, and no glaring problems, you have a good camera to work with, so trust it!

How does film lend itself well to the spoken word format?

The rawness of celluloid, the grain structure of our film stock, being able to have the contrast of deep shadows with highlights, creating a true chiaroscuro effect. All these aspects lend themselves to the spoken word format. I think it really goes hand in hand with Colby's raw performance. Something which we also did was to roughen up the

recording in post, to achieve a more analog sound. At the end of the day, the impression of light unto film gives a certain truth that you cannot get when capturing in the ones and zeros. Ultimately, I think digital images tend to be more detached. I really do think that film connects more with the viewer.

How did you direct your actors with such a heavy subject matter?

I decided to take on a more conversational tone. I didn't want any of the emotions seen on camera to be "directed." It was all based on a conversation lead by the DP Shawna Walker and I. The actor sat in a chair, they listened to the spoken word piece and we proceeded to talk about the piece, sometimes going for 30 minutes until we felt ready to flip the camera on. The emotions in the film came from a real place.

How does time play a part in your piece?

A bad dream is recurring. Time circles back. I think that's the only thing I can say about it.

What film stock did you shoot on for this piece?

7219/16mm 500T

Why did you make the choice to reverse the film?

These issues feel like they are never-ending. Reversing the film was a simple way of saying that. We live in a time that when we think things are better, they seem to go back to where they started.

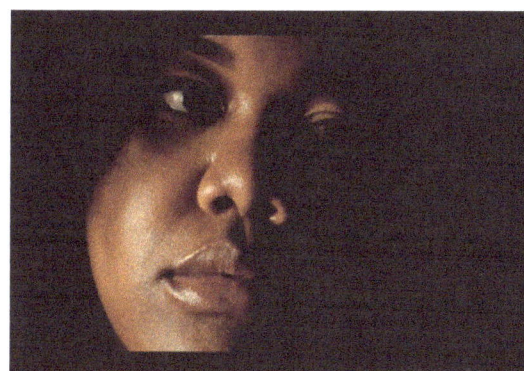

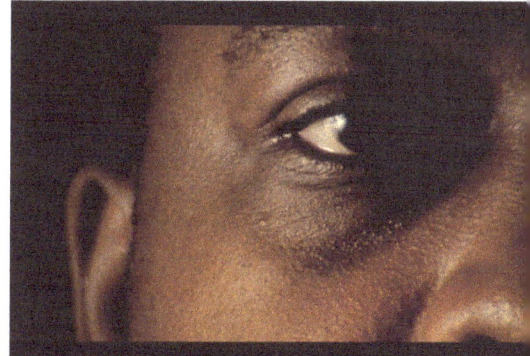

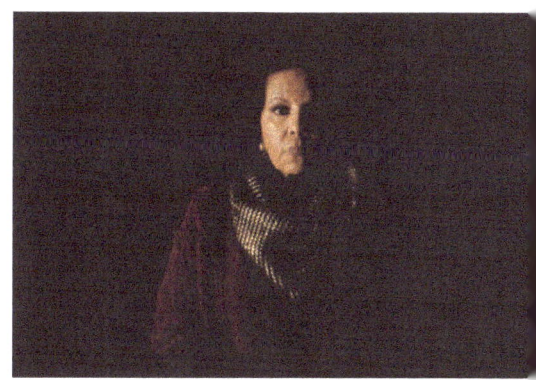

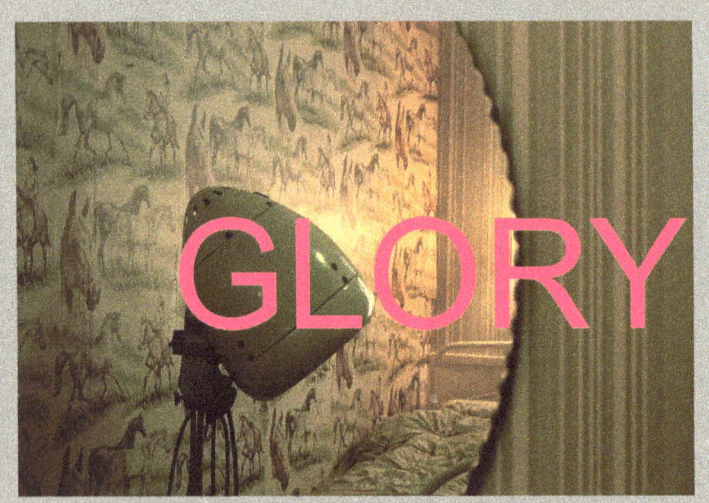

GLORY BOX

Glory Box is an interactive digital artwork that collages a series of archival reinterpretations into a new alternative archive of life in Australian regional areas. It reimagines regional archives for future audiences.

Aboriginal and Torres Strait Islander readers are advised that this artwork may contain images of people who have died and of culturally sensitive locations.

This research took place on the stolen lands of the Brayakaulung people of the Kurnai nation in Gippsland and of the Wotjoboluk people in the Mallee region of Victoria. Sovereignty has never been ceded and a treaty has never been signed. We pay our respects to elders past, present and becoming.

Tell us how Glory Box began.

I suppose I could tell you that it began sixteen years ago when I first started researching the history of Scottish Highlanders that emigrated to Victoria, Australia in the Nineteenth Century. That was when I first became drawn to the enigma that is the Australian landscape, and in life in regional (rural) areas here in Victoria. I think the seed of what is now Glory Box began in a town called Rainbow, which is about five hours northwest of Melbourne. That was when I realised I had collected all these images: from Rainbow and other small country towns, from their archives and from my archive, as well as photographs I had taken on my medium format camera. It was a glory box of sorts: a collection of artefacts and objects for the future.

What was the inspiration for Glory Box?

All the local historical societies, museums and libraries I have visited on my travels through regional areas. What a rich and vital collection of stories and how important that they are preserved for the future. Especially as we think about how climate change might alter life in regional areas of Australia in the coming decades. The landscape was also one of the first inspirations; you cannot ignore it. I have spent many hours travelling through it and in reverie, and it never ceases to motivate me and guide me in some mysterious way.

Why was it important to show Glory Box through an interactive online experience?

I wanted as many people as possible to see it. I had no interest in exhibiting in Melbourne. I exhibited it as a stills exhibition, in Berlin and in Rainbow, and although both experiences were incredibly valuable, the exhibitions themselves were lifeless. I had become so bored of creating exhibitions! I am also a control freak and for past exhibitions had done all the printing myself, but I've realised as I have got older that spending days and nights in the darkroom wasn't good for my health, physical or mental!

Leanora Olmi

At first going digital felt antithetical to my analog values, but it was a new area of creativity for me and I actually enjoyed making the work.

I want viewers to navigate their own way through the piece, it is a personal journey, so an interactive piece seemed to provide that more than walking around a white cube space.

What does it mean to you to be an archive artist?

I wrote in my thesis that "It is my hope that regional archives, both public and personal, are continued to be preserved by their communities, so artists can experience the rich histories encapsulated within them. They are fertile collections, not dead or decaying, but vital with latent stories waiting to be reimagined and brought into the present". Reflecting back on that now, I would add it is the responsibility of those artists to contribute to that preservation, which I hope I am doing in some small way with my work. I consider an archive artist to be one that keeps archives relevant though their work, igniting curiosity not only in the archives themselves, but in the new stories they can tell in our imagination.

What was the most surprising thing you found when going through the archival materials for this project?
The beautiful, quiet, often banal moments that have been captured on film, I feel so privileged to witness them. It is a simple act: to gaze upon an archive image and project your own experiences and interpretations on to it.

I am also surprised that some of these archives exist at all! Both in terms of the materiality of the artefacts, but also as stories. I found myself constantly impressed that these analog archives had survived all these years, and that the stories in them were revealing themselves to me.

What do you hope audiences walk away with after watching this piece?

Perhaps the work recalls for them a memory, or the images echo images in their own archive through the commonality of our personal histories. It really is a personal journey. I hope that they might be excited by the possibilities of archives as generative art forms; to see possibility in the past.

What's next for you?

A move out of Melbourne, so I will officially be a regional artist which will be exciting. I hope to expand on an earlier project, Send Word, about elderly people and the effects of lockdown. I am also very keen to recreate Glory Box as an expanded film performance to tour to regional small towns.

Anything else to add?

Always good to end with the words of someone else:
It is the seduction of the past that lives with us and to which we are ineluctably drawn. And it is the need to grasp the matter of what has been in order to re-make it differently.
- Janet Harbord, La Jetée (London: Afterall Books, 2009).

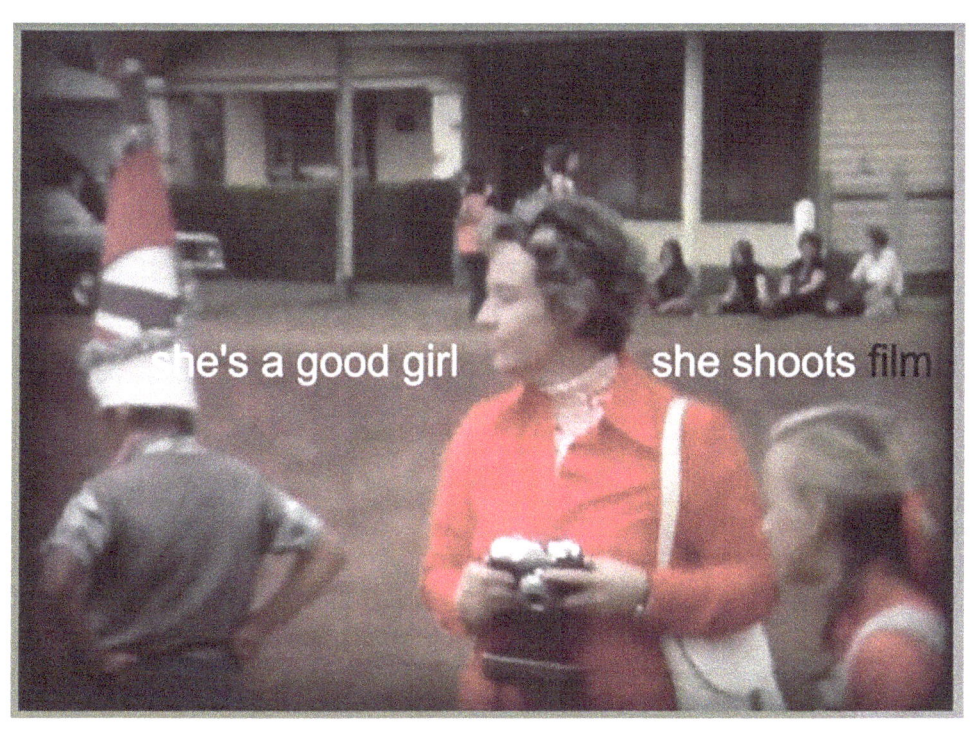

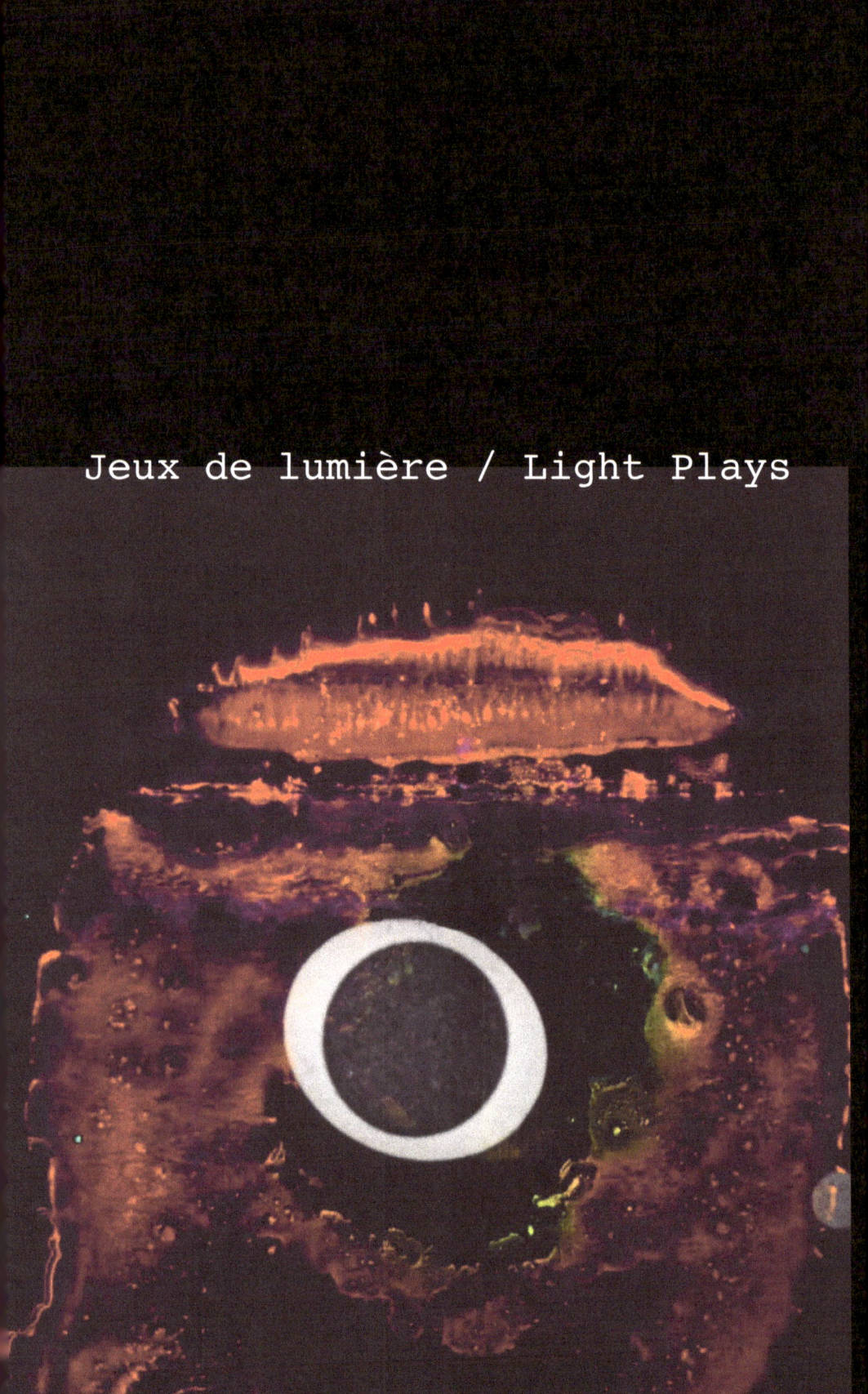

This film was born out of the desire to find new ways to create with 16mm footage. A friend had given me some old footage, found in rusting cans in his garage. I decided to use these as canvases for my exploration. I was seeking a new, unconventional material to paint/draw on film. I thought: what if I painted with light? So I approached a scientist at Laval University, who is researching quantum dots. These are photoluminescent nano-particles. Professor Claudine Allen was kind enough to allow me to take samples of different colors made by her graduate students, to try and do some arts with her scientific achievements.

So I set out to paint, using the dots diluted in a fluid solution. To be seen, these molecules must react to ultra-violet light. So I worked in the dark, under UV light, in a controlled environment much like a scientist.

John Gledhill, from Bit Works Inc in Toronto, did the transfers from 16mm to digital files.
He had to have special parts machined to his transferring device, to expose the film to the needed ultraviolet light. Special filters had to be added to the system also, to filter out a lot of the blue light. We found out that some old films emitted blue light when exposed to the ultra-violet, which was intriguing. John's query was answered by a supervisor at the Library of Congress' Film Preservation Laboratory: fluorescent dye was added to B&W film emulsion to quickly see if it was nitrate-based or not.

I asked Lyne Goulet, musician, to improvise with her saxophone. She was inspired by the sounds from the found footage. I like the way the old music, digitized from the Optical soundtracks, mingles with the newly recorded music.

Making this film brought me in a variety of unexpected directions. Editing it was quite a challenge. I find poetry in science, and the narrators heard in the soundtracks certainly helped that feeling. So in the end, this movie, as much as it was a journey in the making, becomes a journey for the viewer, traveling from sound, to light, to life. I hope you enjoy it.

Anne-Marie Bouchard

Where did you cut your teeth drawing directly on film?

The first project I did that involved scratching on film was a short experimental in 2003, exploring the formal aspects of film/video. In Tableaux Mouvants, I scratched only a fragment of film, but greatly enjoyed it. I projected the film on-screen and filmed it on video, part of the process involved filming the 16mm through the projector lens, focusing in and out of the screen while the film was playing. The next time I scratched and drew on film was for a collective project on resistance, *R_ don't give an inch*, shot in 16mm in 2014. I scratched and drew on almost every frame of that one. The process induced a calm meditative state that I enjoyed, and I wanted to do it over and over again, and get better at it.

Jazz music plays in the background during multiple parts of the film; how does the music affect the overall rhythm of this piece? What was the process of finding this footage?

I have a few musician friends, many of whom play jazz. Music helps to give a sense of unity in the film. It brings the different parts together. The saxophone music was made specifically for the film. It was inspired by the actual sounds of the found footage, which were digitized with the images. Lyne Goulet listened to the soundscape, and then improvised around it, building around the existing music themes of the old movies.

The footage was a gift from a fellow filmmaker who was moving out of the country and had no room for it, nor a project to do with it. He had kept the films in rusty cans, in his shed, in less than ideal conditions. I held onto them for a while before I knew what to do with them.

I started to work around the theme: the light. So I went through the footage looking for shots that had special light; either bright light,

THE QUANTUM DOTS WERE DISSOLVED INTO AN OILY FLUID THAT I USED TO PAINT DIRECTLY ON FILM. I HAD TO COVER IT ENTIRELY WITH SPLICING TAPE TO MAKE SURE THE QUANTUM DOTS WOULDN'T SPILL AND CONTAMINATE ANY OTHER SURFACES.

atmospheric light, a feeling of luminescence. The moon sequences were the most obvious ones to select, and thinking back, I wonder if they did not inspire the whole film.

What part does symbolism play in your film?

I think it plays a huge part. It is not a film to be taken literally, but you have to build sense out of the symbols; the birds, the searchlight, the sound waves, the moon. I think we grasp only fragments of the world and have to make sense out of these somewhat random bits and parts. It is a film about searching for meaning, searching for freedom. It's a quest towards the meaning of life, but a playful one. In the end, this movie as much as it was a journey in the making, becomes a journey for the viewer, traveling from the science of sound, to light, to life.

How does sound play a part in your film?

I was touched and inspired by the soundtracks of these really old movies. The narrators' voices, deep, omniscient, bring both nostalgia and poetry to the film. We seldom hear such voices in documentaries these days. The sound approach to film, then, was also very different. There were long silent pauses in these films, where the viewer is meant to observe. I just played around a lot with each sequence, each shot. I tried to build new sentences, half in English, half in French. I tried to make sense out of the sound bites. I fooled around a lot trying to turn them into poetry. And finally, I settled on a three parts structure because it helped give a sense of order in chaos. It gave meaning to the sound collage. The sound directed the way I edited the images, and the music came in to cement them together.

What were some of the materials you added directly to the film?

I was looking for an original and different way to work on the film. And I wondered about a fluorescent matter that could add light directly to the film. So I met a physics professor at Université Laval, who specialized in quantum physics, who was researching quantum dots. They are luminescent nanoparticles; UV light causes them to produce light.

Professor Claudine Allen is a very generous scientist, and she is very open-minded. I interviewed her, I met her grad students, I filmed in her lab. There was a whole lot of original video footage and sounds that never made it in the film. I think she was curious

to see what the result of my art experiment would be. So she let me take out some quantum dots from the lab; under the condition that I find a lab-like space I could work in: lots of ventilation, gloves, masks are necessary to work with this hazardous material. Fortunately, a print making shop in my art community offered the proper space. It took many collaborators to make this film possible!

The quantum dots were dissolved into an oily fluid that I used to paint directly on film. I had to cover it entirely with splicing tape to make sure the quantum dots wouldn't spill and contaminate any other surfaces.

Quantum dots come in different colors, depending on the original molecule they come from. They exist at the border between physics and chemistry – a chemical reaction is necessary to change their physical state. They are very complex molecules – in fact, smaller than molecules, they are human-made particles, but their main property is that, under UV light, they emit light. That light glows orange, yellow, green; a range of fluorescent colors.

The thing is, in normal light, this "paint" is translucent, which proved to be quite a challenge when the time came to digitize the film. I had imagined that the quantum dots would alter the film's emulsion, that a chemical reaction would occur for them to become visible, but alas, no. So John Gledhill, at Bit Works Inc, had a special part machined for his scanner, and a special filter put in place, and UV lights, so he was able to do a wonderful job getting my not-so-visible colors. The film itself, under UV light, shines all sorts of green, yellow, orange light. We also found out that some old films emitted blue light when exposed to the ultra-violet, which was intriguing. John's query was answered by a supervisor at the Library of Congress Film Preservation Laboratory. Fluorescent dye was added to B&W film emulsion to quickly see if it was nitrate based or not; to prevent fires that destroyed many film storages back then.

So I learned a lot making this film, it was a

long 3 years journey for an 8 minutes piece!

How did you select the color palette for this film?

The quantum dots determined the basic colors I had for my interventions on film. I also used fluorescent pencils, to keep the same intervention colors and also black ink. I used the quantum dots on the moon sequences, and also at the beginning of the film, on the animated sound waves. I made mostly dots and drops, because the fluid was kind of oily and thick, and never really dried, but formed into rings. I had trouble with taping every frame after I painted it. I would probably go about it differently now, it wouldn't be so messy, but at the time I didn't expect the tape to show that much on screen.

The old documentaries about birds were reddish, so they provide a very different looking ending to the film, liberating from the black and white.

Anything else to add?

I worked digitally on the film afterward. I blended 2d digital animation to complete the film. I drew flying birds, a power plant in the background, a self-portrait, frame by frame, drawing onto the digitized frames as I had done with ink and quantum dots on film. These added layers contribute to adding sense and poetry to my film. They certainly add a layer of details I couldn't possibly get by drawing on the 16mm frames. I wanted to blend the two animation modes, make them complete one another. So the film, in the end, exists only in its digital form. If one would project it, one would miss all the quantum dots colors and all the digital animation that was added. Old and new technologies blend together very well, both having their qualities and charm.

DOUBLE X

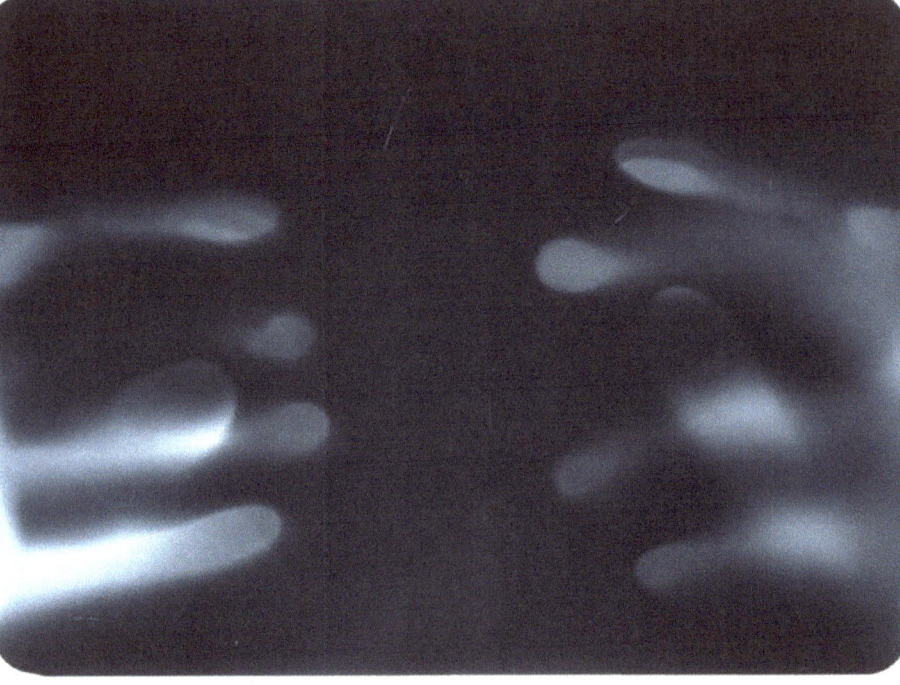

A series of photograms using 5"x7" RX-N Fuji X-Ray film. Unlike the standard photographic film, the X-ray film is a double-sided emulsion. This design is a safety feature that affords the patient less exposure time to harmful rays. The photograms are made by holding the film in my hand and exposing from either one or both sides, to accentuate the physicality of the X-Ray process and as a material. The images abstract the human hand, resembling a ribcage or other non-anthropomorphic forms.

Tell us about your process working with Xrays.

I started experimenting with X-Ray film during my residency at the International Museum of Surgical Science last year, when thinking about the connection between the history of medical imaging, photography and cinema.

X-ray film is a double emulsion film, increasing light sensitivity and reducing patient exposure time to radiation. This double-sided nature of the film suggests a potential viewing experience reminiscent of the early film screenings that allowed viewers who paid extra to sit behind the screen, next to the projector to watch the film. Thomas Edison famously stopped working with X-ray technology after the death of his lab assistant Clarence Dally due to radiation overexposure. I was also at the time reading Atomic Light (Shadow Optics) by Akira Mizuta Lippit, which considered the spectacle of vision and invisibility through the notion of avisuality, in relation to the simultaneous development of x-ray and cinematic technologies.

My hands appear often in my work and the resulting series are photograms made by holding the film between my hands. I felt there was a visual depth able to be rendered only on a double emulsion film that is exposed from both sides and created the images with subtle gestures that enhanced this impression. In particular, I was interested in exploring the relationship between my thumb on one side of the film and my fingers on the other, creating various iterations of textural and spatial depth.

KIOTO AOKI

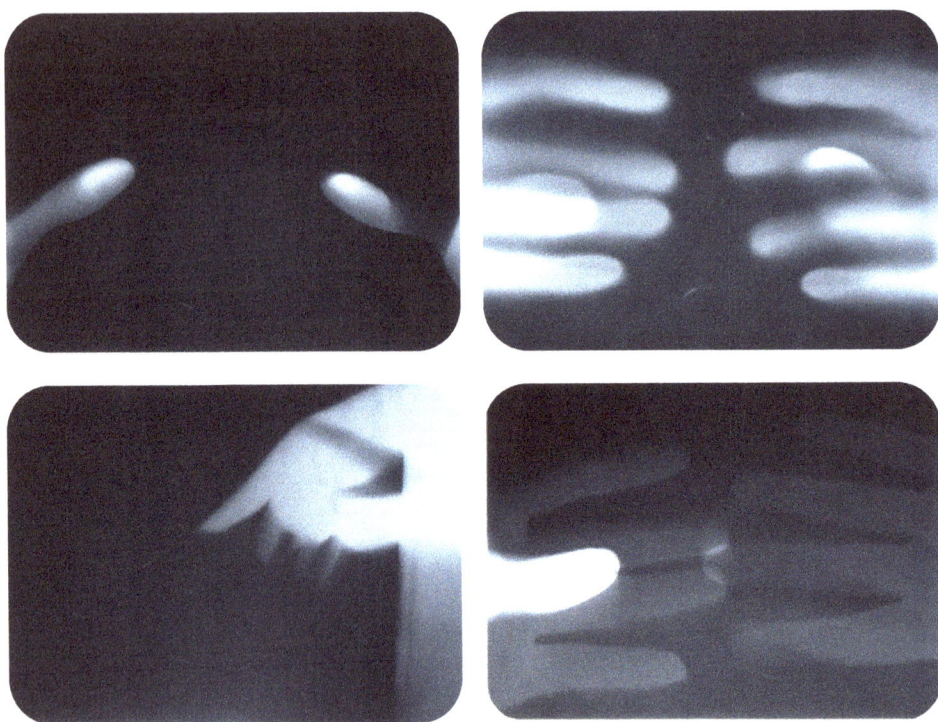

Of course, the first most widely circulated X-ray was Anna Bertha Ludwig's (Willem Röntgen's wife) hand with her ring, so there is a connection to the hand there as well. For the exhibition, I also collaged some of the visually flatter photograms into a screen hung in front of a lightbox, to be viewed from both sides. The single sheets are set in a stainless steel Kodak film holder and displayed in the windows. Part of the appeal is that these images are legible as X-rays through the material and imagery, yet upon a closer inspection you realize that these images are not of any internal bodily landscape. Between the legibility of the hand and the ambiguity of graphic abstraction, the images seek to reveal the physical properties of the film, in a sort of reversal of roles.

How does your own diaspora play a part in your artistic process?

Though aesthetics.

My parents are from Tokyo, Japan and I was born in Chicago, making me Japanese-American. Within the Japanese-American community, I am a shin-nisei, which is a term (translated verbatim as the new-second generation) to describe those born to Japanese immigrants who came to the United States post World War II. As is a common shin-nisei experience, my parents ran a Japanese household so I speak the language, I ate Japanese food, watched Japanese television and travelled frequently to Japan to visit my grandparents. It was (and is) a very flexible and privileged liminal space between cultures.

I think this solid foundation allows my artistic practice to flourish outside the framework of didactically diasporic art. I do not make work about my diasporic experience but my experience certainly influences my artistic explorations. I can trace certain parts of my practice like an affinity for visual reticence or a sensibility of quietude as an aesthetic inherently grounded in Japanese or East Asian philosophical ideologies of time and space. Some works are titled in English, some in Japanese, because that is the nature of how I talk and think: in both languages.

I also have a musical practice as a taiko (the Japanese drum) player. I come from a performing arts family dating back to the Edo period and am carrying on the family and cultural lineage in Chicago, playing in both traditional and contemporary musical contexts. Even here, taiko is not about bringing me closer to my Japanese heritage. It is about carrying on the family lineage, which just so happens to be in the line of traditional Japanese performing arts and music.

Musically I am interested in textural and sonic endurance; of breath as space; of space as an active element of music; and choreographic movement as sonic temporality. Again, my work is aesthetically and philosophically aligned with Japanese notions of time and space.

I think this conversation around the diasporic art and diasporic artists is so important and is something I try to address in my curatorial practice. It is vital that we differentiate the two. There are certainly artists of a certain cultural diaspora who make work about that experience and the social or political ramifications of that experience. But there are also plenty of culturally diasporic artists who make work about material and process and texture, and the latter often go unrecognized.

Can you tell us more about your art

residency?

I was the artist-in-residence at the International Museum of Surgical Science (IMSS) in Chicago during the Fall of 2020. Their residency program invites contemporary artists to engage with the museum collection to create work for a culminating solo exhibition at the museum. I was a gymnast in my youth and always loved anatomy and physiology and at one point seriously considered becoming an orthopedic surgeon; so I was delighted to work in the space.

The pandemic provided more time to spend in the museum and its collections. A few amazing discoveries included a Henry Clay camera from the 1890s that I took out of storage and used for one work; the Edinburgh Stereoscopic Atlas of Anatomy – a 10 volume set of stereoscopic cards of detailed dissections; and the original blueprints of the home from 1916. The final exhibit titled Breathe, Fibres of Papers Past, features eight new bodies of work made during the residency and installed throughout the four floors of the museum. Half of the work responded to the history of the museum building, as well as the history of its founding, creating site-specific works of pinhole images made from paper negatives and cyanotypes of the original architectural drawings. The rest of the works are more conceptual photographic series and one 16mm film related in some way to the body, including the work on X-ray film.

I also pulled relevant objects from the museum archives to be exhibited as well. The show is scheduled to be up through June 2021.

What cameras do you prefer shooting on film with?

My medium format go-to's are Brownies and a Holga. I have a beautiful wood Wista field camera for 4x5. Before I was gifted the Wista I made a pinhole camera from book board and book cloth to shoot 4x5, which is still in frequent use. For 35mm I use a Pentax K1000. My 16mm work is mostly shot on a Bolex and the occasional Double 8.

How does the photographic medium lend itself well to your own artistic journey?

I am first and foremost a photographer & filmmaker. I make artist books and site-specific installation works as well, but everything I do as a visual artist extends from the perspective of an analog photographer & image-maker.

What barriers to entry in the

art world would you like to see destroyed?

The spectacle of diversity or diversification.

What photographers are you most inspired by?

Lew Thomas, Duane Michals, Hitoshi Nomura, Keiji Uematsu, Helena Almeida, Michael Snow, Ueda Shoji, Harry Callahan, to name a few.

How do you motivate yourself to keep up with your photography and artistic process?

I want to make work all the time. Or rather, I think I feel myself getting closer to that state, which is right now excites me. I have been fortunate to have a somewhat continuous schedule of projects to work on recently, which certainly helps. Reading and thinking are part of the creative process too. And talking with my fellow artist friends and seeing what they are working on.

CHRISTINE LUCY LATIMER
INSTANT VINEGAR SYNDROME DYE JOB

My analog practice blends photographic techniques to comment on trajectory, authorship and obsolescence in lens-based making. The resulting hybrids collapse format and origin, creating wonky nether-spaces of weirdness and wonder.

I am a media hoarder, collecting discarded/expired film, film reels, videotapes, negatives and slides. As a result, I have become an adoptive mother for the physical media that no one else wants to hold on to. The gesture of embracing the abandoned is a pervasive theme that runs through my work. It is both an act of love and a political statement - to repurpose what already exists.

Under relative isolation at home during the pandemic, I have been threading up my 16mm projector to view my collection of found 16mm films, which are mostly decommissioned 1960s educational shorts, vinegar-syndromed in faded red and pink. I also enjoy reviewing the scores of unexposed film options in my fridge and freezer. I recently became frantic over a few boxes of (discontinued) Fuji FP-100C instant film at the very back of the fridge. Based on the expiry date and the stability of the chemistry, this film had to be used, as any further age would reduce its tonal range to murky greens and browns. I realized that in this cyclical, isolated process of film watching, film collecting and film inventory, I was preoccupying myself with two completely different forms of analog film from different moments in history, both in liminal states of color decay. I decided to combine the two, using the expired instant film to make dye transfer prints of frames from my 16mm films.

The resulting images are deliriously un-informing photographs: colorful, yet missing authentic color information; incomplete, as the chemistry and dyes in the expired instant film did not retain enough moisture, rendering speckled white absences throughout each print. This process of decaying decay, further incompleting the already incomplete, is symbolic of so much of my personal experience of pandemic isolation. I have had time like never before to scour through my film collection, to assess the state of expired film stocks teetering on the edge of their usefulness, to pull out camera upon camera, to repair things, to turn out the lights and go elbows deep into the chemistry. These activities are so nourishing, so relieving, particularly considering the efforts I've made in the past to carve out space and time for them. Yet, the work I am making is specifically visually incomplete, and this incompleteness represents so much of what I am experiencing under isolation, separated from family, friends, and those activities that, yes, sometimes have kept me from going down analog rabbit holes.

Tell us about your process making these images.

The process involves an experimental technique that originates with Polaroid peel-apart instant film. Known as the "polaroid image transfer", it entails making an exposure, peeling the print away from its chemistry-and-dye-laden negative earlier than recommended, then applying the gooey negative to a different receptive surface (I used watercolor paper), transferring the dyes to that new substrate.

For this series, I used a later-era peel-apart instant film (FP-100C), manufactured by Fuji first as a competing, then replacement brand for those films that were discontinued by Polaroid following its 2008 bankruptcy. Sadly, this Fuji equivalent was also discontinued in 2016, therefore any film germane to this process is no longer being manufactured (though there is a niche manufacturer who has recently generated a new, pricey prototype, creating a tiny ray of hope).

Why did you choose to shoot on expired film?

I collect photochemical and photoelectric materials in various states of exposure, un-exposure, freshness, expiration, stability, damage and decay. I have an unwieldy inventory of slides, negatives, film stocks, found small-gauge motion picture films and tape media; all of which inspire, and much of which get used in my art making.

So many innovative and experimental processes die with the discontinuation of film stocks, chemistries and tape gauges. For me, using a format past its prime is not specifically about nostalgia or bygone-era flag-waving, but more about pressing the format's longevity. Expired film will almost always render an image, it's just less predictable as to what that image will be. The inability that expired film has to produce stable, consistent photographic results (something that would normally repel a photographer) fascinates me and drives my curiosity.

How does texture play a part in your process?

The texture of photochemical and photoelectric media is so revealing, in that each format has its own unique signature and telltale artifact. These artifacts,

byproducts of a particular technology at a particular moment in lens-based evolution, signify that place in history, informing the viewer as to when the image was generated. I am preoccupied with the combining of formats and layering of byproducts to create images of indeterminate historical origin. The unpredictable textures achieved with expired film or decaying found media are ways to push that layering to a further place of indetermination. In combining disparate textures, I aim to create netherspace adjacencies to the known history of photography, which (hopefully) encourages the viewer to spend more time looking.

What type of photographs are the most inspiring to you?

I am in awe of the magic and possibility in analog process, so essentially any photograph that hasn't been snapped on a mobile phone is inspiring, as it reveals a certain kind of intentionality and patience from its maker. Further, I appreciate photography that strikes a balance between content and material, where the texture and imperfections of the process work in concert with the photographic subject.

What camera do you rely on the most in your process?

I rely on numerous lens-based devices, from film cameras to darkroom apparatus. The one piece of gear I return to most frequently is my Daylab 35, the device that I used to create these images. It's a miniature, self-contained enlarger unit with a small, aperture-controlled flash head, additive color filters and a lens that allows for the reproduction and enlargement of 35mm slides or negatives (or something of relatively similar size, such as a few frames of 16mm film, a section of a viewmaster reel, etc.)

I have several different film holder bases

for my Daylab that allow me to make enlargements on various instant film formats, as well as 4x5 sheet film and 8x10 photo paper. I'm currently using it as an exposure box for a contact-printed 16mm film project. The unit is so versatile and allows for so much experimentation that I use it on an almost weekly basis.

What kind of mistakes have you made with film that altered the way you create?

Much of what I create involves using devices and media outside of their intended purpose, so my practice is essentially the product of mistakes.

I think the greatest alterations to the way that I create have occurred in those moments of deviating from the proper way to do something, and understanding that those deviations will deliver unpredictable results. Further, in my choosing to collect discarded, damaged photo materials and broken devices, I am embracing their dysfunction, disrepair and decay. This means that I have to improvise, deviate from process, embrace error and abandon preciousness in order to work with the material. This unpredictability is a very powerful, stimulating force for my creativity.

How do you motivate yourself to keep

up with your photography and artistic process?

Curiosity is and will always be my biggest motivator. I enjoy making work using unpredictable materials, and thrive when I enter into a project whereby it is impossible to foresee or envision the end result. I am most stimulated when I am challenged by the unknowns in a material, and in many cases simply have to start making just to fill in those blanks. I enjoy it when my work evolves beyond my capacity to plan or predict it. Surrounding myself with a panoply of photographic materials, particularly those expired or unstable, is the best way for me to guarantee my continued curiosity and artistic motivation.

What film stock do you see yourself going back to the most?

I really love instant film, integral or peel-apart, expired or new era, mostly because the exposures are so large and conducive to play, and are easily disassembled into components, from the positive gelatin to the dye layers to the negative substrate.

I also have a special place in my heart for a nice slow Ektachrome, in any gauge, motion or still. If I had to pick a gauge, it would be 4x5-sheet film. It's such an amazing stock to hand process because the rewards are so immediate, with positive images visible in full color the moment the film comes out of the final wash.

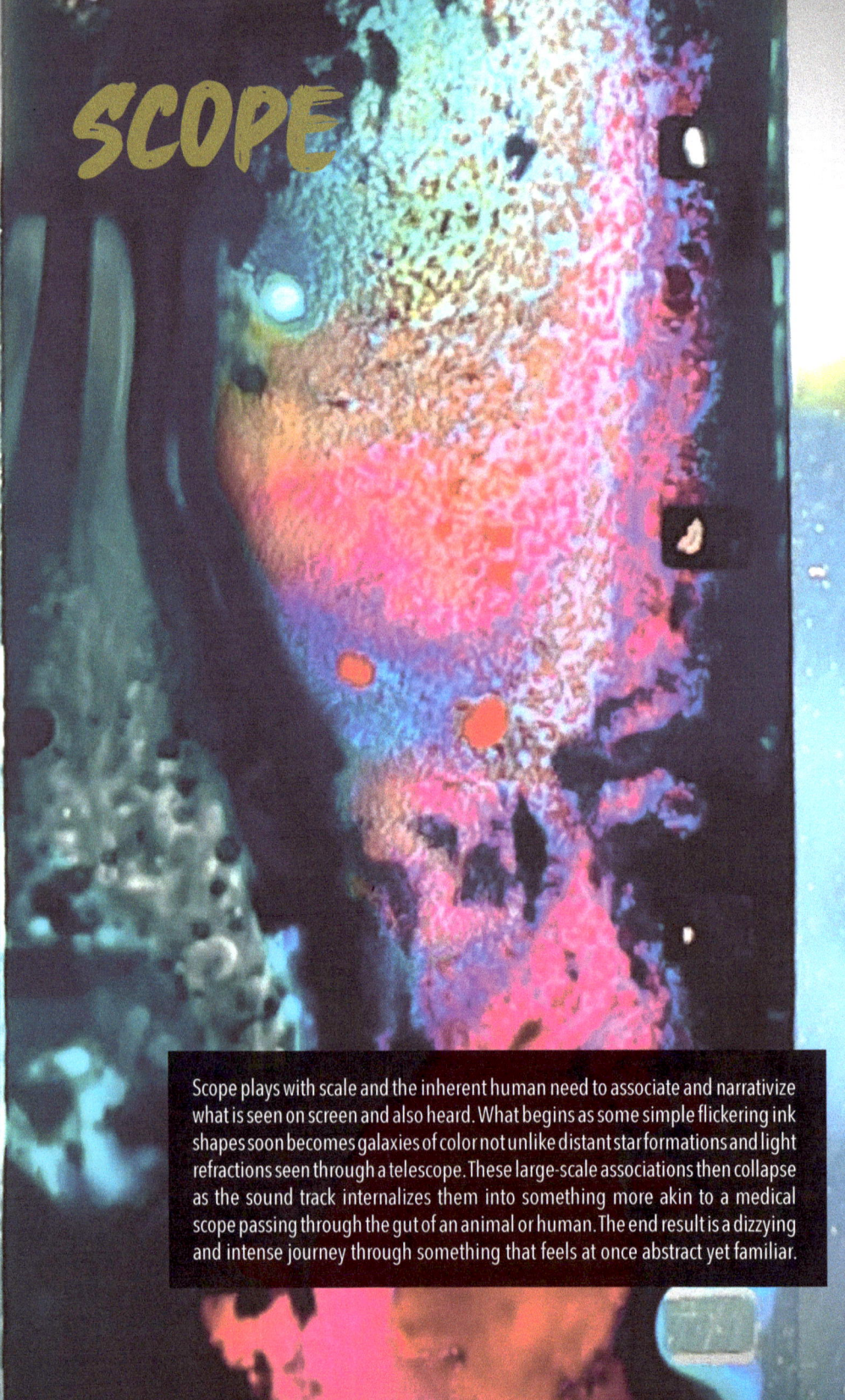

SCOPE

Scope plays with scale and the inherent human need to associate and narrativize what is seen on screen and also heard. What begins as some simple flickering ink shapes soon becomes galaxies of color not unlike distant star formations and light refractions seen through a telescope. These large-scale associations then collapse as the sound track internalizes them into something more akin to a medical scope passing through the gut of an animal or human. The end result is a dizzying and intense journey through something that feels at once abstract yet familiar.

How did you select the color palette for this film?

I worked with what came with a random assortment of India Inks I'd inherited. I generally found myself going for the brightest colors as they seemed to let more light through. I spent a lot of time looking at artists' impressions of outer space in the 50's which often have beautiful swirling pink and purple gasses. After a while the film started reminding me of tropical fish too as I hung it all up on a window to dry and the sun would cast color shadows onto my bedroom floor.

What materials did you use on the film stock to get those colors?

I mainly worked with India ink for the color which works over time, slowly it becomes more like stained glass as it cracks so depending on when you project or scan the film its always changing and becoming more itself. The strengths of bleach also have an effect and how long you leave them to eat the emulsion, it becomes almost infinite where you can take it.

What significance does sound play in this piece?

Sound has always been where I like to play with how images can be perceived. It's such a powerful part of the film language. Without the soundtrack I think Scope wouldn't be as interesting an experience.

What kind of textures are you most satisfied with in this film?

I really love the tiny air bubbles within some parts of the ink that become like another universe when scanned at 4K and zoomed into, it feels like you're exploring inner space which is why the film is called Scope.

What film stock did you use for this film?

I bought some old single perf 16mm black leader on eBay. Unfortunately I don't think it's manufactured anymore so when I see it I get it. I actually liked the fact it was this precious material, it helped keep me focused.

In your opinion, what genre would this fall under?

I suppose it relates strongly to the structural/material filmmakers in the UK in the 70's who created the film course at Central Saint Martins College of Art in London where I studied in the mid 90's. I think being able to work with gauge Film in the UK and their 4K scanner allowed me to take things further

OLLY KNIGHTS

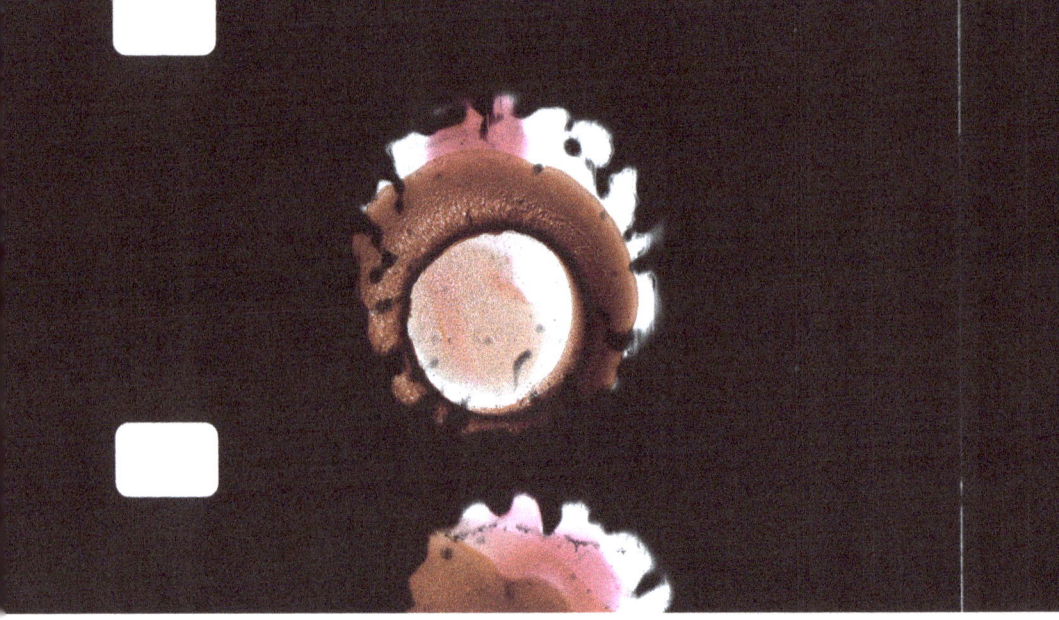

than I could back at college. I did stick very closely to the rules of what I remembered from experimenting with an optical printer as I wanted the power coming from the celluloid and sound track rather than too much digital post production which can be an easy rabbit hole to fall down sometimes.

What artists do you grab inspiration from during your artistic process?

I became quite obsessed with watching huge sci-fi films like Interstellar and 2001 and also B-movies like the remake of Invasion of the Body Snatchers during lockdown here in the UK. I think this was my lo-fi way of making a space movie, except the telescope was turned around discovering inner space instead. The journey I was making via some simple color filled circles became something much larger than the sum of its own parts. I love art that does that and blows up something tiny and mundane until it's huge and abstract and feels like a religious experience. So although I was influenced by all those great structuralist filmmakers from the 60's and 70's I was trying to get to that epic Hollywood bliss of the huge space epic too in a slightly absurd way.

How does music influence the way you've put this piece together?

Music is my day job and I collaborated with Phillip Marten, a producer/musician I've worked with on albums for many years, and we had a lot of fun with the abstract and literal sounds as well as the choral elements that give Scope its slightly spiritual feel. I wanted it to feel like a near death experience where people often recall the sound of angelic choruses and moving through tunnels of light. Every now and then a very literal sound is mixed in which brings things back to the material. I also worked with my editor wife Rachel Knights and she helped me pace the film like a piece of music.

ZEN AND THE FILM

The Corona Virus pandemic, which still determines our lives at the time of writing, has forced us to face the truth of our mortality. We are bodies that grow and perish, that go from one state of energy to another, from one material configuration to another. Along the way we collect scratches and scars (psychological as well as physical), we loose focus, we become less sharp, our bodies have to be checked, maintained and patched until they ultimately fall apart. And so does film. Film is not just images, as much as human beings are not just minds. Film is a body that lives and breathes, it collects scratches and scars along the way until it decomposes. When I attended the Film Farm in Mount Forest, Canada, in 2019, a year in which bodies were still sharing spaces, the product of my week-long work was severely scratched by the projector. I was very frustrated but Phil Hoffmann said, very calmly, that film gets scratched just as we do in life, we simply have to accept it and move on. We have to move on in life just as film has to move on in the projector.

During the last months our communication and our vision has been mediated through light emanating surfaces within the confines of our private homes (if we are so privileged to have one). In this (not so) new digital space we do not have to touch each other nor do we have to breathe the same air; it is aseptic, clean and perfectly smooth. Analog space on the contrary is becoming a threat to our health, it is unpredictable, rough and full of chance encounters. Cinema has always been the space of encounters with the other: other living breathing bodies that we do not know, other imaginations, other sensations and other spaces. It is a space for the unpredictable and of embodied vision. This body of ours as well as the body of film is being more and more negated by the logic of the digital. And cinemas have either become strictly regulated digital entertainment palaces, or archives that subscribe to the idea of a museum more than a cinema.

Museums preserve and repeat. In "The Art of Film Projection" (Cherchi Usai et al. 2019), the handbook for film museums and archives, film projection is considered as the fulfillment of the goal of film preservation and curatorship. The art in the art of film projection comes down to the skill to make it frictionless, invisible and reproducible. If it is noticed by the audience, something must have gone wrong. The ideal approach to film projection is to treat every print as if it was the last one, as if it held the last trace of the film. And a lot of energy goes into the preservation of this trace: it is constantly inspected (a good film inspection should document all the scratches and damages and should take half a day) and digitally restored (removing scratches, color fades and so

ART OF PROJECTION

on). Documentation, indexing, inspection and evaluation are more and more replacing the thing itself. Apichatpong Weerasethakul, in a Q&A after a retrospective of his films at the Austrian Filmmuseum, told the director Alexander Horwath that maybe we shouldn't make films at all and instead cherish the moment. Understandably, Horwath did not embrace this idea. But where does this neurotic compulsion to repeat, to perfectly preserve until the end of times come from? I think that this point of view is at its core already digital, insofar as it negates time, decay and the body. With the rise of digital media the carrier of moving images has become completely interchangeable: it doesn't matter from which computer, with which movie player, in which file format or container a movie is shown. What matters is the source code, a message detached from its material basis. The museum and the archive are manifestations of our desire to preserve the code, or in other words: of our desire to transcend mortality. But we will die and so will film and so will bits on hard drives. In the end, as the famous line of Blade Runner goes, everything will be lost in time like tears in rain. And the question, formulated by Robert Pfaller (2018), is not "Is there life after death?" but rather "Is there life before death?"

Let us imagine a world where we can enjoy what is there in front of us, accepting that life is ephemeral, that film has a body that lives and perishes just like we do, that nothing will last forever, that accumulation is not the way to a better future. Especially in times in which we are bombarded with digital images that emanate from our laptop screens in the confines of our living room, we should again cherish film as a unique event in space and time, a performance of machines, of architecture, physics, celluloid, optics and people. People that live and breathe, celluloid that gets scratched, machines that fail, optics that are out of focus once in a while. This is part of what makes film unique and separates it from digital media. Its experience is not reproducible. And the art of projection is a communal performance, a creative act - an act of creation!

—MARKUS MAICHER

References
Cherchi Usai, Paolo, Spencer Christiano, Catherine A. Surowiec, Timothy J. Wagner, Tacita Dean, and Christopher Nolan, eds. 2019. The Art of Film Projection: A Beginner's Guide. Rochester, New York: George Eastman Museum.
Pfaller, Robert. 2018. Wofür es sich zu leben lohnt: Elemente materialistischer Philosophie. 7. Auflage. Fischer 18903. Frankfurt am Main: Fischer-Taschenbuch-Verl.

This zine is analog

www.ingramcontent.com/pod-product-compliance
Lightning Source LLC
Chambersburg PA
CBHW040110180526
45172CB00010B/1298